THE PERENNIAL AVANTGARDE

THE PERENNIAL

AVANTGARDE

Gerald Sykes

Prentice-Hall, Inc., Englewood Cliffs, N.J.

Previous books by Gerald Sykes

The Hidden Remnant

Alienation:
The Cultural Climate of Our Time

The Nice American

The Center of the Stage

The Children of Light

The Cool Millennium

To My Harem

**BUFFIE,
JENNY**
and
TOURBILLON

PREFACE

This is the third of Mr. Sykes' philosophic excursions across the much-trodden fields of the fine arts, and in my view his best book to date. He has adapted so to speak, the Socratic dialogue, and cast his main theme in the form of an almost-novel. We know of course that he is a practised novelist and here he has used all his professional skill to beguile and alert the ordinary reader (who might be bored with abstractions) with a careful series of snap-shots, taken from different angles, of his central theme, namely: where are we now in the Fine Arts, and what is the calibre of our thinking today? A daunting query enough, but he tackles it to the manner born, using his personified abstractions as reflec-tors, as agents-provocateurs. It is an interesting, and most original way of dealing with his material because it allows him not only to digress and to build up touch by touch the overall preoccupa-tions of the contemporary artist but also to stray along philo-sophic bypaths and hint—no, *insist*—that one can discern in peo-ple's actual lives the blueprint of the ideas which make them tick the way they tick. The result is both a philosophic essay on the contemporary aesthetic, and still a story about ordinary people who exemplify it in their lives. It was a tricky idea to deal with in this way, but he has brought it off perfectly. It is not my duty to try and encapsulate his conclusions in a brief preface—it would be like giving away the answer to a detective puzzle. For reading Sykes and following the play of his mind is part of the rich reward of reading his book. It is an intellectual adventure and our guide, the philosopher-novelist, is fully in charge of his omnibus-load of Canterbury Pilgrims (as he calls them at one point). He has avoided with exemplary skill the pitfalls of a thesis, or of an allegory; his book, so packed with sharply-focussed insights, and so beautifully written, has a form all of its own—just as Sykes has a truly original mind all of his own. Reader, pray give him the mature attention he deserves of you; he won't let you down.

LAWRENCE DURRELL

CONTENTS

INTRODUCTION TO
A MISREPORTED WAR

Everyone agrees that art, supreme consummation of peace, should not be a war; but it is. It's relative unbloodiness, except in dictatorships, should not be permitted to confuse us about its true function, which is to impose honesty and grace upon a world that is seldom eager to accept them. At least from the standpoint of its practitioners, art is indeed a constant war with nature, and our worst reported war.

The correspondents cannot restrict themselves safely to battles and strategies; they must also cover feelings, intuitions, chimeras, originality. On the other hand, they are permitted, and frequently encouraged, to describe routs as triumphs, to crush or ignore the truly victorious, to write as if truth and beauty did not require as supple a change of attack as killing. They do their best work with the old, their worst with the new.

New art makes harsh demands on all of us today. However prudently we may seek to hide away from it, its aggressive leer is sure to insult us on the next page of a newsmagazine, the next fund-raising plea for a university, the person who sits next to us at dinner, the latest ad for a car. We cannot immunize ourselves against the germ-warfare of all those restless, unemployed, unelected, over-inventive egomaniacs who apparently never heard of peace or live-and-let-live.

"What's behind the new art? What do they mean by the avant-garde?" The most backward Crackers have begun to ask these questions. They feel caught in a shooting war, but they cannot see the bullets.

This book is an attempt to guide them—or if possible readers of less recent literacy— through the art wars. Not away from them but *into the midst of them*. In the midst of them, strangely enough, our motherwit can return and serve as an accurate measure of the true and the false. And in the midst of these exciting battles we are offered a chance to expand our minds and

our personalities. In addition, as you will soon discover, there is an amazing amount of pleasure, the only pleasure that can compete effectively today, for most of us, with those of the table and the bed. And the counting-house.

Unless I am mistaken, readers consist mainly of those who like stories about action and those who like commentary about stories about action. For ancient evolutionary reasons, the former greatly outnumber the latter, but the latter are apt to be more articulate (except in the rare case where the reader is equally at home in the concrete world of story and the abstract world of thought).

This book is addressed to both the story-lovers and the commentary-lovers. Each chapter tells a story that actually, with a few disguises, happened in a most advanced sector of the art wars. Each chapter also offers an interlude of commentary, direct or indirect, on the action that has just taken place.

The purpose of the book is to awaken understanding, rather than fear and hate, for talented men and women who are working today in literature, painting, sculpture, music, theatre, movies, architecture—and also in science, philosophy and politics.

The history of the avantgarde in each of these fields is brief. It is longest in science, which is not neglected here, although the book is primarily about the arts. Recently, as the article in the Appendix describes, the avantgarde has been subject to an unexpected corruption. Newness has been raised to an unprecedented importance by the conditions of modern life, and some businesslike minds have therefore been quick to exploit the mystique of the avantgarde.

Out of conflict can come understanding, for those who want it. Out of war can come peace, or as much of it as our innate aggressiveness is willing to construct.

An intelligent interest in the avantgarde, in the part that innovation has played in making us what we are and what we may become, is now, whether we like it or not, essential to survival. It is also needed if we are to enjoy surviving.

"The day will come, incredible as it may seem, when men will quarrel more fiercely about art than about God."
Dostoevsky

"The only subject I really enjoy discussing, my dear boy, is music."
Plato

"In science no one pricks up his ears unless the discovery is *new*. Why should I bother to look at art that copies a style I already know?"
Nietzsche

"The worst misfortune? To be original!"
Stendhal

"Grow old along with me, the worst is yet to be."
Rabbi Ben Ezra
(original version)

PROLOGUE

One night last year, when a sweet April shower barely moistened the drought of March, at least in one part of New York, I participated with some reluctance in an event that now seems to me more dramatic and more significant than any new play I have seen in years. It was *not* the kind of event that can be reported in the press (though some of it did get into the news). It *was* the kind of event that can be reported in a book.

"And yet," I said a year later, "it took me almost a year to realize this." I was talking to a friend, a Greek scientist who was working in New York. He had witnessed the last part of the night.

"Why did it take you so long?" he asked. "I knew right away that it was a very important night, and I only saw part of it."

"I was dazzled by the brilliance and the—how shall I say it?—wholeness of it all, but for some stupid reason I struggled all that summer, that fall, that winter to write down the *meaning* of that night. I didn't see that it would be enough to write down the *action*. It was only this year that I realized that the night must simply be recreated, exactly as it happened."

"They call that phenomenology in science."

"Our sportswriters call it a blow-by-blow account. Anyway, I should have known how much more interesting the people were than the ideas they expressed."

"You certainly should have!"

"They were almost theatrically human."

"They certainly were!"

"Do you know who I think they were like? The Canterbury Pilgrims!"

"I read about the Canterbury Pilgrims at Oxford, but I don't exactly—"

1

"These pilgrims could not agree on their Canterbury, but all of them were going to one shrine or another."

"Well, you could say that of—"

"I think they were as typical of our time and place as Chaucer's pilgrims were of his. If you gave them Chaucerian names they could be called the Publisher; his assistant the Junior Editor; his son the Graduate Student; his wife the Art Dealer; the Dealer's Assistant; the Musician; the Conductor; the Movie Actress; the Architect-Sculptor, the Patron; the Scientist—"

"The Scientist?"

"Yes, that's you. You came in toward the end. And then the Old Man."

"You mean the old man I treated?"

"That's the one. I see them all, including you, as typical New Yorkers. They would be considered glamourous by any newspaper or magazine."

"Glamourous?"

"And yet they all did ridiculous things."

"Including me?"

"Including you. The Publisher counts every cost of every page, but he invites death because he desires an elderly woman, much less attractive than his wife, who resembles a character in a book he dislikes. The Editor allows an unscrupulous author to steal his wife, his children, his car, his clothes, his books."

"I didn't know he did that."

"The Graduate Student feels honor-bound to seek out a bloody encounter with the police during a strike at Columbia University."

"I saw that myself."

"The Art Dealer amuses herself flagrantly while her husband, whom she loves, may be dying in the next room."

This struck home. The Scientist was attracted to the Art Dealer. "When did she do that?"

"Before you appeared."

"In the hospital?"

"Yes. And her Assistant risks whoredom to get an artist for the gallery."

"I heard enough about that."

"The Musician resists the advances of the Conductor because she feels consecrated to Artemis."

"Such a lovely girl, such a mad idea!"

"The Conductor, who resembles a vast male Goldilocks, probably sleeps with his hair in a net."

"That's conjecture, not phenomenology."

"He *did* enough too. The Movie Actress tells the Art Dealer and the Publisher that they are worse whores than she is."

"Did she really? I never heard that."

"The Sculptor horrifies everyone by an act of contempt for the one thing they value most, and then delights them by explaining the philosophy that led him to do it. The Patron cringes before every insult of the Sculptor."

"Some time you must tell me what he said."

"The Scientist wants nothing less than to practise medicine, but he finds himself looking after the Old Man in a hospital."

"I'd forgotten all about that. You wished him off on me!"

"If there was one thing that was said by almost all of them, it was this, 'I'm just as avantgarde as you are.' For some reason they all wanted to be avantgarde."

"I can understand that. Who wants to be an old fogy?" The Scientist was about thirty-five. He dances in a *discothèque* at least once a week.

"They were all New Yorkers, they were all ludicrous, and they were all more passionate than New Yorkers are supposed to be."

"Passionate?"

"Yes. They live in the new capital of the world, the greatest gathering-place of wealth. But it is also the greatest gathering-place of human beings who have been exposed more nakedly than anyone else to the unexpected side-effects of wealth. Their protest is loud, funny and passionate."

"I still don't see them as passionate."

"Progress has made them what they are. It has also been their sorest trial. Something worse than poverty has overtaken them, something that demands entirely new responses of them every minute of the day. *Prosperity*. It destroys their reflexes. It robs them of dignity. No one can sympathize with the rich.

And so they are comic. But they are also looking for answers. The privilege of prosperity: they are passionately philosophic. As passionately philosophic perhaps as the Athenians of old," I told the Greek.

"It's true that Plato and the others didn't have to work. They lived in a slave-state," he conceded, "but—"

"Anyway, whatever they are, ludicrous or passionate, these eleven New Yorkers met together one night, and I was there and watched it all."

INTERLUDE: WHY INTELLECTUALS HATE STORIES

A professor of sociology, an old friend of mine, protested against the use of dialogue in a book that dealt with a serious subject like art. It made him uncomfortable, he said, to be drawn into a modern problem that called for serious thought by the ancient wiles of narration, so often compromised in our day by best-sellers, films, TV. It relaxed him at a time (he admitted he enjoyed the story) when he should have been on his guard. It was enough to ask a sociologist to look at a book about art, but to present the discussion through a contaminated medium was a bit like trying to soften him up with a pretty, book-loving prostitute. It was too much. He had been worn out by his own work, and now he felt, no doubt through emotional conflicts, utterly exhausted.

I apologized. When I asked timidly if it had been legitimate for Plato to use dialogue in serious discussions of art, he replied that Plato had lived in a much earlier time when primitive methods were still a standard procedure in formal reasoning. We now live, he said, in a time when narrative seductions should not be mis-employed to beguile those who desire clarity on large social issues. Such seductions, he said, created an unfortunate atmosphere of levity and triviality, quite improper for discourse of any weight.

His attitude, which in my experience is widespread, can be

traced, in part, to the intense competitiveness, the paranoid fears, the cold struggle for power that characterizes much of academic life (and in other intellectual pursuits to the rewards for a quick ability to make plausible abstractions). My friend would be mistrusted by his colleagues in the sociology department if he showed too much latitude not only on literary devices but on the sister-sciences of psychology and anthropolgy. He would most certainly not be promoted—and he is already running in debt—if an exogamic pursuit of knowledge led him too far from his own tribal tabus, which are none the less rigid than those of the Stone Age because he communicates in polysyllables.

As a reply I quoted someone, in another discipline, he had not read. "In this world a man of culture is either a dilettante or a pedant: you have to take your choice. . . . And I take refuge in dilettantism, in what a pedant would call a *demimondaine* philosophy, as a shelter against the pedantry of specialists." Unamuno wrote that at the beginning of this century, while declaring himself against everything "American," everything that was sure to prosper through the mechanical skill and pedantry of recently liberated peasants. He had been shocked by his country's defeat by the United States in 1898, shocked into an avantgarde understanding of what lay ahead.

It is not surprising that Unamuno is now an existentialist hero among our young American rebels. He predicted the dilemma that confronts them. He also showed them how to handle it. He wrote not only philosophy but fiction and poetry. His subsequent defiance of Franco and his rapid death soon afterwards (perhaps of poisoning) gave them a strong example.

My classroom experience indicates that dull and cautious students will behave like my friend the sociologist (who is simply over-submissive to his environment, like the monks of the Middle Ages). Bright students, determined to become what they can be, will arm themselves with Unamuno for a fight that may be still harder than his.

It is difficult to speak fluently both the language of science and the language of art. It is not impossible, but at present it remains our greatest linguistic barrier. With hard work we can master all the tongues of the modern and ancient worlds. But to be at home in both images and ideas, among people and programs, requires more than diligence. This kind of bilinguality requires a strong desire for freedom—and enough energy to get it.

Great deposits of energy and freedom are to be found in the

account of the avantgarde that follows. Because some members of the contemporary avantgarde have been corrupted is insufficient reason to drop the term altogether, or to forget their predecessors and their honest continuators.

There is a perennial avantgarde which cannot be corrupted. It is composed of delightful surds that could not be fitted in. Their carefree heedlessness can be of help in releasing our freedom and our energy.

Postscript: The Franco-Prussian War Goes On

The president of a large university, after reading the manuscript of this book, wrote that it was a difficult kind of book "to pull off. I think Sykes has done it, but I also think the boys and girls at [a publication] are going to dislike it.

". . . They will react this way because Sykes carries his erudition so lightly as to be an embarrassment to the heavy thinkers. As I was reading I was wondering how this particular bunch of reviewers could be . . . made to come to terms with the central idea of the book, and with the validity of this form of presentation." He suggested that I add something at this point that "would be a straight discussion of the existential condition of present-day myth-making, belief erosion and ideology rejection. The pages of the MSS correctly give the feeling of rootlessness of today's intellectuals. But they are going to miss the point, I think, because they are not given a platform from which to jump into the conversations that follow."

It seemed like sound advice. Here I try to follow it, though with no illusions whatever that I am going to make any rootless intellectuals come to terms with anything. In my experience the rootless *prefer* to remain rootless. To possess power or prestige without responsibility is more fun, and more in the accepted American style of life, than to make difficult demands upon oneself. Social conscience is used to avoid personal conscience. If anyone remains rootless, it is because he has declined the hard and lonely task of rerooting himself in authenticity. He would much rather blame everything on the times or society. Or his parents.

Several friends of mine write regularly for the unnamed publication, which is exceptionally well edited, in the technical sense. I have known them for years; I like and admire them; but

to the extent that they can be lumped together as "rootless intellectuals," which is certainly not true of all of them, it is because by temperament they are polemicists who have found programmatic solutions, some of them owing an early debt to Leon Trotsky, which enable them to deal authoritatively with almost any question and to listen authoritatively to almost no one. Their education ceased long ago. Some of them have been blamed by Irving Howe, anonymously but pointedly, as being in part responsible, through their desire for popularity, for the student bombings that have threatened a wave of hysterical reaction not unlike that which led to the end of the Weimar Republic and the rise of Hitler.

Nevertheless, even if they are only looking for a chance to shoot holes in this book or grandly to ignore it, they seem entitled to "a straight discussion of the existential condition of present-day myth-making, belief erosion and ideology rejection."

To put the discussion in proper perspective, I believe, it should begin with the recollection that we are now passing through the centenary of the Franco-Prussian War. Culturally, the historical evidence indicates *that war is still going on,* and once again the Germans are winning. They lost two more important wars, the one that began in 1914 and the one that began in 1939, but the past century has nevertheless been a better one for them than for the French, at least as an influence on Americans. Whether because "conquered peoples conquer their conquerors inwardly" (Jung), or because the rise of unschooled masses to power required more pedantic methods of education, or because the Protestant ethic favored dullness, or because new technology favored the stolid over the sensitive, or because new methods of communication favored ABC minds: whatever the reason, we are confronted with the fact that Gallic wit has steadily been losing out to Germanic weight.

Esprit is suspect; ponderousness is not. On the contrary, for a newly rich public (or a newly mechanized peasantry rewarded for being robots) that shrewdly equates degrees with power, that came here more often from Central Europe than from Western Europe, that is almost totally unaware, until it becomes really rich, of Western European values, the Nazi appraisal of France is still correct: she is only able to make perfumes and other luxuries, while Germany is *solid.* And a ponderous style is more convincing than one that assumes an awareness in the reader that he does not have—and wishes no one else had. When such a reader finds

D. H. Lawrence calling Americans "escaped slaves," he does not know what he means. He bans the Lawrence book from his schools.

There are no book-banners among those who write for the magazine in question, I hasten to add, but there are some with distinctly ponderous styles and doctrinaire minds that can be correctly described as more "Germanic" than "French." (Not that there is a total absence of pedantry in France or of freedom from it in Germany, as anyone knows who has been in those countries. I am merely using the two countries as symbols, to help me describe a real but generally unnoticed and possibly suicidal state of mind in my own country.)

Why has the United States been especially ready for "Germanic" or over-schematic influence in matters of thought and art? In industry and politics the majority of Americans has remained stalwartly pragmatic, suspicious of all ideologies, in fact anti-intellectual. But a minority of somewhat introverted or educated Americans has become distinctly responsive to programmatic solutions that their pragmatism originally shunned. (The activists move toward neo-Marxism; the quietists toward Zen and the like.) The explanation seems to be, it is suggested elsewhere in this book, that a determined minority feels that it has been over-pragmatized, deprived of too many personal fulfilments by the demands of practicality, and therefore seeks both the fulfilments and a metaphysics that will justify them. Hence the interest among students in such differing writers as Herbert Marcuse, Paul Goodman, Norman O. Brown, Allen Ginsberg, Gary Snyder, Alan Watts, Norman Mailer, Aldous Huxley, Hermann Hesse, D. T. Suzuki, Kierkegaard, Nietzsche, Heidegger.

Virginal minds are easily raped by a single idea. And single ideas are quick to perceive intellectual vacuums among their potential victims. No country has been more hospitable than the United States to the most doctrinaire aspects of psychoanalysis. No country uses more social science jargon on its campuses—and lately in its newspapers. Nowhere else has there been such wide receptivity to "Germanic" styles in architecture (Bauhaus) and "Germanic" styles in painting (Expressionism). (So wide that there have been strong native reactions against them, as there has also been against doctrinaire psychoanalysis.)

Virginal minds keep springing up, however, in prairies, suburbs and ghettos, ever-ready for violation. Indeed, now that over sixty percent of our eligible youth goes to college, one of our largest markets consists of virginal minds. This is why publishers'

lists, profits and mergers move steadily in the direction of Big Business. And why the books they sell, if they wish to sell "big," carefully avoid any of the complications, emotional or intellectual, that might pierce or distress a mental hymen. In such conditions "education" flourishes and the arts become mere agents of production and consumption. Peggy Guggenheim put it well when she said we no longer live in the age of the artist but in the age of the collector.

This situation means that cultural criticism is needed more than ever before, but is only listened to if it is heavyhanded, one-sided, contemptuous of any opinion but its own. Also, it should be boring. Otherwise it will not seem serious. Some critics are magnificently equipped to meet this challenge, and the magazine that must be nameless has given them a chance to display their skills.

It is all very well for me to denounce "Germanic" language, but I have to be able to speak it, when necessary, in the classroom. Otherwise I would not be understood. For example, one of the courses I teach, an interdisciplinary one, unfortunately unique, is called *Alienation: Causes and Cures.* It approaches its subject from the standpoints of sociology (re-enacting the best insights of Marx, Durkheim, Weber, Ellul and many others), psychology (Freud, Jung, Adler, Fromm, Rank, Horney, Boss, Laing and many others), history (Spengler, Toynbee, Ortega y Gasset, Giedion, Eliade, Campbell and many others), philosophy (Plato, Aristotle, Aquinas, Spinoza, Kierkegaard, Schopenhauer, Nietzsche, Heidegger, Sartre, Whitehead, Wittgenstein and many others) and art (too many names to mention). To make all these conflicting insights intelligible and interesting to students, in what seems to me the only way so important a subject can be adequately discussed, I have to improvise a Franco-Germanic American that is really a creation of the drill-punctured sidewalks of New York.

How in such language do I describe "the existential condition of present-day myth-making"? First, myth means more to me than the Concise Oxford Dictionary's definition of it, "Purely fictitious narrative usu. involving supernatural persons, etc., and embodying popular ideas on natural phenomena, etc." I would say that if words were traded on the Stock Exchange, the once dubious noun myth would now be among the most bullish items on the Big Board. Its value has been going up ever since we began to discover that myths are not only fictions but can also provide a scientific approach to the faiths that keep us going. Psychologists

(for example, the Existentialists) study their patients to see if they have a "sustaining myth" that will help them to cope with anxiety, face guilt and death, achieve identity. Literary critics (for example, Mark Schorer) consider myths as the instruments we use to make our experience intelligible to us. And on a less disinterested but more conspicuous level statesmen, manufacturers and media masters seek macromyths and micromyths that will enable them to reach the mind of Demos, which is the final source of modern power.

To reiterate the Marxist certitude that myths are merely deceptions, of no importance in the struggle for power, as some writers for the publication in question have done, is to miss the point of what has been actually happening in the struggle for power. No practical politician, struggling to win the minds of voters, would make this mistake, which may be one reason why Marxist ideology failed to get a foothold in the United States, even in the Depression, except among rootless and bootless intellectuals who could not learn from experience. They were however startled by the Moscow Trials of 1936–37 and the Soviet-Nazi Pact of 1939 into greater awareness, and the more intelligent of them then switched from Stalin to Trotsky. The role of critical observer suited them better than the role of would-be politician, especially since there was an ever-increasing market among the young for their combination of fervor and certitude. At last they were lawyers with a jury they could impress.

The market of virginal minds has been multiplying beyond any statistician's expectations. In the last decade every large publishing house, no matter how "literary" its original facade, has completed a textbook connection (somewhat like a writer taking a rich wife). And the virginal minds were not even alive in the 1930s. So the ideology of Marxism (or the mythology, since it has religious, cosmos-ordering, society-blueprinting, psyche-reassuring recommendations) has been revived, but without the embarrassments of Stalin or his successors. A political theory has been revived, without the embarrassments of *Realpolitik* or actual history, and aimed at the technological society which the young on the whole had accepted in silence until 1964 or 1965, when the escalation of the war in Viet Nam made them sharply aware of its many disadvantages. Most rebellions of American students date from that time. Their activist leaders (for example, Mark Rudd) have credited the de-Stalinized neo-Marxism of Herbert Marcuse with aiding their will to revolution.

Whatever the outcome, whether our student revolutionists

have found a workable program in Marcuse's "one-dimensional" reasoning, whether Lewis Feuer is correct in his thesis that a reign of terror must result from an irrational and reckless youthful will to de-authoritize elders, whether the elders will take Margaret Mead's advice that they learn from the youngsters, whether the youngsters succeed in making a "counter culture" that Theodore Roszak believes will defend them against the aridities of "the technocratic society," we live in a time when there are fewer agreed-upons than ever before. This means that we are in for continual surprises. It will sell newspapers and television commercials, and promote stress diseases in the audience. It may lead, as the Greek scientist says rather Byzantinely in Chapter 10, to a bloody visceral reaction among the uneducated. It may make the Storm Troopers seem rather gentle. It may also lead to a better society than we had before. It will most certainly frustrate anyone's desire to achieve a fruitful harmony with nature, such as is necessary to the creation of a work of art, unless he first achieves a much more supple kind of education than he is likely to possess today. It is a purpose of this book to indicate how such an education may be acquired even now, when everything goes against it.

By presenting briefly a situation that is on everyone's mind I have tried to describe, as concretely as possible, "the existential condition of present-day myth-making, belief erosion and ideology rejection." Myth, belief and ideology have been, as a holist or Gestaltist might have told us, scrambled. We need a sustaining myth to see us through our psychological crises and to make our experience intelligible to us. We cannot act effectively unless we believe in what we are doing, and that finally rests, more than we realize, upon a fairly systematic ideology.

As successful pragmatists we are now obliged to reconsider all the psychological refinements and religious subtleties and philosophic dilemmas that we thought we had once and for all put safely behind us. Our prosperity is no longer a justification or a defense. America has not escaped the terrors of history. Our agreed-upons are vanishing. The gains of a great applied-science are in danger of being wiped out (oh not just yet, but the end is in sight). Perhaps the American way of life can only be continued if it learns patiently from crackpots it once scorned. And perhaps it is too deeply committed to its rich new habits to be able to learn from anyone. There are still all those virginal minds to exploit . . . Certainly, until it suffers a real catastrophe, it will only listen to those who tell it it is on the right track, to those who "soothe as they inform," or congratulate as they misinform.

Our determination to be assured that we are right (the defini-
tion of *hubris*) tells us enough about the state of myth, belief and
ideology among us. I do not have to remind my kind of reader
that neither our churches nor our parties retain their former hold
on either their leaders or their rank and file. Bishops, nuns,
Secretaries of the Interior, wardheelers speak out of turn. Like
Descartes, though with none of his deliberateness, we are all
plunged into "systematic doubt." Hence the wild scramble in the
many runnings of the "mythmaking sweepstakes." Who will win
in it? No one. Who will lose in it? Almost everyone.

The only exceptions will belong to "a very small remnant"
(Isaiah) that can be "French" in sensibility and "Germanic" in
patience. These few will be able to say, *Plus ça change, plus c'est
la même chose,* and at the same time work with Krautish efficiency
for just and intelligent change. How will they achieve such a
difficult combination of opposites? By finding what is authentic
for them, irrefutably authentic, and then sinking their roots into
it. They do *not* prefer to remain rootless. They can think statisti-
cally and also archetypally. They can see the cynicism in a political
speech—and also see the god in every man, which means in
plumbers, waiters, salesmen and housewives, as well as in city
planners, diplomats, poets and ballerinas. They have found a way
to be at home in a time that is more explosive and more exciting
than any that preceded it, a time we denounce because it re-
quires us to equal Shakespeare.

In 1870 the Franco-Prussian War was hardest of all on those
who lived in Alsace-Lorraine. They had to decide whether they
wanted to be German or French. Most of them sided with the
winners, the Germans. Most of our people are siding with the
winners of our cultural prolongation of that war, the "Germans,"
the pedants, the jargoneers, the people who go by the book.

A few however side with the losers, the "French," the people
who do *not* go by the book. These few believe that all "Germanic"
ideologies and myths will collapse, if they have not already done
so. They believe that only a few myths will survive, those that
come from true poetic imagination and that cannot be uttered
just now in the language of ideology. In time they may lead to
new beliefs and new ideologies.

If we read books, we live in Alsace-Lorraine today. A century
later we have to decide which side we are on. I hope a few "heavy
thinkers" will choose "France."

They will not be choosing the superficiality they fear. They will
be choosing life—in all its painful unexpectedness.

Hitler was not a fluke. He was a historical consequence of the *furor teutonicus*. We must all beware, lest we help to produce a *furor americanus*. It might be even worse.

Is this clear? Have I given today's intellectuals a platform from which to jump into the dialogue and action that follow? No? Let me try further.

The *furor americanus* is being inflamed by intellectuals who refuse to be chastened by any experience, who remain intoxicated by the prospect of numberless virginal minds that might be subjected to their influence. Irresponsibility of this kind passes unnoticed in a society that is convinced that thought has little effect on action—until there is widespread youthful violence, and still stronger anti-youthful violence, that indicates many kinds of intellectual influence. Then the danger increases that we may indeed be living in a Weimar situation. And this time there will be no America to flee to. Our country is no longer the "Mother of Exiles."

In a post-puritan culture irresponsibility has *chic;* responsibility none at all. Responsibility in art has been made to seem like a dull middle-class virtue, suitable only to squares, when actually it has become the only way to see the world with a fresh vision. When there is a scramble for novelty, when any new style can be copied in a day, when the arbiters of taste are salesmen, responsibility becomes the only genuine surprise. We are bowled over by authenticity, which seems as *naïf* as the Douanier Rousseau.

The avantgarde was originally based on responsibility, on genuineness of vision (that is, new vision which avoided anything that had been done before) and on genuineness of craftsmanship (unwilling to repeat the techniques of both the academy and hucksters). But now that the myth of the avantgarde has been expropriated by shrewd PR experts who know how to package it for virginal minds (see the Appendix), responsibility must wait patiently until an ignorant public gets tired of fakes. Sure quiet voices must somehow survive until the screamers have bored everyone to death. This will take a long time in a country that is famous for spoiling its children (most of whom have never known poverty)—and for not having, as yet, to pay for its mistakes.

The abuse of the myth of the avantgarde will remind our artists that all enduring group myths have come out of remote times when there were no historians about, and they must descend into the most archaic depths of themselves before they can hope to create durable myths from their own experience. It will remind

our religionists that they themselves are chiefly to blame for the erosion of our beliefs; they were both too credulous and too dogmatic, and they failed to convince anyone by example. It will remind our ideologists that if their ideologies have not stood up in new times, it is because they did not look far enough ahead or deeply enough into the men for whom their programs were devised.

The first responsibility for avoiding a *furor americanus,* that is, the destructions of madness, rests upon our artists and intellectuals. And we reward them when they forget it.

We reward them when they are as intent as businessmen on money and publicity. We do not reward them when they show anachronistic signs of personal integrity. They must behave appropriately as citizens of a merchandising economy. If they were to refuse to behave like salesmen and were to be taken seriously for a moment, they might make everybody else look bad. Unless they twist language with an instantly recognizable skill that is approved by the best newspapers and magazines, they remain dubious characters who must be ignored or played down.

The few artists who can survive this subtle ostracism then face a still grimmer test. Firm as their integrity may be, they cannot prevail unless they acquire a workable method for transforming their day-to-day experience, which in the circumstances must be largely painful, into nourishment for a joy-giving art. No folklore sustains them. No group myth sustains them. (Only the halfway can be sustained by group myths that are picked up through membership in a minority, whether privileged or persecuted.) They are urbanized, uprooted. They must find their sustaining myths in themselves, in their ability to face social aridity and transform it into artistic fertility.

This is as difficult a demand as any person can make on himself. And yet it is now necessary to the survival of the artist, who must function without a folk or a faith, except as he can find them for himself by transforming the bloodless, abstracted scene that confronts him into a poetic source of aesthetic abundance.

When dried-up intellectuals fail to discover such wellsprings within themselves, it is not astonishing that they get their revenge with "Germanic" dogmatics. God help anyone on whom, in the nameless magazine or anywhere else, they can vent the fury of their defeat!

ONE

THE ONE UNCHALLENGED FAITH

The man I am accused of killing had one of the saddest faces I have ever seen. Its heavy-bearded saturnine (painfully clean-shaven) power had been disfigured by an excessive overlay of warts. When he looked at me his left eye looked somewhere else. I have often wondered what he saw with that eye. And whether it hurt him to read.

In my defense I must point out that he was not in the best of condition when I met him. That was in his office in New York, in March of 1968. While we shook hands he distinctly said that he felt below par. Since he was the editor-in-chief of an old publishing house, known the world over for its books, it cannot be assumed that he used words carelessly. He was merely stating what would have been obvious to anyone. His skin was grey. He complained irritably of the tranquillizing music in the elevator that took us downstairs. He puffed audibly when we got into a taxicab. He said he had been having some trouble with his heart.

There are writers who would like nothing better than to lay claim to the death of a publisher. I am not one of such heroic stuff. If his melancholy face and oversoft body awakened any emotion in me, it was a rather low sympathy for a fellow-creature whose life had been sacrificed, as I understood him, to work in which he did not altogether believe. There was none of the zest that I had encountered now and then in other members of his profession (though later he did show some, I must admit, and I am blamed for this). His frequent sighs seemed to issue from a profound despair. I wondered if he would be able to get through our conversation.

The restaurant to which he directed the cab was not of the fashionable kind where publishers usually take authors. It was

called the 20 CM. Club. It was owned and run by the person whom I might accuse here, if I knew the correct spelling of her name, of being more responsible than anyone else for his death. This person was French. Her restaurant lay on the west side of Penn Station, not far from railway tracks, noises and odors that would have been considered inappropriate for literary discussion by anyone but this publisher. Yet his reason for choosing it was literary enough.

"A lot of railroad men come here," he told me with more animation than he had shown in the office or the cab. The sight of blue caps, both dark and pale, together with overalls here and there, appeared to make him feel that somehow we were both getting close to reality. "It's like that railroad joint in Sartre's *Nausea*. I feel like vomiting the minute I come in the door. It's wonderful!" He also told me how much trains had meant to him in his boyhood in Indiana, especially the express train between Chicago and New York.

But the Frenchwoman meant at least as much to him. "See that big broad over there behind the cash register? She owns the place. I'm trying to work out the same arrangement with her that Sartre worked out with the woman who owned his joint. All he had to do was raise his hand, and she would go upstairs, take off her clothes and get ready for him. No money changed hands. They didn't even talk. It's a great idea, but I'm having some trouble with the details," he confessed rather boyishly.

And then with a sigh he took his mind off this delicious prospect by an act of will and reawakened in himself the less exciting sense of duty that had caused him to write me a letter, change our appointment several times in the course of several months (as first he and then I had to go out of town) and finally get together with me in this unlikely place.

"Now then! I read your article in *The Times Book Review*. "The Changing of the Avant-Garde." * Good title for a think-piece, but not good enough for a book. You've got a great idea there. 'The one unchallenged faith.' It cheered me up. It said some very harsh things, and yet it gave me hope."

* This appears in the Appendix.

THE ONE UNCHALLENGED FAITH / 17

I must point out here that it was on this single statement of his, repeated later in a hospital, that I had given him hope, that the accusation against me, the accusation of being responsible for his death, was founded. We shall see later how thin the evidence is against me.

While he talked he appeared to gain energy. The place did create a kind of enthusiastic nausea in him, and he also appeared to think that something similar would be good for me. Each time he said something favorable about my article, he wiped it out with a harsh reminder of the laborious struggle that I must endure if anything worthwhile were to come of it. "Very interesting. But it will need a *lot* of hard work. Just like that French kitten over there." I looked again at the kitten, and the unseemly thought occurred to me: "I'll bet she's a grandmother."

His questions began. "Now tell me something. We've been talking about your article in my family, and this question came up. When did the avantgarde begin?"

"Well, you could say the original avantgarde consisted of one man, Prometheus. His name meant Fore—"

He looked impatient. "No, I meant, who invented the term?"

"Well, Malory used it in the fifteenth century."

"I mean modern times. It must have been a Frenchman."

"Oh. The scholars say it was Saint-Simon. The socialist, not the duke. Around 1825."

He shook his head, to suggest that I was being obtuse. "What do people think of the avantgarde *now?* What do *young* readers think of it?"

"That's easy." I had had to answer that question before. "Nearly all ideas that college students hear come from one avantgarde or another. Almost no one studies the classics any more. Avantgarde ideas are exciting. They come from exciting lives. Baudelaire, Rimbaud, Stendhal, Dostoevsky, Nietzsche." I confined myself to writers, for his sake. Publishers can be unaware of other artists. "They tell students to rebel or drop out. They make lectures sound better. They promise revolutionary changes in lives that otherwise would lead straight to what dad and mom have been doing."

"Rebel or drop out, eh? Thank God my kids have gotten be-

yond that. Or have they? Go on. This is interesting." I was already beginning to arouse the hope for which I was later blamed.

"Then students discover that lec*turers* are not as exciting as lec*tures*. Their desire for leaders they can respect is thwarted. Teachers are rarely as interesting as the ideas they spout. They have had anything but the radical encounter with life they are talking about. They fuss about tenure, committees, promotion. The students feel a deep sense of disappointment. A few of them direct their emotions with the zeal of inspired saboteurs. Rebellion brews. Riots break out."

"How do you know all this?" he asked suspiciously.

"I've taught a while. Recently I've been appointed, because of a book I wrote about students, as teacher *in absentia* to the leaders of the Berkeley riots, while they are in jail."

"Go on. My son would love this! He's at Columbia. He says there'll be trouble there. He's not dropping out, but he *is* rebelling."

"Education is now our chief myth. Students expect a lot from it that they are never going to get. They expect something to come from the outside that can only come from within. They think they are going to get adventurous guidance from tame academics who are still shaking from the ritual castration of the Ph.D."

"Boy!" He felt better. "Am I glad I didn't go to graduate school!" He stared at the French kitten on the other side of the cash register. He held a hand over his face, to cover his bad eye and warts. I could see enough of her to notice that she spilled over the chair. "Go on!"

"When students discover the truth, that the new knowledge requires a lot of painful personal experience if it is to be understood, they begin to feel a let-down. When they look around and see that if they are not as bold as their heroes, their lives will not be greatly different from dad's or the dean's—that's when fires break out in the dorms. The silent generation turns into the parricidal generation. They become as moralistic about politics as their grandfathers were about sex. Obscenity flows like beer. Nightsticks crack over-intelligent skulls. Administrators feel betrayed. They might have looked at their own reading lists."

A major objection rose up in him. "But how could you get anyone to buy that? Our public likes to believe in education. You're making education seem hopeless."

"No. I'm only making it seem hard. Only a few are willing to do what it tells them they have to do."

The word few made him look at me with suspicion. "Oh you're that kind of guy, are you?"

"I'm merely repeating Emerson's *Self-Reliance*. They all read that in school. I'm merely pointing out what it means *now*."

"You've overlooked the sales angle, the handle. You haven't found a way to make readers *want* to hear what you have to say."

"I'm not a salesman," I said with more disdain than I should have used with a man who sold books. "*Is* there any way of making readers *want* to hear that they are in for a lot of hard work?"

'Of course there is!" Now he was in his element. His sighs ceased. He spoke out loud and clear. "I *am* a salesman, and I'm not ashamed of it. I am now going to tell you how to put your book over. If you want to sell it, this is the way it's got to be done. You talk directly to the reader, and you tell him what's what.

"Listen, Reader, you say, the money you've got in your pocket, money that would very wisely be spent on this book—it's tax-deductible if you belong to a profession, and you probably do (my wife gave me that idea; oh we discussed your article a lot!)—that money was put in your pocket by an *avant-garde* economist who was once totally disregarded, no, laughed at (my son told me about this). About forty years ago he wrote a book that brought your capitalist system back when the Marxists thought it would go under. His name was Keynes. If the English had listened to him in the twenties, they would have been stronger in the thirties, and Chamberlain would not have had to kiss Hitler's backside."

Now it was I who said "Go on." I was beginning to realize how stupid it had been of me to feel disdain for the art of salesmanship, and to remember how subtly it had been used by Shakespeare, Dostoevsky and many other writers whom I admired.

"The clothes on your back have been refabricked, with

synthetic fibres," the publisher continued, "by avantgarde scientists who had to justify themselves to DuPont, or whoever it was. Their names were—what the hell were they?—let's call them Glutz and O'Rafferty.

"Your heart may pound a few years longer—I hope mine does!—because some other avantgarde characters helped it along. Weinberg and Neville, or something like that.

"Your teeth were saved by Schmodsky and Carillo. Your eyes have been opened by Kandinsky. Your ears have been cleaned by Stravinsky.

"Your words, whether you make love or make deals, were given you by lowbrow highbrows (my son thought up that one). Like Lawrence and Joyce.

"You are a *prefab of the avantgarde*, Reader, and it is time you met your maker. You cannot stop where you are. The dead avantgarde has been replaced by a live one (my daughter told me this)—alive and kicking you. The new avantgarde is as sure to change your life as the old one already has.

"If you don't know what the new avantgarde is up to, you may lose all the dough you have so carefully stashed away in Switzerland. You may also lose your life. The new avantgarde is no longer content to rebuild you with art and science. It has moved on to politics, diplomacy and war.

"This book is a guide to all the avantgardes. If you don't read it, you may never read anything else."

I felt like a composer who has just heard a score of his given a brilliant performance by an amazing conductor. I told him so. Once again I was ashamed of my previous unwillingness to recognize the need to sell an idea with all the legitimate devices at my command.

He shook his head modestly. By this time we had eaten an almost inedible meal with greasy knives and forks. "Oh it's just an idea for a blurb. I do them all the time. But that's the way you should think about your book. I'll be in touch with you. I want you to meet one of our new editors."

He did not wish to talk to me any further just then. The kitten got up from behind her cash register and walked with whatever seductiveness she still had toward a door that led upstairs. It was plain that he wished to follow her.

He shook hands hastily with me. "So long!" he said firmly, and made sure I was on my way out before he followed her upstairs. The last I saw of him, he was pathetically covering his warts and his bad eye with a hand intended to make him look handsomer.

I did not know then that he was going toward his death. It was months of course before he actually died. But the death-blow, as I see it, was delivered then.

INTERLUDE: WHAT KIND OF WORLD DO STUDENTS FACE TODAY?

One evening after I had lectured on the different importances of the avantgarde to students—which I have done at several universities, some with ivy that needed weeding, some with plastic that needed washing—a student asked me if I could give a brief picture of the world a student faces today. He also asked, saying he was majoring in philosophy, if I could make my answer as unjournalistic, as timeless as possible. He did not want me to talk about topical subjects like the draft, however important it was just then, but about things that are not likely to change. He said there was a television show called "Mission: Impossible," and he realized he was putting me in a similar situation, but he would like to see what I would do with it.

We all laughed. But I was still expected to do the impossible. And so I tried.

Strictly speaking, I said, the only things that are not likely to change are birth, procreation and death. If however we look closely at the world we live in, whether as students or as anything else, we see a few other things that are probably going to remain as they are. Philosophy, as Nietzsche said, has become an ancillary of psychology—that is, a servant girl—which means that we'd better not be too rigid or conceptual in our thinking, until we have looked more closely at the psychological processes that largely determine our thoughts. These psychological processes are more

concerned with our emotions than our thoughts. The first lesson of a useful psychology is that we seldom decide anything by thought but usually have things decided for us by emotion.

One fact that is not likely to change is death. Our approach to it is emotional, most often, rather than intellectual, even when we are still of student age and rarely give a thought to it. (That, incidentally, is one reason why the army drafts nineteen-year-olds; they are sure they are never going to die, and so make better soldiers.) Our approach to death is so emotional that we can be sure, if we look ahead with any readiness to accept the truth, that we are going to feel greatly disappointed, as our death approaches, if we have not made the most of our lives.

It is precisely because so many of our more gifted students have looked ahead in this way, and compared the lives of their parents and their teachers with the lives they desire for themselves, that there has been a rebellion among them. They have been alerted by avantgarde artists to realize how meanly bourgeois most lives are. They may officially ascribe their discontent to the obvious faults of administrators or to things like the misplacement of a gym. Such reasons look better in the press. Their real reason is their desire for better lives than they see around them: a desire that unless they fight very hard for it they may never realize.

One thing, then, that is not likely to change is this: we are ruled by emotion, our own emotion, and we seldom gain enough self-knowledge to be able to master it. Even our professional philosophers usually let us down here. In a time of great cultural confusion like the present, the more one affects the pure reasoning of a philosopher, the more it is likely to be pure affect.

A corollary of this preponderance of unexamined emotion is that, since the majority rules, we prefer people who cover up their real emotions with pretensions to worthy causes. Especially worthy causes like those of helping the uneducated and eliminating poverty. There are many uneducated people who need help, and there is much poverty to be eliminated. Social workers, psychiatrists and teachers do most of this useful and necessary work. Politicians get most of the credit.

Another timeless truth: those who really help others are not the kind of people who clamor to get attention for themselves. Beware of all names in headlines!

What kind of world do students face? This is another fact that is not likely to change. They face a world that is ready to believe them, accept them, reward them if they know how to set up a hue

and cry about their devotion to worthy causes. And some of them, since youth is no proof of sanctity (remember how the Nazis used theirs to get power?), can do this. Students who show a premature skill at public relations are headed straight for the Establishment they pretend to hate.

And bright students know all about this, better than I do. But they still have to face the unchanging fact that they will be punished—or if they are lucky, overlooked—when they try to understand themselves and the world around them. And rewarded when they stop trying and merely do what they are told to do.

Another unchanging fact, then, is a preponderance of hypocrites. (We all may belong to them. We are healthier when we recognize it.) They cannot be legislated out of existence, like the draft. They are here to stay. Their hypocrisy consists of imposing nothing but fear of the law upon themselves, as far as their real activities go, but pretending, with a capacity for self-dramatization that still fools the foolish, that they are weighted down with humanitarian obligations, and sometimes moral, religious, civic, aesthetic as well. It is they, when they are clever, who take the discoveries of the avantgarde and squeeze every ounce of profit— political, emotional, financial—that can be made from them.

Lest we exaggerate the importance of the avantgarde, we should remember that great as its contributions have been, its members have not always behaved with exemplary devotion to social duty. Leonardo's birth preceded that of the avantgarde by some centuries, but he offers a good example of the artist's attitude toward work that is not to his purpose. While he was painting *The Last Supper* in a monastery in Milan, the Prior complained to his ducal patron somewhat like this: "It's all right with me when he's *painting*. But a lot of the time he *just sits there* and does nothing. When he's not painting he should be out in the garden with the monks!" Leonardo was outraged when the Duke told him this. He explained that it was when he was *just sitting there* that he produced most.

Still another thing that is not likely to change: those who do really new work will have to spend a great deal of time *just sitting*. There is no other way to come up with something fresh. You can't fit in nicely. You can't kid your demon with Worthy Causes. You have to be stubborn, ornery, mean. You have to realize that Woodstocks are a group-approved substitute for the real thing.

And perhaps in spite of all that, nothing new or interesting will come of your orneriness.

That also is part of the world that a student faces today.

TWO

THE LITERATURE OF FRACTIONS

"Now then," said Warts, "who belongs to the avantgarde?" It was two weeks later, we were eating a somewhat better lunch at his club, surrounded by the browning portraits (needing restoration), of frockcoated members with Victorian beards who had never bothered their heads with the question. With us sat a younger editor of his firm who wore dark glasses and a fearful look but had an impressive brahminical way of putting the tips of his fingers together when he made a point. Until recently he had taught English in a well-known university. When I heard his name, which was (here at least) Gulley, I remembered a story, unlikely but true, which made him the rather celebrated victim of a writer who had stayed in his house and stolen his wife.

But I had to think about the question Warts, no longer looking pathetic, had asked. It was a legitimate question, I felt, and I should have sat up all night thinking about it. It took me by surprise, so I answered immediately with great assurance and no forethought at all, "Who belongs to the avantgarde? Innovators who are still interesting."

That stumped Warts for a while, but only for a while. "Why do they have to be innovators?"

"They don't want to say something that's been said before."

"Mmm. I have a dream every night, the same dream. We have found a way to kill off all the *innovators* who send in manuscripts, and it's just as simple as the way they killed off all those rabbits in Australia."

"Do you like the old stuff better?"

"It sells better."

"But does it read better? You liked Sartre's *Nausea*. That was avantgarde."

"Who said I liked it? I only liked the way he got that woman to behave. My son made me read it. And now I wish I hadn't!'"

He uttered the last sentence with so much feeling that I had a strong impression he wished nothing further to be said on the subject. (Later I learnt that he had forced his acquaintance upon the woman in the 20 CM. Club, and had been induced by her to put some money into her strangely named restaurant. Soon after his investment she flew to her home in France, and at the moment of our conversation in the club he was wondering whether he hadn't made a dreadful mistake. His lawyer was looking into the whole affair for him.)

The subject of Sartre was dropped, but the names of other authors came up. Warts asked me why writers *wanted* to belong to the avantgarde. What was wrong with them? Why didn't they write like regular guys?

My answer went something like this: "No writer *wants* to belong to an avantgarde. The most original ones—like Blake or Kafka—had no idea they belonged to an avantgarde. It was a posthumous label pinned on them by historians.

"No writer *likes* to be misunderstood. If he becomes a pariah, it's because he doesn't see things as others do. It came as an outrageous shock to Herman Melville that *Moby Dick* failed to be a best-seller. He had already written a best-seller in *Typee*, and he knew *Moby Dick* was better. It flopped, and its failure made his life painful and led to a long breakdown. Writers don't enjoy being ahead of their times—"

"All right," said Warts, "I get the point. But why is the avantgarde so recent? Who was the first avantgarde author, anyway?"

"Other people have other ideas about it, but I say it was Blake."

"Why?"

"Let's put it this way." I didn't like his habit of asking me to speak, of getting me there specifically to speak, and then interrupting me. Life is short, and literary lunches seem to me one of the worst ways of throwing it away. I had no desire to be published by him, no matter how touching his private life proved to be when he revealed it to me, as I was certain, from past experience, he would do, if I gave him half a chance. My

desire was to terminate the meal as quickly as possible. "But for God's sake let me finish my idea. The literary avantgarde came a long time ago, about two centuries, after the scientific avant-garde. That began in the sixteenth century with Copernicus and Galileo. A little later it got its philosophy from Bacon and Descartes. Once those men of thought gave you men of action the go-ahead, everything was progress, discovery—and ex-ploitation. We had explorers, colonies, slaves, more deadly weap-ons, the Industrial Revolution. And the first phony art. The avantgarde artists reacted against it. One of the most beautiful of these was Blake, who was so new, so fed up with the en-croaching vulgarity, so determined *not* to say anything old in the old way, that he died totally unknown and completely happy."

Warts started to speak, but I continued. "No, let me finish and then I will shut up. You want everything to be cozy for your publishing business. I'm going to tell you why it can't be.

"Blake lived at a time when publicity still meant nothing. He worked every day, on his pictures and his poems, even when he was sick, and he made just enough money to keep going. He lived in London, when the first factory soot was falling, so he and his wife—who couldn't read or write—went as naked as Adam and Eve in their own backyard. He made so little im-pression that shortly before he died Charles Lamb—famous of course and the darling of the publishers—had to assure a friend that 'Robert' Blake did exist, although Lamb had never read one of his poems. 'There is one to a tiger,' Lamb wrote, 'which I have heard recited, which is glorious, but alas, I have not the book: for the man is flown, whither I know not—to Hades or a Mad House.' Or something like that.

"Today Blake would be locked up. He writes casually that he dined with Isaiah and Ezekiel. And at a party he described a fairy's funeral. 'I was walking alone in my garden; there was a great stillness among the branches and flowers; I heard a low and pleasant sound, and I knew not whence it came. At last I saw the broad leaf of a flower move, and underneath I saw a procession of creatures, of the size and color of green and grey grasshoppers, bearing a body laid out on a roseleaf, which they

buried with songs, and then disappeared. It was a fairy funeral!' "

"You'd better not tell that story in a gay bar," said Warts.
"They'd all howl."

I shrugged my shoulders. "What I was saying had nothing
to do with Blake or fairies or funerals. There are a few people,
a very few people, who see things that others don't, and when
you publishers forget about them, and publish only best sellers,
you die inside, you lose all the fun of life, and what's more, you
end by losing money. Do you know what Blake said just before
he died? He saw a beautiful little girl, and stroked her head. 'May
God make this world, my child,' he said, 'as beautiful to you as
it has been to me.' That's the real avantgarde, not the phony
one that you publishers have created."

"Don't get me wrong!" he assured me. "I'm all on your
side. Don't you remember the sales talk I thought up for the
avantgarde? You said you liked it. I'm just trying to bring the
whole thing out into the open, so you can write about it."

I turned back to my veal cutlet. The cheese on top of it
had grown cold during the fairy's funeral, and the meat was
soggy.

To come to the rescue of his superior, the junior editor raised
his fingers in brahminical salute and asked a question. Most
of his conversation, I noticed, was phrased as questions. Per-
haps this habit originated in a desire to put candidates for the
doctorate, as neatly as possible, on the defensive. It committed
the questioner to nothing and slily turned the questionee into a
victim.

"Do you really believe," he asked me, as if astounded by
my credulity, "that any artist can be as naive today as Blake
was? Didn't that article of yours imply the opposite, that the
artist today has to be aware of the market, propaganda, the
latest scientific research, politics, and his own image?"

"It did." The question bored me, but since he seemed to think
he had caught me in a trap, I saw that I had to extricate myself.
"And that is precisely why we are so often disappointed in
artists today. When they are truly talented they begin by being
as naive as Blake was—there is no vision without innocence—
but now we ask more of them than we asked of artists in the
past. We ask them to keep their naiveté, their freshness, but
also load it down with all the complex new knowledge that our

scientists, our philosophers, our politicians have been acquiring. We ask them to be supermen, to do what we wouldn't dream of trying to do ourselves.

"They think we're trying to squeeze them into a double bind, to catch them between the demands of conscience and the demands of the world. So most of them secede and tell us we are not their bag. They speak only to each other in a private language—no, in several private languages, because the writers don't speak to the painters any more, the musicians don't speak to the sculptors, the architects don't read, and the theatre men look only at the theatre page."

He looked annoyed. I had extricated myself from his trap by referring to a well-known fact about which much had already been written. "I see," he said grimly. "But how do you propose to handle all this confusion in a book?"

"I would say that sooner or later we are going to *have* to assimilate the new knowledge. Even the artists can't duck it forever, however much they prefer to stick to their own little pockets of sensibility. Our youngsters are being forcibly introduced to the new knowledge. The artists among them usually recoil from it and form little groups of their own, but their audience will sooner or later demand arts that are not exclusively addressed to little groups but to all reasonably well informed people. That will take time, much time. But the first job of a book about the avantgarde, about the perennial avantgarde—that's an idea for a title, *The Perennial Avantgarde*—would be an examination of sects."

"Jesus, Mary and Joseph!" said Warts. Until then I had not known he had some Irish Catholic in him. "You're not going to make them take off their clothes?"

"Not sex, sects." I spelled it out. "Even the best artists have grown frightfully sectarian, and with a lot of justification. The more they are alienated from society, the more they speak only to their own kind. They are like Jews who are fed up with the *goyim*. If a book about them were to be useful, it would have to deal with the central problems in *all* the arts, as well as science, philosophy and politics."

Gulley (the junior editor) glowed. At last he had me. "Are you qualified to take on such a job?" he asked.

"Of course not," I said, as a simple statement of fact. "But I

have had a strong sense of homelessness ever since I was a child. I didn't fit in anywhere. So I tried to create a home for myself among any others who seemed congenial. I spent years among writers, painters, sculptors, composers, theatre directors, actors, movie directors, movie actors, architects, scientists, philosophers and politicians."

"And you actually believe that the time spent among these people would qualify you to write about such a huge subject?"

"No," I admitted, "it wouldn't. It hasn't. If I took on such a job, and I have no intention of doing it, I would let others, the specialists I have known, speak through me. It would be their book, not mine. I'd merely be the middle man." Between each of these words I was chewing my salad carefully, to make him wait for every syllable.

If he felt annoyance, he did not show it. He merely tested me, with undiminished relentlessness, on one of the arts. "What do the writers you know think about the condition of literature today?"

"That's simple. When they are intelligent they realize that the central problem of literature today is a scarcity of good readers. Leisurely contemplation was forced upon our ancestors. Time hung heavy, as they said, on their hands. Contemplation is no longer forced on us, unless we live in a very *un*urbanized place. And yet contemplation is necessary to get the feel of a book. And now it is not only avoidable, it is economically inadvisable. None but the lonely adolescent can afford to be carried away by mere words. A general proximity to new wealth and new power, to 'making it,' has meant a steady decline in verbal satisfactions. Even among the young, few prefer beautiful words to beautiful cars. If they think about words, except as a way to manipulate others, they are not going to do well.

"We can assume an appetite for stories and poetry in children, at least when they are *very* young. We cannot assume it in adults. By the time they are 'mature,' that is, ready to compete with their more ambitious neighbors, they have almost always lost the capacity to be held by a mere story. Or a mere idea. Or a mere phrase.

"Beauty of language or thought is only cherished if it can be used to beguile their customers. They—"

A waiter approached our table and asked Warts if one of his guests was Mr. Gulley. When Gulley said yes, the waiter told him he was wanted on the telephone. While he was away from the table I recalled that he had indeed been victimized by a well-known writer who had visited him while he was teaching in a university, and stayed for a few weeks in his house, ate at the same table with his wife and two young children, wrote in a quiet room of his own, and generally made himself at home. One day Gulley came home for lunch and found his wife naked in the living room. She explained that she had forgotten something downstairs and run down to get it. Then Gulley went to hang up his coat. In the coat closet he found the writer, also naked. Angrily Gulley told him he was going to go back to the university and return in an hour. When he got back he wanted the writer to be out of the house.

Exactly an hour later he returned. He found the writer had left, but so had Gulley's wife and children, in their new car. The writer had also taken Gulley's best clothes and books.

Gulley had perhaps been born to be victimized. Earlier he had lived in Greenwich Village, with a desire to be a writer. A tough young Italian had stolen his typewriter (he was trying to write another *Moon Over Mulberry Street*), and when Gulley reproached him the Italian had said, "What do you want with a typewriter, anyway? You haven't got any talent!"

I recalled some of these details while I chatted with Warts during Gulley's absence from the table. And I understood Gulley a little better, I believed, and resolved to be a little gentler with him when he returned. No wonder he was looking for victims! There had to be a next in the pecking order. My conversation with Warts turned on mutual acquaintances while we tacitly agreed to await the return of Gulley before we resumed our discussion of the avantgarde.

When Gulley came back he looked, if anything, paler and more tense than he had before. Later I learned that the call came from his wife, his second wife, who telephoned him repeatedly at the office and made him quite as miserable as the first one had.

"Well now," Warts directed me, "go on with what you were saying."

"I'll try to cut it short," I promised. I could have wished that

our dialogue enjoyed the relaxed intellectual play that made Plato's *Symposium* possible, but Warts had stolen a glance at his wristwatch while he spoke, and anything said during our brief encounter would soon enough be forgotten. Indeed, the rapid evaporation of consciousness, under the infrared blowers of efficiency, was the very point I had been trying to make. "Literature is in a bad way. It is wilting under the glare of the tax forms. Any tolerance of imagination is a poor preparation for fact. New and less demanding media will almost surely cause literature to lose its place as the favorite art of our society, if in fact it has not already been demoted.

"Poe said that as much genius is required to read a book well as to write a book well. Communication requires equality. The strain on their imaginations is getting too great for our readers. Most of them cannot stand the austere loneliness that a book now demands."

"That was a good point you made in your article," said Warts encouragingly. "About the readers who buy a book but only read five pages of it. I'd say it was closer to two."

"So you publishers have most of the ideas for new books, and order about eighty percent of them."

"Oh it's not that high," he said.

"Whatever the figure is, the fact remains that literature may soon reach as few people as it did in the Dark Ages. There is a minority protest against all this, a healthy minority protest that still loves poetry and fiction, but it is a very small protest indeed. Few people can afford to think symbolically. Few people are sufficiently educated or free to think symbolically.

"You asked about *young* readers. Let's go back to the students for a while. It's not simply avantgarde ideas, delivered by not very avantgarde professors, that are making them riot. There is a deeper cause than that. They are being exposed, through their studies, to too much raw experience, and given no adequate means of assimilating it. A society endures only as long as it gives its members a set of reflexes that organize their experience. It makes life endurable for them through its *mythology*, that is, through an instant method for structuring experience which its members can accept and sometimes, if they are strong enough, enjoy.

"Only a few people can stand a naked encounter with experience, and even they with only a limited portion of it. They are the artists and intellectuals who are able to stand up under the new need to create a myth of one's own experience.

"But the mythology of *all* Americans is now crumbling. They are exposed to naked encounters with reality for which they have no preparation. Our prosperity has over-pragmatized us. Our students look at the emptiness of their parents' lives, and forget that it was this very emptiness that made the money that put them into college. Successful businessmen and their wives are not satisfactory, by avantgarde standards. There is nothing exciting about their prudence or their skill. The safe-and-sane myth they try to pass on to their children is being rejected. The children are reading other myths that they like better, if they don't have to go out and make money."

"Now there you're *all wrong!*" Warts cried. "My children don't feel that way."

"You're very fortunate."

"Why do you say myths? I thought myths were lies."

"The word does mean lies. It also means a scientific way of approaching the faiths that keep us going. I'm using it in the latter sense. In that sense every society has its ruling mythology, and every individual also has his. You believe in helping people with the printed word. I believe in purifying the word that gets printed. Making sure that it's truthful, clear and *new*."

"Go on," Warts said, "but you're all wrong about my children. And there's nothing the least businesslike about my wife. At least about her own work. She's an artist, and nobody buys her pictures." He chuckled grimly.

"Our students are forced to make their own myths of their own experience. And only a few of them have enough talent to do that, and it would require a lifetime. So they improvise new *group* myths—Marxism without the curse of the Russians. Anti-Establishmentarianism. Peace. Flowers. Love conquers all. And so on. Meanwhile the books that do get read are read only to help along a budding new group myth.

"Nor can any student be blamed for this. They were born —not only in the United States but in the other countries that are trying to imitate the great technological effectiveness of the

United States—they were born into a world that gave them no adequate initiation rites. Or rites of passage. They have not been prepared for life as it is, they see that their elders are even more confused than they are, and they want to change things. If they emphasize irrationality, it is because they have been exposed to irrationality. They have seen the rhetoric of reason break down.

"But such students are a minority, and all dissidents are a minority. Society as a whole wants order, and will insist upon it, sooner or later, with force. The new order is more likely to come from the right, in the form of some kind of totalitarianism, than from the liberals, who believe in laissez-faire."

"What has all this to do with literature?" Gulley asked. He had recovered from whatever message he had received from his new wife and regained his inquisitorial fervor.

"Quite a bit. It means that even among the young there will be little of the internal energy that is needed for the enjoyment of literature. There will be little of the playfulness that is required for the production of literature. We are producing kids who are bewildered, and told to succeed before they are thirty. When they accept commercial or academic discipline they give us no more trouble. But when they insist upon having a life of their own, and enjoying it in their own way, they worry us. Actually, even then they cannot relax enough to find their true energy and be ready for a real experience of life and art. Too much new information is dumped on them daily. Too many complex new demands are made on them daily. Literature requires *dolce far niente*. Literary energy requires leisure, and lots of it.

"When a kid says of literature 'it's just too linear to last,' as a student quoted to me the other day, he's not only showing off his knowledge of a phrase from McLuhan, he's also revealing the extent of his own inner fatigue. He's been tossed into a world that is too much for him. He hasn't been given any of the guidelines, the myths, which as a young person he feels entitled to. And as a consequence he lacks energy. He has a heedless energy that can get headlines, the energy of youth-minus-myth, but not real energy that prefers health to publicity.

"The only way he will get it will be by facing his problems,

seeing himself as he is, and recognizing the fact that he can expect nothing essential from others. It is not likely that he will do any of these things. And if he doesn't, he will never care much for books, except as they back him up in his withdrawal from an unequal combat.

"Outwardly our society is healthy, inwardly it is sick. Only a few hardy souls can survive its internal decay. Only a few can find energy of the kind that keeps literature alive. I hope that answers your question," I said as gently as possible to Gulley, "and doesn't infuriate your boss." I looked at Warts.

"Oh, I'm not sore," said Warts. "I'm beginning to see your point of view. And there's something to it. Or at any rate, a book could be made of it. Hold on a moment! When you say myth, do you mean faith?"

"In a sense. Tacit, sustaining faith."

"And all our popular faiths are going?"

"Yes, our group mythologies are crumbling. Society imitates art. The group myths of artists crumbled some time ago, and they were forced to try to mythologize *their own* experience. Now the plain people are catching up with them, being forced to try to understand life in terms of their own experience, rather than in terms of inherited theologies or ideologies. In this negative, painful sense the army *has* caught up with the avantgarde. But a small portion of the avantgarde is in a better position to forge personal myths than the army. Only a few, a very determined few can forge personal myths."

"Still harping on the few, eh?"

"The collapse of group mythologies, which every newspaper confirms, obliges me to. Group mythologies can help groups to obtain group power, as in the case of Black Power. But they can only help persons who are willing to surrender personal yearnings to group yearnings. Some people like this kind of group discipline. It gives meaning to their lives. Others, fewer in number, prefer to stand or fall alone. Usually they fall, but that is their choice.

"Most people think as their group tells them to think—we whites even more, perhaps, than the blacks. Black Power is getting the headlines now, because White Power is taken for granted, and is alarmed at any encroachment upon its traditional

privileges. White Power still sustains *most* white people with a ready answer for everything. The blacks are trying to create the same kind of political weapon. But there are *a few* blacks, writers, artists, intellectuals, who stand aloof from the Black Power mythology, because they want what all writers, artists and intellectuals want, a chance to work their own *personal* mythology. An example—"

Whatever fresh anxiety Gulley's telephone call had brought him now seemed to have been calmed. His professorial cunning reasserted itself as he put his fingertips together and interrupted: "I hate to repeat myself, but what has all this political talk to do with literature, which only a few people understand anyway?"

"I'm glad you agree with me about the rarity of literary appreciation," I began. "It—"

"I'll grant you your *few*," he assented grudgingly. "What about them? They love literature, they produce it. But you say nothing about them."

"I'm coming to them. They cannot be understood unless they are seen in the context of the historical events that are reshaping them."

"Reshaping them?"

"Yes, the collapse of group mythologies—and the frantic efforts of new groups to improvise new myths—both the Hippies and the Backlash that hates them will do as examples, though there are lots more—all this has been hard on the writers, and the lovers of writing you talk about. There *are* good writers, and there *are* good readers, but they are being forced into the category of producers and consumers of a luxury. Actually, literature is, or should be, our daily bread, the staff of life—the honest, well-wrought, wholesome insistence on truth and beauty that keeps man sane. Authentic literature knows that it is central, an essential commodity in any sound community. But realistically it also knows that its present social function is peripheral."

Gulley started to interrupt, but a look from Warts made him stop. Warts also looked at his watch.

I wanted to stop. I felt it would be impossible to reach either of them. I thought my observations were accurate, and I knew

it had taken years to assemble them, but I felt no desire to express them. I continued them nevertheless.

"A peripheral literature becomes a literature of fractions. To get a hearing among their own kind—they can't expect it anywhere else—writers become content to be marginal, to refine their peculiarities, to make the most of their differentness. The minority to which they belong has become sufficiently numerous, during the population explosion, to make it possible for them to escape almost entirely the oppressions of the majority. There are enough in the literary minority, in fact, to permit it to break up into warring factions of its own. The struggle to gain attention for *over-personal* myths becomes so competitive that popular magazines speak of 'the final decline and total collapse of the American avantgarde.' The majority is delighted to see the highbrows become as commercial as themselves."

"But some writers refuse to become commercial, don't they?" Gulley protested.

"Of course. And their courage under pressure and against confusion is one of the best things we have. But the confusion that surrounds them is so thick that the best way to understand them, and to help them, is to try to understand what they are up against. Ever since the group mythologies that once sustained them began to collapse, they have been engaged in a mythmaking sweepstakes of their own. We cannot understand the avantgarde unless we understand this mythmaking sweepstakes. It has stimulated our best minds in the most exciting competition of our age. Finally it has a profound effect on each of us, even the dullest. It—"

Warts, after bolting his dessert, had now drunk his coffee. He looked at his wristwatch again and said:

"I'm sorry, but I really must get back to the office. Another merger is coming up. We don't know who will own us tomorrow." He shuddered. "Don't worry, I'm listening with interest, and I'll be in touch with you."

When we shook hands and separated at the door of his club I hoped his promise would be forgotten, and neither my telephone nor my mailslot would be troubled by any message from him. I felt sorry for him, I wished him well, but I had no

desire to see him again. And my feelings about Gulley were just about the same.

I walked away from them, but looked back when a loud noise came from their direction. A few feet from the club stood a stationery store, with a large electric sign swinging in a stiff wind over the sidewalk. The sign chose that moment to break loose from its moorings, and fell to the sidewalk. It almost hit Gulley, who stared down in terror when he saw what had nearly happened to him.

The next day a newspaper reported the incident of the sign that fell. Its story included the line:

"The sign narrowly missed hitting an unidentified pedestrian."

The unidentified pedestrian was Gulley.

INTERLUDE: IS THERE ANY HOPE FOR WRITERS?

A talented young writer said that of course it was true, as one of the characters in the foregoing chapter remarks, that literature was growing more peripheral and more fractional every day; but what was a writer to do about it? He preferred seeing people who appreciated his work to seeing people who did not. He found it necessary to spend most of his time with literary types like himself, if he was to get any commissions for magazine articles, any lecturing jobs, any grants from foundations. It was both natural and practical for him to restrict himself to a limited round of activities, as natural and as practical as it was for the physician who was treating him for premature prostate trouble to restrict himself to genito-urinary disorders. Both of them did better work because they specialized.

He begrudged every moment that he had to give to a marriage he felt he should never have gotten into (and was said by friends to revenge himself by picking up boys whom he never had to see

again) but he did not begrudge either the excessive time that really good writing required or the social activities that got it published and praised and rewarded. When he needed money he edited manuscripts or taught writing. If this meant that his work got more and more special, it was just too bad. Sooner or later, by working hard and living cheaply—he spends a bare minimum on meals and clothes, and walks when he can save subway fare— he hoped to create a public that appreciated him and his devotion to literature.

Anyone who refused to hear his remarkably frank confession would be guilty, on grounds of a fraudulent morality, of wilful ignorance. This writer is telling the truth about an environmental condition that requires a great deal of imagination to understand and define. (It will be harder to remove than smog, and may prove to be equally dangerous.) He is reporting something important about terrors that go unmentioned but actually exist in literature today. Those who would rather remain unaware of them, or exclude them with a sneering reference to the presumed purity of the past, will take refuge in a worse immorality than he has ever shown.

When we scant the literature of our own day we also scant honesty. And we deny ourselves the dignity and style that might transform our troubles into ennobling antagonists. Literature is being scanted today by a crude neo-primitive rediscovery of the magic of words (the verbal sorcery that sells products and wins votes) which has made honest communication seem like an anachronism. A bright child can become a master of public relations as soon as he has rushed through the three R's. Often he knows more about getting space than a college president. When our perishing republic shines into its final eclipse (the most hesitant editorials now suggest the possibility) our autopsists will find a major cause in our habit of preferring glossy falsifications to rugged accuracy.

The question remains: what can a writer do about all this?

Professional writers who can profit by the situation will not want to look at it too closely. They have not been handicapped by real talent that hankers for real fulfilment. Tradition is not in their bones, nor is original insight, nor original verbal magnificence. Their standard of excellence is the best-seller list. They are not bothered by a breakdown of communication; it is one of their chief sources of revenue. Their misuse of words may be a worse pollutant than any factory. They will go on performing

routine tasks of feeding the linotypes and confusing the young. And be applauded for it.

Our amateurs will be busy obtaining a rhetoric that can do some kind of justice to their chaos of emotions and ideas. (They cannot be professionals because they are attached to chaos.) Their struggles with language will so intensely occupy them that, unless they can move on to a direct confrontation of the problems that *others* have to face, they will remain unaware of the new peripheral and fractional state of literature and the things that may have caused it.

But what of the specially gifted, specially resolute writers whom every culture in civilized times has expected to deal verbally with its most urgent and its most hidden problems? Those writers whom we ask to remove our problems from oblivion and transform them into symbols of delight? Do we have any of them? And if they exist, what will they do to meet our present situation?

They do exist. Every culture produces a constant stream of talent. Artistically, on the whole, what distinguishes one culture from another is what it does to help or hinder its talent. One will carefully nurture it, another will forbid it to express itself freely, still another will seek to corrupt it. The culture we live in today is more complex than any of these. It is so complex that I have tried to suggest its hydraheaded unpredictability by the story that forms most of this book. Narrative seemed to me both more exact and more allusive than analysis, even when it appeared to say the same thing.

In spite of all the pressures against them, truly talented writers, inspired, demonic, resourceful, responsible and genuinely new, do exist here and now. They have been flung however into a situation that has made their art peripheral and fractional. What can they do about it?

There are many answers. One of them is this: let them forget their demon and become socially useful. There is much work for them to do in the field of introducing the public to the conditions of the modern world. And helping it to relax from the strain. Actually, this answer was originally Russian, and caught on in America even sooner than the fur hat that Wall Street also borrowed from the Kremlin. Our professionals perform these chores of instruction and entertainment.

Another answer, less political and more aesthetic, is this: let writers become more peripheral and more fractional than ever! Sooner or later the public will try to catch up with them. Isn't it

now imitating the literary inventions of previous generations? Where did it get those naughty words? Those costumes? What phrases does it have, what ideas, except as it lifts them from writers? Even the best journalism is a pale, retarded blowup of books. Oscar Wilde was right, "Nature imitates art." Refine your peculiarities, and when you are old your loanshark's grandson will repeat them in his term papers. This answer, which echoes the old *épater le bourgeois*, or middlebrowbeating, trick of the pre-1914 generation, has run however into unforeseen difficulties. In the good old days youngsters could be depended on to read and copy. Now they don't read, they listen to rock and look at TV. Also, they have been tossed into so much new experience that they make up new phrases or steal them from Harlem. If the phrases lack style in the English Department sense, they couldn't care less.

The writer, then, who lives in our untraditional day, cannot repeat an earlier answer but must discover a new one. He must possess honesty and imagination to an extraordinary degree, and discover clearly how unimportant and ornamental he has become. If he clings to an earlier prestige, all is lost. If he recognizes his unimportance, however, and still takes pride in his art, his deepest energies will be consecrated to establishing his relevance.

He cannot establish it unless he has it. How does he get it? If he is able to shake his vanity, he can realize that a major portion of his talent, usually hidden from him by his connivance in the romantic poses of genius, is his vulnerability to common experience. He has a decision to make. He can either cut himself off from the pain and bother of daily life, or he can accept it and wring from it the ideas and words that a great literary tradition is no longer able to feed him. He can dry up elegantly, while writing a peevish imitation of an earlier avantgarde author (who had the good luck to be born when society was crumbling, and one could enjoy one's part in helping it along) or he can learn patiently from a society that is humanly in ruins but mechanically triumphant. The second course takes a lot more time, and may lead nowhere, in a literary sense, unless literature is going to undergo as much of a change as life most patently has. It means that he has to bet everything on what he thinks is relevant.

In a less trying time he might not have had to be so demanding on himself. But now he does. If he feels the confusion and anguish of others as if they were his own, if he cannot live a life of narcissism extenuated by occasional moments of social piety,

he has to work hard to establish a new and therefore unpopular kind of relevance.

If it is at all possible, he will be able to cope best with his world when he is at home in other arts besides his own, in painting, sculpture, music, theatre, film, photography, architecture, in addition to science, philosophy and politics (hence the lay-out of this book). His art has always been the most inclusive one—less pure but more human. And today the tradition that feeds him can no longer be restricted to literature. (He does not live in the cosy days of T.S. Eliot.) He has been chosen to try to find a new mythology in all of life. The specialists cannot do it. He might.

While he seeks to understand the life around him by exposing himself to it (the only way he can acquire relevance) he has to choose a career. Since he realizes that he, like everyone else, only thinks when he has to think, and only understands by an extension of his own experience, he chooses a career that throws him athwart the typical problems of his world, rather than one that permits him to avoid them. It would be absurd of me if I were to try to be too specific here, since the possibilities of athwartness are many, and the quick intuition of the writer will know which is best calculated to make the most of his gifts. The purpose of athwartness is obviously defeated, however, by attachment to money or prestige. Or, for some, an attachment to sex. (An awareness of this is shown by the architect in Chapter 7.) It can be safely said that since a writer must make his imaginary world seem more real than the real one, he learns from his experience of the real one how to make the written one archetypal and solid.

He has the wit to understand that he can no longer count on the cultural unity, the middle-class imperturbability, that gave his avantgarde ancestors something to fight against. They could delight in the break-up of a rotten old order that had oppressed them. That was what gave them their kick, what still gives them their kick. But he has to live among the shards of what they left. He belongs to a society that, because there is such a cleavage between efficiency and spirit, every day doubts its capacity to go on. He is almost in the position of the first shamans when there was no such thing as civilization, or social order as we know it. The difference is, he himself has been broken up into as many pieces as the modern world that asks him to interpret it. To put it graphically, he is broken up into many more pieces than are represented by the subjects and problems that are listed in the Table of Contents of this book.

The poet, as Horace said, is born, not made. Today he is still born, but he has to be reassembled—by himself, out of the fragmentation of his world.

There *is* hope for the writer, if he is willing to work harder, and with less assurance of understanding, than anyone else in the community. (This dubious distinction will be disputed soon by the practitioners of other arts.)

THREE

THE MYTHMAKING SWEEPSTAKES

It was the son of Warts who enticed me into my next meeting with the erotically ensnarled publisher who had one eye that always stared somewhere else. (The time had advanced, my diary tells me, to April, 1968.) On the telephone the son identified himself in a pleasant voice as Tommy Black, but at first I did not know who he was. Soon Tommy made everything clear. He told me he was a graduate student in a university where I served as a part-time lecturer. He also said slily that he did not believe he was going to be emasculated by a doctorate, if he ever got one. That made me realize that his father had remembered our first conversation. Tommy added, with equal cunning, that he had read and admired two books of mine, one about students, the other about psychology, and hoped I could join him and his father for drinks in a bar (*not* the 20 CM. Club, I noticed) that afternoon.

When I said I would have to call him back, since I had another date that would have to be broken (the truth but also a standard response of mine to debatable invitations), he urged me to come with shrewd directness. "The old man wants to give you a contract, and the book sounds thrilling. Off the record I would advise you to ask for a big advance."

Half an hour later I called back and said I would meet them at five-thirty in the bar of a midtown hotel, still vaguely glamourous among antiquarians for an earlier hospitality to the declining art of letters. It was Tommy's flattery, more than the smell of money, that brought me there. I still did not want to write the book.

Now of course I am glad I went. The book was written *for* me by Tommy, his father, his sister, his stepmother and a few others I saw in their house. Although it took me a long time

to appreciate my luck, all I had to do was to hear the words that fell from their lips and observe the bizarre behavior that accompanied them. If at first I slowed up the action with a few words of my own, it was merely because abler speakers had not yet arrived to shove me aside and take over. My book was all but handed me, printed, sewn and bound. It was done without a tape recorder, but it is nonetheless a mere transcript, dictated by the rather melodramatic debating society into which, one lucky evening in spring, I tumbled reluctantly.

At my previous meetings with Warts he had directed the conversation. Now Tommy took the lead in questioning me and expressing opinions of his own. Much of the time his father looked on with approval. He seemed especially pleased when Tommy clarified an order to our waiter, who came from Salonika, by translating it into modern Greek. If Tommy's education had cost his father much—and his scholarships had certainly reduced the expense—Warts was getting value in full. Tommy's summer on Mykonos with his hellenophile sister had not been wasted.

The disfigurements of the father had not been passed on to the son. Tommy's unblemished cheeks were a healthy red, his unsquinty eyes large and dark, his mouth gentle and relaxed, his black hair abundant around the neck and, as sideburns, in front of the ears. His engaging combination of intellectual discipline and emotional self-assurance, as well as the alertness of his strong-featured face, suggested a wise and devoted mother, possibly Jewish, who had known how to prepare him for the modern world. He had a grave male confidence that is rare among American youths. He had charm. He also appeared to know where he wanted his numerous endowments to take him.

"I'll get my Ph.D. in psychology," he said, knocking the wood of the table next to his glass of *ouzo*, "and I may practise a while as an analyst, but what I really want to do is make films."

"You have many talents," I murmured. The chief peril to him, I felt at the moment, was that he might scatter his gifts in several directions, without making one of them truly effective.

"I've already made a documentary about the Viet Nam

War. It hasn't been exhibited yet, but at least it got me a summer in an artists' colony." And then as if to demonstrate to me that he was not without literary skill (one of his few acts of ostentation; he must have been more nervous than he seemed), he incongruously added: "I celebrated the event with immortal rhyme:

> There was a young fellow named Maddow
> Who—"

"No, no, no!" his father stopped him, and then explained to me: "It's a filthy limerick about a place called Yaddo, full of four-letter words and showing no gratitude at all for the chance they gave him to write."

"They loved it," said Tommy. "They're going to cut it in stone over the mantelpiece. Now then," he addressed himself to me with a phrase and a manner that he must have picked up from his father, "Dad tells me you say our writers are engaged in mythmaking sweepstakes. What do you mean by that?"

"It's too complicated," I protested. "Tell me more about yourself. I wish your father had let me hear your limerick. I'd rather hear about you than give a lecture, which is what your father always seems to want of me." Warts showed no emotion on his face. "This is the time of year when lecturers get hoarse and should shut up."

"No," Tommy insisted, "you actually do have an idea now and then, because you're so fundamentally maladjusted, and I want to hear this one."

"Take another *ouzo* and I'll take another Campari."

"No. I want to think. Not drink. Besides, I have to be on my toes tonight. Something big may pop at Columbia."

I spoke as parsimoniously as possible about mythmaking. My response, I now realize, was intended to discourage him from further questioning. If his father wanted to offer me a contract, well and good, I would consider it. But just because the boy was young and charming seemed no reason for me to sing for a drink that I'd rather have drunk at home.

His father listened attentively enough but with what seemed to me a conviction that a love of ideas and words is a mere sub-

stitute for a disappointed love of power and things. He would praise me fulsomely if he liked what I said, but even while he paid me a compliment he would convey his secret belief that no one could love literature for its own sake but only as a consolation for an essential defeat. No one could possibly prefer a minimum of things and prestige, so that he might explore the unknown with less baggage and less inner confusion. A writer was inescapably a cripple, though a few of his kind might take command of the public imagination. In that case, it was only good business to see that they were treated with proper respect. They had become properties, in the jargon of the trade, and must be spoken of with reverence, always with reverence, lest the revenue they brought should decline. (And lest the labor that was lavished on them should seem meaningless. The dignity of publishing must be maintained.)

"The mythmaking sweepstakes," I told Tommy with curt oversimplifications that I hoped would silence him, "is being run every day in every form of competition. Not only in books, films, psychologies, but also in eyeshadow and deodorants. You can only reach people by giving them a myth. They don't believe in the old ones, but they clutch at the new ones.

"I'll stick to literature. It's some time since the clean, victorious myths of the nineteenth century—oh, say Goethe, Hugo, Dickens, Tolstoy—were shoved aside by the dirty, hard-hit myths of Joyce, Lawrence, Proust and others who made us look at the world that actually lay around us.

"The age of literary heroes gave way to the age of literary victims. In America, Whitman gave way to Eliot, *The Open Road* to *The Waste Land*. Now we prefer victims, or at least they are all we get today who seem authentic. We like a franker world that laughs at heroics and finds its poetry in simple fact.

"The victory of anti-heroic literature is complete, at least in the respectable English Departments. And in the French Department too. No one reads Balzac any more, his hero conquered Paris. But Stendhal does better every day, his hero was guillotined by Paris. We don't want success stories, we want failure stories. Except—

"Except that our most imaginative students no longer care

about failure and frankness. Failure and frankness are all around them. But they *do* want to organize the confusion that each morning scatters the certainties of night."

"That's true," Tommy whispered. He was listening closely.

"So now they read Hesse, Zen masters, Vedantists, Neo-Marxists, Existentialists, and your psychologists. They are seeking a new creed. They are still ex-puritans, they are still fiercely committed aesthetes, but they also want something besides verbal beauty. They want meaning too, meaning that will help them to organize their day-to-day experience."

"You can say that again," Tommy told me.

"So the mythmaking sweepstakes, in literature at least, comes down to this: who will win out, the exquisite victims or some tough, new, uncouth unpredictables who want to be heroes again? They want to dominate their environment, symbolically, not politically. (They always end up as liars when they go into politics.) They think they see a vacuum in spiritual leadership, a vacuum that is waiting for them to fill it."

I stopped. His encouragement had made me say more than I had intended to, and to express it with greater warmth than I wanted to feel or to show.

There was silence. Tommy was thinking. His father motioned for another round of drinks, although Tommy and I had barely touched ours.

Finally Tommy spoke. "And you're on the side of the new heroes, the meaning-seekers, the organizers of day-to-day experience! But who are they? I've never seen anybody like them."

"Neither have I. But when they arrive, *if* they arrive, they will be the new avantgarde. They will be as misunderstood and unpopular as the old avantgarde. They will be able to pull together our many new discoveries, and talk about them as if they were the ABCs. If they have any influence, it will be posthumous. They will be mutations, of course."

His scientific training reared its head. "Most mutations are deleterious, the geneticists say."

"A few of them aren't. And we're talking of people, extraordinary people, not beans."

"But human mutations are more likely to be specialists than generalists."

"It all depends on what humanity needs. Now it needs the breadth of generalists and the intensity of specialists."

He surprised me by making a spontaneously pessimistic reply. "That's something it's not likely to get."

I reminded him of his own contradiction. "A while back you were talking about becoming an analyst and also making movies. If you are going to be good at both of them, you'll have to be quite a mutation yourself."

Tommy turned to his father. My reminder of his own dilemma seemed to strike home. "You know, he's really got something there. The breadth of a generalist and the intensity of a specialist. Now that's something to shoot for. Sort of a new Leonardo."

"I haven't the haziest idea of what you two are talking about," said Warts. "But I do know this. It wouldn't read well in a book."

I thought I saw a chance to wriggle out of the traps that Tommy's educational needs were setting for me. "It shouldn't be put into a book. It's too early for a book about these things. These things are important, they concern our final objectives and the faiths that keep us going, but people don't want to think about them just now. Write about a problem that is really gnawing at your reader's innards, and he won't so much as look at your book. Write about the newest crater on the moon, and the reader will gobble it up. It hasn't anything to do with *him*. He can still feel superior to it all. But write about the various avantgardes, and the new headaches they are leading us into—not the *theory* of the avantgarde, but the way it actually affects us—and you won't find any public at all."

"Oh I'm not as gloomy as all that," Warts exclaimed.

Tommy shared his father's confidence, though in a different way. "Some of us want to look at our real situation. And *do* something about it too." The ambiguity of literary symbols was brusquely blown away by a gust of political action. I had felt that gust more than once in my classrooms, and welcomed it when it came from a student with political talent—and *not* welcomed it when it came from students whose talents, like Tommy's, were scientific or artistic. "You'll be hearing some interesting news from Morningside Heights in the next few days."

At that very moment, as if he had rubbed a magic lamp, a tall, djinn-like young man with a forceful scowl between dark windblown bangs and the beard of a prophet, wearing expensive handmade shoes and expensive handmade trousers but a cheap workman's blue shirt and no necktie, and an African amulet on a hairy chest, stood over our table with a sullen reproach. "Black!" he cried to Tommy. "Where the hell have you been? I had to find out where you were from your sister. The big thing has already started, but I think we need you. You have some good connections with the blacks, and—"

"I'll be there," Tommy said lightly. The Greek waiter looked questioningly at us, as if desiring our command to throw the intruder out. Tommy motioned to the waiter to let the intruder stay, in spite of the unfavorable attention he was getting from other tables. "Sit down, Leon. This is my father, and this is—"

"I haven't got time to waste on mere amenities," said Leon rudely. He ignored the hand offered by Warts, who was not used to being snubbed by young intellectuals. "I should have known better than to trust anyone from the Graduate Faculties. The big thing has already started. And I shouldn't have to run after you!"

Tommy ignored his petulance. "I'll be there," Tommy repeated, as lightly as before.

"*All right!*" said Leon, and turned and left us, while the waiter made a despairing gesture of relief.

"Who's your delightful friend?" asked Warts.

"Don't mind him," Tommy reassured us. "He thinks he's Lenin. Actually, he's only Trotsky. His days are numbered."

"What in God's name are you mixed up with?" Warts demanded with paternal anxiety.

"Oh nothing, nothing."

"You said it was awfully big, and you acted awfully hush-hush. What is it? Are you going to steal the lion from the library?"

"That's kid stuff now." Tommy wore an expression of contempt on his face, such as Lenin might have worn in the Kerensky days.

"All right. When do you assassinate the Tsar?"

"It will all be covered in your favorite morning newspaper."

"Tomorrow?"

"Now, now, don't get nosey." Tommy turned to me, who had of course kept out of a family dispute. "Actually, all this political stuff bores the be-Jesus out of me. The speeches you have to sit through! But I'm really excited about the stuff you were talking about. I'm interested in art and science. I'm no activist. But there are still times when I have to *act*. Go on, go on with what you were saying. How are we going to get the breadth of the generalists and the intensity of artists?"

It was like asking me to go on playing Mozart after someone in the audience had shot his wife. I was being requested to present a think-piece immediately following a bulletin from the front. I replied rather snappishly: "I thought I'd answered that. A few mutations have to be born with an innate capacity for maybe doing the impossible, and then they have to devote the rest of their lives to doing it."

His father keened like an Irishwoman whose mate has been lost at sea. "I wish I knew what you were talking about!"

"Don't mind him," Tommy said affectionately of his father. "He pretends to be dumb, but actually nothing gets by him."

"I've noticed that before," I said.

"Who are the writers that you like?" Tommy demanded of me. "Which ones are heroes, or if they are not as good as all that, which ones are moving in the right direction?"

"I hate these invidious comparisons. The good ones *are* heroes. They should be encouraged."

"What about the bad ones?"

"They should be encouraged too. It takes a lot of misses before there can be a bullseye. Literature can't be understood—any art can't be understood—unless you begin with a spirit of generosity."

"That's *too* tolerant," said Tommy. "Most of them stink, and we should not be afraid to say so."

"Go ahead and say so, if it makes you feel better." I was being sucked into a pedagogic rôle, a rôle I detest, but I no longer minded. The kid had something good in him that required direction, and perhaps I could, ever so slightly, be of help. "Sooner or later we always find out who are the good ones and

who are the bad ones. It really doesn't matter. But it *is* important to understand what they all, good, bad and indifferent, are up against."

"What's that?"

"Nobody has time to read them. Really read them. Except a few specialists in reading who know nothing about anything else. We have too many other things on our minds. We can't really give ourselves to a book."

"I can!"

"Listen! You got me here to talk about literature. But even you, without half the problems that your father has to face every day, even you have your mind on other things. On psychology. On films. On something that is popping at Columbia."

"It's a big world."

"Yes, so you have to learn how to take it according to *your* rhythm, not its. You want to be an artist. That's the way good artists have always worked. If they had a capacity for breadth, they finally took in all the world, or as much of it as they could, but in *their* time, in *their* beat. They never let *it* call the tune.

"Listen! I had a second father who taught me a lot more than my real one did. I met him when I was about your age. His name was Alfred Stieglitz. He was a really good artist, though some idiots say that photography is not an art. And the big thing he said, over and over again, was: 'Don't be distracted. Don't let your essence be diluted. Don't chase after a thousand and one things. Stay clear. Stay simple. Do what you believe is right for you *at the moment*, and don't do anything else.' "

Tommy stared at me for a long while. Then he said: "You know, you can be very powerful when you want to be. When you drop your defenses, when you drop your *irony*. Then you speak straight out."

"I always speak out," I said, "when I think the other guy can take it."

"He can take it," his father said. "Tommy's a good boy. He deserved that smacking you just gave him, but he'll respond to it in the right way. His mother did a good job on him. Better

than I did." The cyclopean eye of Warts now examined me more closely. "I didn't realize you could talk like that. I want you to do that book for us. It can have guts in it. And I also want you to come home with us. I want to introduce you to my family. Finish your drinks and let's go."

"Mind you," Tommy warned me while we were drinking, "action is still important. There are times when it is much more important than words."

"Of course. The important thing is knowing whether *your* job is to act or to speak. If you act, the danger is that you will become a liar. Words are now our principal tool of action, and we misuse them when we want to have our own way. And if you only speak, the danger is that you will become a coward, incapable of action, a griping parasite. It's all a question of knowing who *you* are. If you were born to act, then go ahead and act. Big things are not accomplished by men who stick to the exact definition of words or to the exact requirements of conscience. Most of us are born men of action—a few to give orders, the others to follow them. But a still smaller number are men of thought. If you're one of them, as you well may be, then you have to understand your real motives. If you are out to make a splash, or grab headlines, or accumulate money, or merely display yourself to advantage, it's best if you know what you are after.

"Almost nobody does. Our men of action always have some noble public motive to cover up the real one. But good books are written to remind us what our real motives are. And when the people they are written about are safely dead, we read them."

"What *is* the literary situation today? When are the really good writers, the writers of stature—the Shakespeares, the Tolstoys, the Dostoevskys—going to come again?" Tommy asked.

"Never. Why judge the future by the past? New art will be entirely different from old art."

Warts groaned.

"That's what the avantgarde is all about," I continued. "That's why we have to be clear about it. You must bet everything on your deepest feelings, your deepest judgment. When you do you won't worry about what the new art is going to

be like. You will recognize the real thing when it comes along. And if you have been chosen for the job, and devote your life to it, you may make some of it yourself."

"There can't be another Whitman?"

"Why should there be?"

"But I want one! And I want another Joyce and another Kafka."

"You spoke like a grown-up before. Now you're speaking like a child."

"Come on," said Warts, who plainly liked the turkey I was talking to Tommy, "I want you to meet my family."

And so I let myself be dragged into something I didn't at all desire. My wife, when I telephoned her, told me to go ahead and not to worry about her. Some friends of ours were at the house and would take her out to dinner.

I think she would have wanted to accompany me if she had known who the second wife of Warts was. The woman he had married a few years before, after Tommy's mother had died, was a woman I had known a long time ago. She had been a painter then, and now she was a dealer. My wife is a painter, and she had mentioned to me more than once the sensational success of a new art dealer with the rather fancy name of Althea Lovelace. She had been in her gallery and met her. But she didn't know, and I didn't know, that Althea Lovelace was also Mrs. Black.

INTERLUDE:
WHERE A MINORITY RULES

A well-known professor of English hooted at the suggestion, made in the preceding chapter, that the best writers of the early twentieth century might be superseded by a cruder set of "meaning-seekers" and "organizers of day-to-day experience." He said it was ridiculous to assume that a reader of taste would ever pre-

fer inferior writers, however helpful they might be to the organization of his inner world. There seems to be a confusion here, he pointed out, between literature and philosophy. Literature would continue to have its ancient appeal for those able to appreciate it. And there was no danger that James Joyce would ever lose out to Hermann Hesse in any mythmaking contest.

A well-known poet said that the best writers of the early twentieth century were already losing much of their appeal among talented young poets. But he acknowledged that present-day writers would have to draw upon a deeper and more varied experience, such as contemporary life required, and then be able to put it into more powerful words, if they were to create more powerful myths. For him the supreme test of a writer was poetry, because when it was done well it crystallized the present situation better than any other literary form.

These are matters of constant debate among our better writers and in our better universities. The mythmaking sweepstakes draws a smaller audience than a horse race, but its bettors are more intelligent and its outcome more important. In time it will help to determine the sustaining myths of new generations, to shape our future style of life. It may even affect our statecraft and our ability to survive.

Even the anti-intellectual and the anti-literary are beginning to understand this. Their motives are anything but disinterested, but they sense the importance of the faiths that keep us going. This is especially true at a time when the faiths that could once be taken for granted have become harder to sustain and to calculate. The relationship of mythmaking to power is being studied by those who have power or wish to get hold of it. They know that final victory belongs to the side that writes the dispatches. So the mythmaking sweepstakes, which formerly was restricted to serious writers, has now been entered by newspapers, magazines, television shows, films, political parties, religious groups, propaganda services.

The serious writers of my acquaintance attach no importance to this attempt of the media masters to get into the race. They say that nothing of lasting mythical significance has ever been created by anything but a disinterested poetic imagination, whether it expressed itself in verse or prose. All attempts at ersatz, however spectacular for a while, are sure to collapse. In matters of imagination only the most discriminating criteria prevail. Group myths are now sure to be false. Only individual myths

can hope to be honest—and able to stand up against time. And they can only be born of loneliness and trial. Furthermore, there is no competition among genuine myths. On the contrary, they are welcomed by those who can understand them as a fresh interpretation of our common experience.

The real mythmaking sweepstakes, not the popular one, will be followed by connoisseurs. Whether its next running favors pure literature or literature-mixed-with-philosophy will depend on the new historical needs of those who can understand it. This is one of the few situations where a minority rules.

The majority, of course, will be unaware of these un-American niceties. Few people understand that a common mythic base is necessary for the survival of a church or a state or even an economic system. Most of us do not realize that these institutions are in serious trouble (and are giving us serious trouble) because the myths on which they rest are no longer accepted. Most of us therefore become impatient when we are reminded that the institutionalization of "binding myths," especially those myths in which we have placed our trust, including those that involve the dollar, has broken down.

It is not surprising that many kids believe they can escape all this in an art. And their mothers of course encourage them. Meanwhile art becomes each day more of a concern with dollars. It is hard to remember a time when it was not.

FOUR

PAINTING AND SCULPTURE: WAITING FOR MICHELANGELO JONES

Althea Lovelace had been a formidable woman of twenty-five when I last saw her. Now she was a far more formidable woman of forty-five. She was still beautiful. She still drank Pernod, though in merely nostalgic amounts. Her hair was still astonishingly red, indeed even more so. Her skin was still astonishingly white, and she was only a little plumper. She still pretended that George Santayana had seduced her in Rome, at a time when he was surely no longer capable of such prowess, if he ever had been, and had followed her to America, though I knew from his books that he had left the United States long before she was born, in 1912, never to return. She still revealed her origins in South Boston, as Althea Leary, by the way she said Cuber for Cuba, but otherwise her English, her French, her Italian, her German were without flaw, in fact distinctly upper class (to the extent of pronouncing the last word clahss). She still painted exquisite landscapes in the dark, rich tones of Braque, but finding insufficient response to them in an art world that demanded greater novelty, she had restrained her passion to become the greatest woman painter since Sophonisba Anguisciola, had resigned herself to an occasional Sunday canvas and devoted the rest of the week to selling the work of others.

At first she had worked as the saleswoman and assistant manager of two or three galleries. Then she had met Warts, who was as helpless before a determined woman as he was adroit in his dealings with men. (The head of his firm had persuaded him to edit the writings of women only when they were dead.) Recently widowed and searching over-hopefully for a replacement for the saintly mother of Tommy and Judith, he had married Althea within a week and soon afterwards set her up

59

in a small, out-of-the-way gallery of her own. There she had shown the same strength of will that had helped her to learn languages, avoid offspring, renounce her art and land a prosperous mate when she was approaching forty. The small, out-of-the-way gallery had moved from 10th Street to a large attractive space on 57th Street.

Envious males had to admit that at least one woman dealer was not hopelessly attached to some unsaleable part of the past. Althea kept up with rapidly changing fashions in art as well as anyone else. She also kept her weight down by trotting all over town, in New York, London or Paris, for this or that quick profit in modern masters (Delaunay, Picasso, Kupka, Javlensky, Miro, Matisse, Klee, et al.). And she developed a sixth sense for the profitable unknowns. Each of her newcomers had sold out his entire show within three years. ("I get a certain feeling in my coccyx when I know the public will love them," she explained.) So she provided respectable competition for Janis, Emmerich and Castelli, took one artist from Kootz when he closed his shop and almost got another who went instead to the much larger Marlborough-Gerson firm.

To my surprise, she slipped in all of her old inventions—the story about Santayana, her birth in a castle in Sussex, the noble name of her French mother—as soon as she got over the shock of seeing me brought into her house's elegant "drawing room," which had mostly Louis XV furniture on its floor and mostly Pop Art on its walls. I had been brought there without warning by her husband and her stepson, who had no idea that I knew her. It was plain that her legendry had been imposed upon them. But when it came to her actual accomplishments, her success as an entrepreneur in a very difficult business, she spoke with almost maidenly diffidence, as if she had done nothing at all. Since she had started out as a painter, only a triumph as a painter would have satisfied her pride. And since that was lacking, she was almost apologetic about her triumph as a dealer. I have seen a similar modesty in composers, who attached no importance to the success of their books, except as it helped them to get their music played.

I pretended to swallow all of her inventions exactly as she made them up. I knew that she would have no wish to see me if

I cast any doubt on the fabrications she had been feeding her family. On the other hand, I could serve, and did, as an accomplice in achieving a willing suspension of disbelief. Tommy and his father looked startled when I discussed details of the castle in Sussex, almost as if I had been there myself.

Why did I do it? She fascinated me in her new part, and I did not wish to be thrown out until I had collected her story. Also, our attitudes and ideas were so irreconcilable that I saw no point in dispute.

From the corner of my eye I observed Tommy and Warts silently taking themselves to task for ever doubting her word. And so she was grateful to me. Instead of getting her back up, as she started to do when I was first led into her living room and introduced to her, she changed her tone quickly and welcomed me with warmth as an old friend whose name she saw now and then in print. Tacitly we agreed to forget her studio on West 55th Street, where I had in bachelor days conversed more than once with her, my hand now and then on her intuitive coccyx.

Her success had brought with it one strangeness. She could sell painters and sculptors—they had made her fame and they were on their way to making her fortune—but privately she loathed them. Perhaps it was because they were doing what she still longed to do, or perhaps there was some other reason; but our conversation, try as I would to make it amiable, soon turned into a distinctly bitter dispute, of the very kind I had hoped to avoid. In it I served as attorney for the defense of the very artists whom in public she praised as culture heroes and in private denounced with the gossipy wrath of a Fury. Her denunciation of them, including those in her own gallery, was strictly personal. She never said anything that would injure their sales. To her they were monsters, dwarfs, cripples, thieves, perverts and problem children, with whom it was an inhuman trial to do business, but out of their enormities came masterworks which it was the duty of good citizens to buy and to cherish.

Another woman was with her when we arrived, a trim young blonde with black eyes whose name was Miss Harris. She served as chief assistant to Althea in running the gallery, and faithfully supported her in the fierce aesthetic debate that blew

up with the unexpectedness of a twister. In the fashion of the day she wore a yellow miniskirt that seemed to serve her sex on a platter. She looked like a banana that Tommy or Warts would not have minded, if I could read their desires in their eyes, peeling and consuming.

Althea wore beige, which I remembered as one of her favorite colors. It went well with her foxlike red hair, and it had been cut well by an expert designer who had known how to make the most of knees and waist that were still remarkably youthful. At forty-five she was a very attractive woman. If Warts had been drawn to the bulging grandma of the 20 CM. Club, the fault lay not with the beauty of his wife but with some unfortunate quirk in an unfathomable brain.

Our first dispute was over a sculptor who had been expected to appear at the gallery that afternoon. If he did not come to the gallery, he was supposed to come to Althea's house. She was trying to get him away from another dealer. His full name was Michelangelo Jones, but everyone in the art world knew him as Angelo or Angie. His father and mother were both Irish, but somehow they had acquired a Welsh surname and given an Italian first name, hard for anyone else to bear, to their son. The Church accepted it as coming from an archangel, rather than an artist who had quarreled with a pope. Like certain other American artists who went against the weather of their country because their minds were subtle and complex, Angie had had a belated success which arrived after he was fifty. But when it came, it came with a rush. He was cheered so solidly by fellow-artists, of the kind who do more than anyone else to make reputations, that soon his face appeared on the cover of *Time* and lucrative commissions were offered for his austere but playful constructions. Critics said that his work was new but timeless. In the highly professional miniworld that lives for optical refreshment, he was the most exciting news of the year.

Althea railed at him because he had not shown up. "Do you know what he said when he saw this room?" She mimicked a high-pitched voice that I had heard many times, because he had come many times to our house to see the paintings of my wife, and we went to his for dinner on New Year's Day. " 'Ah,

very tasteful, very tasteful,' he said. Now I know Angie, and 'tasteful' to him is a cussword, an insult."

"I don't think so," I said. "Angie doesn't attack anyone."

"It's because he started out as an architect," she continued as if I had not spoken. "He worked with Frank Lloyd Wright. Can I help it if my mother was a Montmorency? That's why this room is *ancien régime*. He's drinking, I'm sure of it. He'll come in here blind drunk, if he comes at all."

"I met him," said Tommy, "and I liked him."

"He has the kind of generosity that is rare among artists," I said. "That's why he has been so helpful to other artists. They all say that he really *sees*."

"He talks in a high squeaky voice, and he's as full of blarney as the Jesuits who educated him. And as fat. Every time I see him he has a different girl. I wonder how he does it, with that belly." The Leary in Althea had a way of triumphing over the Montmorency.

"He's a family man," I said. "He just likes students, pretty students of course, to help him bring out his ideas."

"Why are we gossiping like this?" Tommy exclaimed. "I didn't come back here to talk about personalities but ideas. I don't have much time before I have to go to Columbia," he warned his stepmother who, I noticed, did not speak sharply to him, though she frequently did to his father and to me. She was almost always sweet to Tommy. I wondered if she wished to play Phaedra to his Hippolytus and have her revenge on the unfaithful Theseus, who was at that moment making another Scotch and soda for his unfillable gut. Tommy was a healthy, good-looking youngster with a mind of his own who must have been quite a temptation to a woman as predatory and as resolute as Althea.

Tommy addressed himself to me, in an attempt to move the conversation away from trivialities and toward general ideas. "Would you say there was as great a scarcity of people who understand painting and sculpture as there is of people who understand books?"

"It's even greater, I think."

"That's what I thought," said Tommy. "I watch the people who go to Althea's openings. I time them with a stopwatch

that I got from the Psych Lab. The amount of time that the average viewer devotes to pictures at an opening is thirty seconds. If it's sculpture, it's twenty-five."

Althea smiled at him. "You made it all up, but I still love you."

"I didn't make it up. The average viewer stays thirty-three minutes and consumes three and a half ounces of alcohol."

"Isn't he marvellous!" said Althea, brushing a dark curl from his forehead. "A born scientist! A *savant*."

He ignored her but moved out of reach of her hand, which smelt like a gardenia. I was sure he locked the door of his bedroom every night before he went to sleep. That unprincipled woman, who had once caused me to dream of being pursued by a tigress as tall as the old elevated railway, must have been a disquieting housemate, perfumed with feline effluvia and ever ready to pounce. "That was a good piece you wrote on Pollock in your book on psychology," he told me, and then turned mischievously to Miss Harris. "You should read it, Deborah. I've got a copy upstairs. Come on up, and I'll lend it to you."

Deborah Harris did not have to study her employer before she replied decisively: "No, thanks. I've got too much reading to do just now. Three art magazines arrived today, and I have to catch up on what they said about our artists." And then for fear of offending me, she said to him: "Bring it to the gallery some day. I'd *adore* reading it."

"I wasn't going to attack you," he said. "You females are all alike. Always thinking of sex. I'm interested in *ideas*. This man," he indicated me, "has ideas. He writes about Pollock, for instance, something like this. Heroism was forced on Pollock by the nature of his talent and the place and time of his birth. He was symbolic of the gifted people who have been thrown, with a minimum of defenses, into life as it is today, without any of the traditional help that older countries provided, or used to provide, for the transcription of raw experience into art. We hear a lot of talk about the *vigor* of American art, and he is supposed to be one of the most vigorous. Well, the source of that vigor is pain. Am I quoting you right?" he asked me.

"I'm sure you are. I've forgotten every word of it. But go on, you make me sound more intelligent than I am."

"Don't be so cagey. When Americans are kids they are me-
thodically exposed to the very best in the arts, to the greatest
works that took centuries to develop and ripen—Shakespeare,
Bach, Michelangelo and hundreds of others. Then we are told
to equal them. We make the most *vigorous* showing when we
find a way to bypass—that's the word—bypass all traditional
requirements and come up with a new style of our own. That's
what Pollock did. He found a way of adding something new
to art history."

Althea hooted. She may have been making some painful com-
parisons between herself and Pollock, because she was listening
to Tommy without pleasure. "The drip method? Hans Hof-
mann invented that!"

"But Pollock carried it further. Anyway, he was simply a
guinea pig in a big blind social experiment, an experiment that
provides a new kind of performing animal. That's the *vigor*
you're getting in your new American art, the vigor of hamsters
and sea lions."

"You're making me cry," said Althea with scorn. "The min-
ute any talent at all shows up here, there's some sentimental
woman that wants to hold its hand and clean its didies."

Tommy ignored her and went on summarizing something
he said I wrote. "There are a lot of people who love new art when
it shows anti-cultural or anti-humane tendencies. They want
to see all the ancient humanities thrown overboard. They
have watched the ancient humanities being abused by dictators
and tycoons, to keep people from thinking about their real condi-
tion. So they welcome any savage new style that comes out of
a wilderness that never heard of the humanities. They don't care
what the lack of decent living conditions does to an artist, they
merely *use* him, the way clever connoisseurs have always used
talented barbarians, as one more weapon in their own fight
against the dead hand of the past. They don't care that our kind
of vigor really comes from national fatigue. They don't care
that the European Picasso has a full life, and the American
Pollock had almost none."

"Picasso and Pollock!" Althea said. "How can you mention
the two in the same breath?"

"Because they are both human, and they are both painters.
One of them knows what the score is from the beginning and

has a very rich life, rich to the point of producing a flock of bastards whom he can support. That's real success." He leered at Miss Harris, the unpeeled banana. "But the other guy—what a film it would make!—the other guy is so frustrated, so unaware of how to live that all he can do to express himself is to get drunk, or pee in somebody's fireplace, or drive so fast on the wrong side of the road that sooner or later he is sure to get killed.

"As a psychologist I find it all very instructive. I want to create some works of art myself, after I get my degree. I also want to have a full life. This man is right," he said, pointing to me, "we can all learn a great deal from Pollock, especially those of us who want to avoid what happened to him. There is a vogue of chaos, people say that where ignorance is bliss it's folly to be wise. But I say, it's better to know what you're doing. Sooner or later real talent must face real consciousness. We can't go on the way we're going now."

"I'll say this for Pollock," Althea admitted. "If it hadn't been for him, or rather for the work his wife did for him, I wouldn't get as high prices for my pictures as I do. His work established a new plateau for American painters. But if she hadn't been such a promotional genius, we wouldn't even be talking about him now."

"That's just the point!" Tommy said with energy and anger. "You've confirmed what I was saying. Pollock sensed what was taking over in the art world, the new emphasis on prices. That's why he killed himself. That woman in Venice was right: this is no longer the age of artists, it is the age of collectors. And the dealers and curators who help them get their names in print. God, they hang their canvases in the museums as if they were animal skins they had shot on safari! They're the same kind of people as the ones who got us into Viet Nam. Always aiming at conquest. But always pretending it's for somebody else's good. It's a conspiracy, a general conspiracy against everything hopeful, everything young and clean. And the funny thing is, I'm not exaggerating."

"Only about a hundred percent," Althea remarked with as much anger as he had shown. She was no longer smiling at him.

Miss Harris took her cue again from her employer, and

rushed into a defense of dealers and collectors. "How would our children get to know about the new art if it weren't for our great dealers and collectors and museum directors? It's very important that our children see art, the new as well as the old. Our dealers and collectors are part of a wonderful new step forward in education," she pleaded tenderly. "They're not in this thing just for money. They want to enrich people's lives. All the poor people who have so little, all the young talents that need direction."

Tommy stared at the articulate banana, and shook his head sadly. "The less art is crammed down a kid's throat, the more he will love it. I'm a victim of progressive education, and I know. I was dragged to every concert, every museum in town, and I had read all the world's classics by the time I was seventeen. I hated art, I hated music, and I hated literature. Then one day I was working on a summer job, building a skyscraper, and I nearly got killed. I had an experience of my own, and I began to wonder for myself what life was all about. Then science, art, music, literature began to speak to me, and I loved them for the first time."

The power of his personal experience was wasted on Miss Harris, who repeated earnestly, "If it weren't for our great dealers and collectors—"

"Oh keep quiet, Deborah," he said. "You're too good-looking to understand anything."

"Deborah's right," Althea said. "The artists are so damn neurotic, so self-centered that if there weren't others with some kind of perspective, nobody would ever see them. I don't have a single artist in my gallery," she waved at the pictures on her walls, "who has any use for the others. They're all *children*. They have to be dried off when they wet themselves, built up when they're depressed, told off when they're too cocky. Never get sentimental about artists. You don't know anything about artists. I do!"

Tommy appealed to me. "What do you think?"

He was always putting me on the spot, and yet I liked him. But I wanted to avoid a useless argument between entirely different interests that could never form a dialogue. "It depends upon the person, of course, whether art is to be a pedantic

bore or a liberation. It was also a pedantic bore for me at school. But your bigger argument, about the *exposed* neuroses of artists, as opposed to the *concealed* neuroses of collectors and so forth—that merely means that our rich society now prefers sellers to makers. There was a time when we couldn't get enough makers, but makers are now a drug on the market, and sellers are in command. Those who impose merely legal obligations upon themselves run the show. If a person imposes more than legal obligations upon himself—and a good artist must; he may impose not only aesthetic but moral and philosophic, even religious obligations on himself—such a person is bound to lose out. That is, materially. Symbolically, he may score a great victory, but usually it is only recognized as such long after he is gone, by a posterity that wants to use him to beat down still newer innovations."

"Good God," said Tommy, "if that's true, and I feel in my bones that it is, then we really are headed for trouble, and every university should change its curriculum, so that the kids can know what is going to happen." He glanced again at his wristwatch. "I've really got to be going." He made no move to get up.

"Our society probably *will* collapse," I said, "because it favors its worst people over those who might have been its best."

This infuriated Althea. "The artists are the best?" she sneered. "Those punks?" South Boston was again winning out over Sussex. "Where the hell is Angie? I knew he wouldn't show!"

I decided to make a final statement, as near to my real convictions as I dared, and then leave. "Yes, they are potentially our best people, along with our scientists, even when they show up as badly as they do now, because their energy is so over-specialized. Of course they are at their best when they are content to score symbolic victories that only those of equal depth can appreciate. But there is something to be said for them even when they produce the most openly commercial Pop Art." This time it was I who waved at her walls, covered with huge images of a plane made of spaghetti, a hand scratching genitalia under a bikini, the chin of Dick Tracy, a can of mock turtle soup. Instead of placating her, I knew that I would merely in-

crease her wrath; but since my departure was imminent, I might as well go without pretending to be impartial in her quarrel with Tommy.

"How very kind of you!" she said icily. "I am sure your opinions on Pop Art are both learned and important."

"There's no need to inflict them on you," I said, and got on my feet. I turned to Warts, who had said not a word since he introduced me to his wife. "Thank you for taking me home and introducing me to your family. It's been delightful."

"Don't go now," he protested. "I want you to meet my daughter."

"You *can't* leave," said Tommy. "I should be somewhere else, but I've stayed on only because of you. I want you to tell Althea what's wrong with Pop Art. I know it brings in the dough, but I have to live with these horrors, and sometimes I feel a moral obligation to come down here in the middle of the night and destroy every one of them. At last I can understand the Iconoclasts. I never thought I'd be a religious fanatic, but that's the effect they have on me."

"See that you don't give in to that impulse, sonny," Althea said drily, who knew that he would not.

"Holy Mother!" Warts cried. "We'd better get them out of here. We could never collect insurance if my own son did a thing like that. You'd get your degree in Sing Sing," he warned Tommy, "or some nuthouse."

"I promise," said Tommy. "I promise not to destroy them if you," he turned to me, "can say one word that justifies their existence. But if you fail, the knife, the insurance man, the nuthouse!"

"I really must go."

"No, stay!" Althea commanded. "What *is* wrong with Pop? Everybody keeps saying its day is over, but some new version of it keeps coming along every season, and the people just eat it up. Go on, tell me," she pleaded. "If its day really is over, I won't handle it any more."

I remained standing. "My guess is that some new version of it will always keep coming along. The mass mind has to find an outlet, and the better it becomes acquainted with the tools of expression, the more it will express itself."

"Do you hate everything popular?"

"Not at all. And I don't want the masses to be docile, either. The strange thing about Pop is that nobody thought of it sooner." I stayed on my feet, as if I were giving a lecture, as indeed I almost was. But all the time I kept looking for a line that would help me to make a quick exit.

"Pop got its start and its name in England, but its real momentum came from this country, when it was taken up by American painters, all with considerable training in commercial art. They were used to making money. Their wives, if they had them, didn't have to support them, the way some of the wives of the Abstract Expressionists had to."

"You can say that again," Althea remarked.

"The Pop artists took the advertised products that visually dominated their daily lives on shop counters, streets and widescreens—the flags, the cleaning pads, the beer cans, the cigars, the soups, the garter belts, the hot dogs, the hot nudes, the comic strips, the stars of Westerns, the political widows—and instead of retreating from all this vulgarity into good taste, in the approved manner of the fine arts, instead of refusing it entrance into the sacred grove (which they had never heard about), they embraced it with a warwhoop. A treble warwhoop in some cases, but they had a surer knowledge of the public than any of their *pure* competitors. To hell with your painterliness, they said, we'll make pictures out of what everybody lives with. We don't give a damn about plasticity, and we're not afraid to be 'literary.' We'll also bring in the third dimension when we feel like it. And we'll turn out our pictures fast, and price them to sell."

"If you can say all these nice things about them," Althea protested, "why are you against them?"

"I'm not against them, any more than I am against hotdogs. I'm simply trying to understand them. Pop strategy was clever —and very American and up-to-date, in the true revolt-of-the-masses style. It passed up psychology, art history and truth and high seriousness. (Later in some cases it tried to creep back to them.) Pop was deliberately ephemeral. It had the fun of camp. You could despise it while you enjoyed it. And millions of kids had been doing just that to the TV shows they both loved and hated."

"So," asked Tommy with professional interest, "the kids are really ambivalent about TV? It makes them feel superior to the adult world?"

"I think that's what it aims at. In TV shows for kids, or comic books, it's usually the grown-up who says something stupid or takes the pratfall. And Pop had the same kind of primitive cunning as TV. If Pop was art, then the man in the street didn't have to worry any more about art, and his complete failure to understand it. Pop made him feel better.

"And it gave the museum men something *new*, and after all they are under tremendous pressure to increase the numbers at the turnstiles, so that politicians will be impressed. The museums are tax-free, they are always subject to political review. One of the most learned of the museum men was impressed favorably by a forerunner of Pop who painted flags with style. Soon afterwards we began seeing pictures that were more Pop and easier to talk about. Soon the monster necktie was as familiar as Old Glory. The museums were turned into a new kind of circus, and it all helped to keep the politicians at bay."

"Where they should be kept," said Althea. "They're getting tougher about tax deductions every year."

"Pop was so ingenious that you couldn't say anything against it without incriminating yourself as a square. Instead of drearily denouncing the new mechanization, which worried everyone else (and made the tasteful painters duck), Pop treated it as fun. It pretended to be healthily extraverted, to take a positive attitude toward everything."

"Now I get it!" Tommy cried. "Pop was anti-psychological from the start because it had so much to conceal. Actually, all it discovered was a new way to hide mental illness, and there are always people who want that. It wanted to conceal its obsession with money and attention."

Warts entered the discussion unexpectedly. "What I want to know is this, was Pop Art avantgarde?"

"It was *safe* avantgarde. It never celebrated a found object that had *private* value. As for example the beautiful boxes of Joseph Cornell did. It never took chances. It never sought to establish something personally experienced. Its expert eye chose only the publicly recognized myth. Or one that the public will

get very fast. Which is always a phony myth. It stayed within the safe orbit of the newspapers. It did not venture, as art must venture if it is to bring back anything new."

Althea eyed me grimly. I decided to speak out once and for all about a subject that involved the avantgarde. There was no point in doing a book for her husband if he didn't know where I stood. After I had spoken, I would go.

"And since Pop was safe, it has already suffered the fate of the outwardly bold but actually cautious. It has become an old joke. It should do very well for a long time in the antique shops, as a period piece. And in its present forms it will go on selling. This is a big country, and it takes the people out there a long time to catch on. They have not yet discovered that bad art is more dangerous than smog. But the human spirit is not shallow, and in the long run it demands something more than an ingenious manoeuvre in public relations. Now I really must go. Goodbye again." I started to shake hands with Althea and the others.

She would not let me off so easily. "You can't say things like that and just run away! Since you're so rough on the Pop artists, what about the *pure* ones? Are they really so pure? I don't think so. What about ————?" and she named an artist who is very well known. "Why has he had so much publicity? Because his wife had an affair with the editor of an art magazine, and the magazine has consistently praised him over everybody else, even when he was obviously slipping. Now his prices are so high that he is rich, his wife is rich, and the editor could get more for his pictures than I ever expect to own.

"And what about that other *pure* one, ————?" she named another, almost equally well-known painter. "He's stuck with his image, he can't change the style that the public knows him by, or his collectors would raise hell, and the bottom would fall out of his prices at the auctions. And so he's dried up as a painter, and he's falling apart physically. And like the other *pure* one, he's drinking himself to death.

"If you want to talk about art, let's really talk. I'm not married to Pop, I carry lots of other kinds of painting in my place. I'm in business, I have to pay the rent, I have to pay for a lot of other things. You mentioned public relations. Do you know how many of your *pure* ones hire public relations firms to keep their name before the public?

"You don't know the first thing about the art world! You're as innocent as I was when I gave all my time to painting. I didn't know that I should have been sleeping with a critic or an editor or a collector. I just painted. I knew nothing at all about the kind of psychological warfare, or ideological warfare, that has to be carried on to sell pictures. I didn't know that I was up against a lot of ex-Marxists who were very familiar with ideological warfare. I just painted. Fashions meant nothing to me. I assumed that if I painted well—and I did paint well—sooner or later the world would beat a path to my door. But it didn't. And meanwhile I was getting older, and I was seeing a lot of artists who didn't have a thing on the ball, but knew how to get ahead, make big names for themselves, get invited to Venice for the Biennale, and all that. And finally I caught on. And when I caught on I really caught on. I worked in galleries, and I found out what you had to do."

I was moved by what she said, surprisingly moved, deeply moved. She was trying to speak out to me as directly as she could, to give me an *apologia* for her life. As far as the conditions of her life permitted, with her husband within earshot, she was asking me to understand her, to have pity on her, to realize what an unjust struggle she had been forced to endure.

"Thank God the book world is not like the art world," Warts said. "The book world is decent."

"The book world is just as bad!" she said. "You tell me stories about it that make my blood run cold. But if you prefer to live in a dream and believe it is decent, I can't stop you!" She said it so sharply that he ventured no further comment. From my entrance into the house I had had the impression that their marriage was one of long tactful silences, which they preferred to home truths.

She turned to me, now without anger. If she showed any emotion, it seemed to be one of appeal. Perhaps I as a stranger and, as she called me, an "innocent," might be able to throw a brief light on her problems. Or so at least I imagined her intention. "What do you think is going to happen to the art world?" she asked.

The question was one that I knew I could not answer. And yet I felt an obligation to try. "I think the scandals, the false reputations, the injustices will recede. They are an inevitable

part of life, so far as I can see, and one must accept them and if possible use them to deepen one's insight and tolerance. We are all thrust into a tragedy which we do not want to accept. But it is a sacred tragedy, and it rewards us profoundly when we do accept it. And it also helps us to make the world better in the only way it can be made better. The good painter, the good cook, the good shoemaker and all the other good makers— they are the only ones who really change the world. And they have to renounce fancy phrases and illusions about themselves, if they want to do their best.

"Good artists know that art is sacred. There is a Kent cigarette ad which illustrates what I mean. It consists of a drawing of a profile which had been plainly taken from a Hopi Indian picture. If a picture is really worth a thousand words, these two pictures give us clear-cut images of the sacred and the profane, the real and the phony, the thing that will last and the thing that will not. Sacred means merely the real, the enduring. But it takes a long time to get back to it, if you have been brought up on the unreal and the ephemeral, if you think for a moment they can fill your life. We whites don't get as good an education as the Hopis do.

"Art is a hard-won retrieval of symbols from nature, or it wears out awfully fast. It satisfies the most prolonged contemplation, or it goes into the cellar. Why do we assume that posterity will be as easily persuaded by our sales talk as we are? To survive contemplation, a work of art must come from as deep a life as that of the viewer. And some of our ordinary citizens are now obliged to live more deeply than some of our artists. The innocent eye, in more ways than Ruskin knew, finally decides. It looks hard, it looks long, it is willing to be cleansed, and at last it understands."

"I feel like painting again," Althea said.

"Artists are terribly privileged persons. They deal with the sacred at first hand. The unworthy ones do not matter. The worthy ones are thrust straight into the deepest of all experiences. And they know what to do with them. We are right to treat them as heroes. A Titian still painting at ninety-nine, a Cézanne literally catching his death while he painted in a field—"

"But if I painted again," said Althea, "the gallery would go to hell." She heard someone walking toward us. "Ah, there he is! Angie!"

"No, it's Judith," said Warts affectionately. He got up and put his arm around his daughter, when she entered the room with the grace of a dancer. It was plain that she rewarded him for all his other trials.

INTERLUDE: MYTHS THAT SELL PAINTINGS

A few rare people live through their eyes. In a desert they see its occasional flowers before anyone else. As students they copy in their notebook: "The light of the body is the eye; if therefore thine eye be single, thy whole body shall be full of light. But if thine eye be evil, thy whole body shall be full of darkness." Their chief enjoyments are visual. Usually they draw or paint in childhood.

"One is never tired of painting," Hazlitt writes, "because you have to set down not what you knew already, but what you have just discovered. . . . There is continual creation out of nothing going on. With every stroke of the brush, a new field of inquiry is laid open; new difficulties arise, and new triumphs are prepared over them." And so on. If I quoted any more, he would seem too romantic about his second art, which he preferred to writing. "In writing, you have to contend with the world; in painting, you have only to carry on a friendly strife with Nature."

At this point the contemporary painter begins to hoot. As if he didn't have to contend with the world! As if he didn't have to be as aware of it as any congressman! The good old carefree days are over. A painter must now be as cautious about his image as a movie star. And still more alert to the sensibilities of his fans, who might become collectors.

The American painter also hoots when he reads his hero Ryder saying: "An artist needs but a roof, a crust of bread and his easel, and all the rest God gives him in abundance. He must live to paint and not paint to live. He cannot be a good fellow." What

lovely nonsense! It may have inspired the painter in his student days, but now it is a needlessly cruel reminder of the Golden Age. Or La Belle Epoque. If he cannot be a good fellow, able to charm collectors with his words as well as his pictures, how can he possibly sell? (One artist moved near a museum, so that he might lunch with its director, and both painted and talked his way into an exhibition that changed his whole career.) He knows there never was a time when artists could ignore the market, whether it was papal, princely or bourgeois; but he also suspects there never was a time when they had to be so continually aware of it as now.

He has also observed that continual awareness of it dries up an artist. If art is not a free play of the imagination, it is nothing, and the man who makes it is sooner or later despised.

The usual resolution of this tough dilemma, which calls for sympathy not scorn, is that artists of genuine talent seek a predominant image (or style) that is distinct from that of everyone else and then develop it as well as they can, in the hope that it will lead them to critical acclaim and a market. They have discovered that they will make less of an impression upon collectors if, as happened more often in earlier days, their image (or style) wanders from an easily explained historical line. The minds of collectors have been influenced and narrowed by the repetitions of slogans and advertising.

Collectors are important to painters and sculptors. If an artist's work is bought regularly by a few serious collectors, he is sure to win a serious place in the art world. Prices are sure to rise, as other collectors feel it necessary to have examples of his work. Advertising is sure to increase. (The linage of art advertising in *The New York Times* has tripled in the last ten years.) Therefore most discussion of art, in articles, books and lectures, is really aimed at collectors or potential collectors. It may appear to be addressed to the general reader, and to meet its journalistic specifications it must satisfy him, but its real targets are collectors. In this expensive courtroom they are not mere spectators, they are the jury.

I have had a chance to collect a few collectors, and wish there were time, as we say of paintings, to hang them properly. One of them seems enough to suggest here some trends that are important. And as a human being he is more interesting, certainly more dramatic, than most.

When I met him several years ago he was just beginning to live in a beautiful new penthouse apartment that had been designed for him by an architect friend of mine who had graciously per-

mitted him to keep one discordant ashtray from his old place. He was also just beginning to collect pictures. He bought them from prominent dealers whom he met through the architect, who was doing over not only his dwelling but his life. The pictures were good examples of the work of a vigorous group of American painters—I recall canvases by Willem de Kooning, Hans Hofmann and Franz Kline—who were at last, after much admiration from painters and much neglect from others, attracting attention. The pictures looked well on the collector's new walls, which had been designed to make the most of their scrotal, risk-running, take-it-or-leave-it power. He said he got a big kick out of them. And he felt superior to the "old fogies" who were afraid of new art.

Some time later, after seeing the collector again at several exhibitions, I heard that he had divorced his wife. He was living alone in the penthouse apartment, and now divided his time between the stock market, where he had made a fortune, and the art galleries, where he bought pictures. He was living a simple life which consisted of studying art history, watching the market, eating health foods—and of course collecting. The pictures gave him a bigger kick than ever, he said. If it had not been for them, he might have committed suicide. But they were animated by a great idea, and it was that great idea that had kept him going in his darkest hours.

The idea was that art offered a person—a person like himself, who had felt unfree all his life, under a compulsion to do not what he wanted to do but what was expected of him—art offered him a chance to leap into an entirely new world. He could share the freedom that artists felt.

A critic had explained it to him. The artists had realized that the world was dreary enough and in a state of acute collapse. There was nothing in it they wanted to paint, or even look at. But the act of painting had become more important than ever. Through it they could embark upon objectless adventures that might lead to rich discoveries—or nothing. They were bored by the usual routine of landscapes, nudes, still lifes, portraits and the like, and had nothing but scorn for fellow-artists who continued to do them. They gambled for higher stakes.

He liked the ability of these "abstract" artists to take a chance. He felt the same way about his own life. Each morning was to him what an empty canvas was to them: an opportunity for a great event.

I have lost touch with this collector, but I continue to get re-

ports on him. My latest word is that some time ago he sold his beautiful apartment. Someone offered him such a fantastic profit on it that he could not resist. He has also sold his paintings at much more than their original price. He had planned to build a house in the country and install them there, but he was offered so much more than the land cost that he felt he had to sell. Now he lives quite simply in another part of New York City. The report from the architect is that he is probably getting his present kick out of drugs. He still studies the market (a test if there ever was one for hallucinogens) and eats only eggs and vegetables that are "organic." But he does not study art history any more, and he does not buy pictures.

Fortunately for artists and dealers, not many collectors get over the art-habit so quickly. His new habit is regarded by dealers as unworthy of discussion. Fortunately for us, as so often happens with psychopaths, he provides a case-history introduction to a real but overlooked situation. This time it is the art-scene in the city that is now generally regarded as the art-capital.

He wanted a kick, but what kind of a kick? Since he was extremely intelligent—he could not otherwise have acquired a fortune when he was still young (he was not quite forty, I would say, when I met him) and had started without an inheritance—he wanted something that went beyond intelligence. He spoke more than once to me of his desire to break away from the excessive prudence and caution of his background. He wanted, as he said, something that took chances, that used intelligence to surpass the usual experiences. The first thing he said about his pictures was that they were avantgarde. *He wanted the avantgarde kick.* He was not an artist himself, and he had never bet everything on intuitions that he would have to realize with his own efforts, but he envied the achievements and the satisfactions of those who had.

Also he wanted to feel *in.* He had always felt *out,* even after he became rich, because as he put it he attributed his successes as an investor to a skill which he did not value highly, while he did value highly the ability to be "creative." He possessed a streak of humility that one encounters rarely in any walk of life. It was balanced, as we shall see, by some arrogance, after he had been propagandized into believing that there was only one kind of art worth looking at and he had gotten in on it. Once he became a collector of valuable paintings he was given a chance to enter an exclusive inner circle as one of its most besought members.

Since his paintings meant little to him in themselves, when a profit became irresistible he sold them. The distorted, scornful, this-is-it myth of the avantgarde that had kept him going for a while proved not to be as strong as an earlier belief in money. It had been a dubious myth from the start, drawn not from respect for the heroism of bold imaginations but from a desire to profit by them spiritually (financially, too, later on).

Above all, he wanted to feel hope. And for a while the ideology (here, unfortunately, interchangeable with "myth") that had been worked out by the critic he admired—that society was in a state of advanced disintegration and familiar art-forms had collapsed with it, but bold improvisation could turn the tide—gave him more hope than anything else. At least when he was under the spell of his canvases, or rather the ideal they represented to him. There was death all around him, but through the activity of his imagination he could bring about a renewal of life. I remember how often he used the word "rebirth."

But the paintings themselves, it was evident even then, meant little to him. Some people exist who have an instinctive response to every evidence of visual beauty. A flower will change their darkest mood into joy. We feel a civilizing influence the minute we enter their houses, which they do not ask anyone else to decorate for them. They are naturally eye-minded, and when they acquire connoisseurship in paintings they know how to show them. As human beings go, they are gentler than most; reverence has softened them.

This collector had no such feeling for nature or for pictures. He demanded an expert's approval before he would even look at pictures. And when he acquired them he used them not only as guidelines for a renewed sense of personal direction, as talismans against suicide, but as weapons of aggression. Anyone who spoke naively of them, without an exact knowledge of the ideology that had been woven around them, was most sharply put in his place. And anyone who disagreed with the ideology, or said a kind word for nature, was dismissed dogmatically, as dogmatically as any heretic who in medieval times defied the Inquisition.

Other propaganda-lines have succeeded the "abstract" line which sustained this collector: propaganda for schools and styles called Pop, Op, Minimal, Hard Edge, and so on. For newcomers who are getting acquainted with a situation that has confused experts, it is necessary that dealers, editors, critics, museum directors and fund-raisers find words that will fire the imagination.

These words must serve as beacons for a public that is rich and eager to put Rosa Bonheur's *Horse Fair* in the attic but uninformed as to what should replace it. (What a market! exclaim the merchants when they think of all the customers who want to start life afresh without any dismaying pictorial associations.) There is competition therefore among the words that will be given the dealers. The words soon suffer the fate of all words in business transactions.

Our collector was not a fool. A potent myth had to be created to catch him—*after* the pictures had been painted by artists who are not to be blamed for the sales talks invented to glamourize their works. The collector's uprooted urban intelligence, his up-to-the-minute politicalization, his inferiority complex, his secret fear that he understood nothing but the quickest way to power, his parasitism, his guilt about having made nothing of value himself, his self-contempt: all these had to be appeased and channeled into picture-buying. He had to be made to feel that he was venturing upon a dangerous highwire act, although of course he was also told that underneath him stretched a solid net of money that would protect him from any harm. Even if he fell, even if his investments in art did not yield a profit, he could always get his money back by giving his pictures to a museum and deducting their cost from his income tax. He would then be acclaimed as a public benefactor. Only the interest on his money would be lost. He could not miss.

The myth that caught him, if I may use the language of ancient Chinese thought (I think it puts the matter in perspective), insisted that art is a *yang* experience that satisfies one's love of conquest and appeals to a warrior's mentality. It dogmatically rejected the patience, gentleness and tolerance of *yin.* It denied the value of humility before nature, of receptivity to conflicting, anti-ideological experience, of empathy for others, of peace. Though it claimed the sacred prestige of pure art, its militant one-sidedness was not far from that of political posters. It pretended to be in the critical tradition of Baudelaire and Apollinaire, but its methods were those of *agitprop.*

Art has always been a felicitous mixture of both *yang* and *yin.* If there has been any predominance in it, it has been a predominance of *yin,* as a counterbalance to our natural *yang* aggressiveness. The art that has survived centuries of close inspection has been able to meet the demands that people have made upon it in their moments of ego-free contemplation. To think that we can bully our way out of those demands, by shouting how

artistic we are or how brilliant our program is, is not only to parody the original aims of the avantgarde but to announce our secession from reason. Contemplation is still the final test of any picture.

A new myth has risen lately to challenge the value of contemplation. It is the myth of Impersonality which has been woven in the last few years around works that it sees as seeking the anonymous, hermetic otherness of chunks of nature or chunks of machinery. This myth leans heavily on the belief that we are going to be made much freer by our new technology, our exploration of space, our imaginative use of computers. The sociologists who say that our technology has become anti-humane, this myth contends, are all wrong. They remain locked in a gloomy old pessimism that is natural enough in those who do not know how to use their hands. The new technology is now a permanent part of our style of life. Well then, we are going to use it to make our lives richer and more beautiful! And the way to do that is to create works of art that are impersonal, free of the old associations, free of the old feelings, free of any feelings at all, free to guide us into a wholly new style of life. The sky is blue. The sky is the limit.

Since this hopeful myth is addressed to a nation built largely by engineers descended from pioneers, men who for a long time have avoided self-confrontation through the exploration of new lands or new mechanisms, it may prove in the long run to be more potent than the myth of Vicarious Action that hooked our Wall Street collector. How urbanly narrow and admittedly neurotic, by comparison, was the idea that sustained him! It began with the assumption that all cultural values had come to an end, and the individual had to improvise his redemption. The new Impersonal myth begins with the assumption that we are entering upon the most creative period in history, and have only to get over our obsession with our own feelings and our own thoughts to share in its magnificence. The Impersonal myth appears to owe some of its mystique to the successes, past and future, of the Houston Space Center. Geographically it is to some degree a Texas myth, and more of the "grassroots" kind —to use a favorite term of popular mythographers—than the New York myth. Television has had much to do with its insemination of our minds. Its appeal to the silent majority can be expected. In time it will most likely mean even more to them than the Tenderness Recaptured myth of Andrew Wyeth.

An art work that embodies the Impersonal myth is the painting

by Frank Stella that was chosen by the Metropolitan Museum as the emblem of its centenary. This painting, in colors that almost resemble those of different flavors of ice cream, is so simple, so handsome, so free of any but the most agreeable associations, so unlikely to arouse the controversial emotions that modern art usually arouses, so independent of any private drama the artist may have felt, so close to being an abstract continuance of Norman Rockwell that it might seem merely bland and conventional, at first glance, if we did not understand how carefully it has been addressed to a rapidly multiplying audience that wants to look at art but does *not* want to get involved in its darker complications. It has been reported that this artist is already earning more than a million dollars a year for his pictures. Such popularity is not accidental. In trying times any new way to reassure the public is rewarded.

A great deal of popular energy is waiting to be taken hold of and directed. A great many people want the excitement of new art without the intellectual, emotional and sensory disciplines it requires. Picasso was right when he said that painting was like another language that had to be studied and lived with if it was to be understood. But such work is hard for most people, harder still than their jobs, because they consider it superfluous. So a way has been found, in the Impersonal style, for them to avoid it.

The possibilities of the Impersonal style, in terms of popular consumption, are plainly enormous. It is new. (Or apparently new; actually it derives much from painters who lived in Paris before World War I, such as the Delaunays. More than one critic has pointed this out, with no discernible effect on its popularity.) And it releases its public not only from work but, still more important, from any need to look into its own hidden life and make unfavorable comparisons between its own spiritual indolence and the intrepidity of artists. The Impersonal artists have spared the public that. They have even invited the public, as was also done in the case of Pop, to *despise* their art, as not being nearly as serious or as worthy of respect as the day-to-day hard work done by the average man. Impersonality is being paid handsomely for its confirmation of an old bourgeois prejudice: that artists are no damn good, or at best mere entertainers.

Another reason for the lucrative reception of the Impersonal— or, as some artists call it, the Public—style can be found in the discovery by perceptive psychiatrists of a growing apathy among their patients.

Here once again I cannot neglect, or apologize for insights that come from other fields when they seem valid. No art can any longer be intelligently approached by narrow confinement to its own techniques or tradition. Every good artist I know complains privately that he gets almost no stimulation from art criticism. The reason is obvious. Critics cannot tell him nearly as much about painting as he already knows. But there are others outside his art who know a great deal about other aspects of the human situation that could tell him a great deal about painting, if he were to relate their knowledge to his own. This he is seldom ready to do, because he is afraid that new knowledge might diminish his effectiveness. Ordinarily he only becomes hospitable to external insights when he is in trouble, when his collectors for example have begun to desert him. And then old habits of intellectual rigidity make it difficult for him to open himself up again, as he might have done in childhood, to the rest of the world. Seldom is he capable of self-expansion. Yet that is exactly what the most rapidly changing situation in history now requires. If he is serious, he must expand or expire. What heroic demands we make on him, demands we would never make on ourselves!

To return to the discovery by psychiatrists of the widespread apathy of their patients, this has been traced to their inability to become emotionally engaged by the routine or mechanical work that earns them their daily bread. (Here, as often elsewhere, I make a value-judgment. Apathy has also been traced to other causes, but on the basis of my own observations I think it is most plausibly laid to occupational dissatisfactions.) In more traditional language, a great many people do not enjoy their work, which does not engage their best capacities, and so they fail to show up or are listless when they do. Out of their apathy grows occasional violence and continual indifference. They lose their capacity for love. If Impersonal art can help them with its message of hope without self-examination, it will be the most therapeutic art ever discovered.

"Why has the art-world become so awful?" The question was first asked me by a student who had been brought up to believe that art was the best thing we had. Later he had become disillusioned when he discovered some evidence of favoritism in an art magazine.

Others since then have asked the same question.

I told him and I told them that I considered the question over-emotional. It would be more intelligent, I said, to remember that

all art-worlds have always been awful (or awful enough to release our paranoia). Why do we respect our art heroes? Because they triumphed symbolically over hostile environments either while they lived or after they died. We now put some of them into the pantheon of the avantgarde for that reason and pay them our unnoticed homage. We make a typically American mistake when we expect things to be cleaner and easier here.

What is to be done about the present situation? If you really don't like it, and believe there are ways in which it might be improved, the first step is to try to understand it. And the first step in doing that is to try to understand the myths that in a real sense keep it going. This interlude has been an attempt, the first attempt unless I am mistaken, and therefore faulty, to look at those myths, how they came into being and what effect they are having.

It is upon our sustaining myths, upon the faiths that keep us going, that our art preferences depend. With the breakdown of the old faiths, religious and secular, as the determining factors in our secret lives, we are all forced, even when our roles are passive, into the mythmaking sweepstakes.

Vicarious Action and Impersonality are only two of many new group myths that have been whipped up to sustain a bewildered citizenry. I cannot promise an examination of all the new group myths in all the other arts, and certainly not all of the individual myths, which are still more interesting, but as we move along some of them ought to come into sight. They will indicate, I believe, some of the innermost sources of our aesthetic activity.

Postscript: The Death of Mark Rothko

I discussed the new Impersonal style in some detail with Mark Rothko in his studio shortly before his suicide on February 25, 1970. Though he was in low spirits at the time, and had been for years, he spoke out on the subject with exceptional clarity and vigor. And mentioned it briefly again a few days later when he came to my house for dinner.

Now that he has killed himself (this is written soon after his funeral) many of his friends have been asking themselves why he did it. They have been deeply shocked by his action, and they know no simple explanation will do. Some of them feel that if they had helped him get out of his depression he might still be alive. His depression was not rational, they say: his physician had

recently reassured him on his health; in spite of many changes in art fashion, he retained the highest respect of his colleagues; he had kept on painting steadily (I saw his last pictures); large exhibitions of his work were scheduled for the future; he had earned more money than any other American painter (about five million dollars, according to his devoted friend and accountant Bernard Reis); he was surrounded by other devoted friends and relatives. Why did he do it?

No one can presume to know why. But apart from private matters that cannot be discussed now, I should like to offer one possible clue to his depression. It is a clue that others besides myself have observed. He seemed to get less satisfaction than anyone else from the little commonplace pleasures that may be an important reason why the rest of us prefer to go on living.

What are these "little commonplace pleasures"? They are such things as flowers, children, animals, sunlight, rain. They are the sensory and emotional sustenance that complements love, faith, food, play and work in nourishing within us the will to endure. The friends of Mark Rothko whom I have questioned on this matter since his death agree that such things meant little to him. They point out, for example, that he could walk by one of his own paintings, in an unfamiliar setting, without observing it. Someone else would have to point it out to him.

Why did these creature compensations mean so little to him? A portion of the answer may lie in his early training in Russia, where a rabbinical tradition forbade gifted boys from occupying themselves with anything quotidian or "not serious." Certainly this tradition contributed to the development of extraordinary talent (for example, in Einstein) that has had much to do with the historic survival of the Jews. Certainly also Mark Rothko had an exceptional capacity to shut out anything that did not seem to him truly important. The style of his mature painting was reductive: it reduced the picture plane to rectangles that gained their effects through subtle modulations of color. It is possible that his zealous pursuit of perfection led him to exclude too many everyday joys.

But speculation on a suicide is unending. His death remains a mystery. It may serve however to remind his survivors of the many-sided strains, more crushing perhaps than those borne by any other members of the community, that an artist is now expected to bear.

FIVE

MUSIC AND THE SACRED

Judith Black was a priestess, a priestess of music, a priestess of new music. She looked like a youthful Nadia Boulanger, with a grave, handsome head on a slim, handsome body that was already dedicated to the production of organized sound rather than disorganized children. She was two years older than Tommy, already in her middle twenties. The religious nature of her calling was suggested by the black she wore most of the time, edged in white.

She taught composition in a music school in Manhattan. She had stopped trying to compose music, and recognized that her talent lay in helping others to do what she could not do herself (so I was informed later by others). She spoke in a low, clear voice. Her words were always modest and precise. She made me feel that almost without strain she had triumphed over her animal destiny and come as close as was humanly possible to being pure spirit. Since I have rarely encountered such effortless sublimation, even among the professionally religious, I was impressed by the intensity of her sacrifice.

Her father called upon her to speak almost at once. "We've been talking about the favorite subject of all squares, the avantgarde." He made the term sound American, not French. "What is the avantgarde doing in music?"

She laughed. "That's the third time you've asked me that." She turned to me. "Mr. Sykes, you don't know what a controversy you've stirred up in this family. My father *cannot* understand why a good piece of music has to be new."

"I'm beginning to, my dear," he said. "The patient is making a little progress."

"I'll believe it, papa, when I take you to a concert and you don't fall asleep."

"We've been talking about the sacred, Judy," said Tommy, who had kissed his sister when she arrived, kissed her on the cheek with a warmth that he showed no one else, including his father. "That's right up your alley." He turned to me. "She's a nut on the subject. She makes me read books about it."

"So am I," I admitted. "I think we have to recapture the sacred, the real, the enduring, or all our arts will mean nothing. Our sciences too. Psychology needs it as the basis for a new norm. Without it the avantgarde will be a meaningless French phrase."

"Do you really believe that?" She now directed her attention toward me with more than polite interest.

"Does he!" said Tommy. "I remember it now, in that book of his about the millennium. If we don't resacralize our lives, our entire civilization will be destroyed."

"Resacralize? What does that mean?" she asked.

Tommy answered for me, before I could speak, and I must say I was grateful, even if he oversimplified things a bit. "We gained our scientific control over nature by *de*sacralizing it, by losing our awe of it, by no longer treating it as a mystery. Now we have to retain our practical attitude toward it, go on improving our technology, but at the same time *re*sacralize our lives. It's a very difficult psychological feat, impossible for most people, and so we are going to have a great catastrophe. People will use their new practicality, their science-liberated minds to get more fun, more money, more sex, more conquest, more violence. After the catastrophe, men *may* regain their sense of the sacred, or at least some of them may."

"Good God!" cried Warts, as if it had already occurred. "Is that what's going to happen?"

"I think it's going to happen," I said, "but of course enough people may become aware of the disaster to avert it."

"Resacralize," Judith murmured the harsh new syllables like an incantation. "What an interesting word. Then that's what young musicians must do, resacralize music. Make it holy again. So that we *have* to treat it with reverence. Feel it the way Bach did, and Berlioz did, and Bizet did, and Stravinsky did. And so many others. Thank you," she said to me, "I'll be able to teach better now."

"Thank *you*," I insisted, "for taking a mere word and making it come alive."

"Look out for him," Tommy warned his sister. "I've been checking up on him. When he was my age he wrote one of the most horrifying, no, diabolical stories I ever read. It's named *Geld Your Enemy*, and a worst psychopath never put pen to paper. His friends called him Lucifer, or Baby Lucifer. Now all this diabolism is *apparently* concerned about the future of mankind."

"I see," she said, pretending to be alarmed. "I'll be very careful. Don't come near me, sir!" she laughed at me.

"I'll keep my distance," I promised, "if you'll help me with this book your father wants me to write. Why is it that we feel such a difference between what's called modern music and the music of the past? What happened? Did the change take place in the late nineteenth century? Did it begin with Debussy?"

"That's all old stuff," she said, "that revolt against German romanticism, against Wagner and Brahms. But you're right, it did begin with Debussy."

"He came later than the Impressionists, didn't he?" said Althea. For some reason I had expected her to go into another part of the house when Judith arrived, because the subject changed abruptly from painting and sculpture to music. But after bidding goodbye to Miss Harris, who left soon after Judith came, Althea stayed on, sipping a drop of Pernod, and as time passed I began to believe I knew why. She was doing her best to be a conscientious stepmother, to take an interest in the things that meant so much to Judith. My respect for Althea, which had increased when she spoke out as frankly as she dared about her own predicament, increased again. She must have felt like a stranger among the Blacks, but she was trying to be one of them.

"Yes, Debussy came later than the Impressionists. Satie also." Judith was drinking fruit juice.

"Tell me this," Tommy asked anyone who would answer. "Why is painting so much more popular than music? Hordes jam the museum openings, and new faces too, but you see the same old faces at concerts, and they seem to go there as a duty."

"My students are bitter about that," Judith said sadly. "They

say painting takes so little time to consume or have an opinion about."

"It only seems to—to people who don't love it," said Althea.

"But when you go to a concert, you have to sit there for a long time and listen, or pretend to. That's what my students say. I hate to think they're right, but I suppose they are."

"Can you draw her out?" Warts asked me about his daughter. "She's a wizard at teaching others, everybody says so, but she refuses to give me a single lesson. Now who was this man Debussy and what did he do?" I think he was pretending to be more ignorant than he was. He liked to get others to perform.

"Oh papa!" Judith protested. But after a while we prevailed upon her to give a very brief history of modern music for her father. We all listened attentively. Althea listened as attentively as anyone else. She held the hand of Warts while his daughter spoke. If Judith objected to this intrusion upon her earlier territorial rights, she gave no sign of it. She seemed reconciled to Althea's replacement of her mother as the senior female of the family.

"Before you start," Tommy said to his sister, "let me ask you this. We've been talking about a scarcity of trained readers for books, and a scarcity of trained eyes for painting and sculpture. Is there a scarcity of trained ears for music?"

"Oh yes."

"But I notice that a lot of kids listen to music who never look at pictures and only look at the books they *have* to. They turn on their radios or their TVs, and then they study. Even graduate students. Sometimes they can only look at their books, at exam time, when they are also listening to music."

"That's not listening to music!" Judith protested. "I think they're just looking for a way, through sound, to escape feeling lonely."

"I see," he said. "It's insurance against solitude."

"It doesn't help musicians. Especially composers. They want an audience that listens as acutely as they do. They write their music for that kind of audience."

"Will they ever get it?" Warts asked, unable to hide his skepticism.

"In time, of course they'll get it," she said with perfect faith. "Webern jumped when somebody dropped a fork at the next table. His sensitivity seems fantastic, but someday we'll all be as sensitive to sounds as he was."

Warts did his best to conceal his doubts. "What did you say his name was?"

"Anton Webern. Originally Anton von Webern, but he dropped the von. I'll tell you about him later, if you're really interested," she promised with a teacher's eagerness.

"I'm sorry," Tommy apologized. "Go on."

"When a composer is original, really original," she said, "he has to wait a long time, patiently, until his music has created an audience that can appreciate it. Some of the halfway composers are awfully clever at creating audiences for themselves. They have more skill at self-advertisement than at music, and their music always suffers from it. This is not the age of Liszt and Wagner, when you could blow your own horn and still have something left for the rest of the orchestra. I didn't make up that joke," she admitted, as if speaking to her students. "If composers have real talent and lack the ability to advertise themselves, sometimes they have to wait until they are old before they find an audience. That's what happened to Edgard Varèse. Don't ask me how to spell his name, papa. I'll show you some records of his, with his biography and everything.

"Audiences for new music are already being created. So much of the old music is played again and again, on the air, that people get bored with it. Actually, understanding new music is not as formidable as it seems. All it requires is a willingness to listen, not only to music but to street noises, harbor sounds, building rackets, jukeboxes, speech, birds, armpits. A peasant showed Stravinsky when he was a boy what wonderful sounds could be made with an armpit. Our ears are so fascinated by the sounds we hear every day that we prefer to ignore them. They are too exciting."

"You make me want to re-educate my ears," Tommy said with admiration. "You always do. Do you think auditory sensations are more primal than visual or verbal? Are there more ear-minded people than eye-minded?"

"I don't know. That's your department."

"You didn't ask for my opinion, but I'll tell you what I think. I think," he said, "that sound *is* a hotter medium than sight. That nut in Toronto is right. Sound is more primitive, more inflammatory."

"I don't know," she repeated.

"You know what this man says?" He pointed to me. "He says that all new art is a humiliation. We either accept its affront to our settled habits, and become willing to learn what we can of its language, or we tune it out altogether. Usually we tune it out altogether. We have raincoat minds that shed everything beautiful, strange, unprofitable. It's easiest of all to tune out music. There's so much of it. Bach, Rock, Tchaik—we stopped listening long ago. 'Silence is pleased,' Milton wrote after a nightingale had sung. I got that from a song by Charles Ives that *you* took me to hear. There isn't much silence now, and it is never pleased. Does that mean that good music will have to go underground?"

"I suppose that's what's happened to it," Judith confessed dolefully with a sigh. Her faith of a few minutes before had deserted her. She looked easily discouraged. Her voice dropped.

"Why don't you let Judy talk?" his father reproached him. "She was going to explain modern music to me."

"I can't explain it, papa," she said, as if depressed by a thought. "It's something we all have to get for ourselves."

"Then tell me about its history. This Debussy—what did he do?"

"Oh you could say he led the fight against Wagner and all those big love-swoons that Wagner went in for. Debussy was elegant, trim, aristocratic. He didn't reach the big, beer-drinking bourgeoisie that loved *Tristan*. He worked out of a more complex sensibility." She was regaining her faith and her voice. "You have to follow each syllable of *Pélléas* if you want to understand it."

"Would you say he was an 'innovator who is still interesting?' " Warts asked with a glance at me.

"Oh yes. He's very interesting, and he certainly did something new. As new in its way as what Schoenberg and Stravinsky did later on."

"Then he came first?"

"Yes, he was born in 1862, Schoenberg in 1874, Stravinsky in 1883."

"They were not only rebelling against German romanticism," Tommy said with the assurance of new learning, "but against the egotism of German philosophy."

"Let Judy speak! You keep stopping her. Go on, Judy!"

It began to be clear to me why she was a teacher of composition, not a composer. She lacked a native self-assertiveness and was happiest not in debate or competition but in the orderly intellectual cleanliness of a classroom, where the work of others could be evaluated and encouraged, and there was no need to bring forth creations of her own that might be subject to dispute and attack.

"Debussy's training, which he received at the Conservatory in Paris, was Germanic and thorough. In the end it helped him," she was gaining courage as she spoke, "to find a style that is unmistakably French in every note. This is an important lesson for our young American talents, who can become all the more American if they will face the creations and the theory of Europe. Or for that matter, Asia and Africa. Foreign composers ask us hard questions that we cannot afford to overlook. There is something in German musical thought that helps the truly gifted to find their deepest selves, because it is so rigorous."

"That's true in psychology too," Tommy said. "William James and Freud became much more original because they had a stiff training in German scholarship."

"Sssh. Go on, Judy."

"I don't mind him. He helps me to see music in a better perspective. Schoenberg lived in Vienna, directly under the shadow of Wagner and Brahms. Wagner was his particular—well, my students call it his hang-up and he wrote some lovely music under Wagner's influence. *Verklaerte Nacht* is a good example. But in time he worked his way through him. Strauss, Mahler and Bruckner did not, but he did. He was well over thirty before he found his own style and his own theory."

"I think painting has a lot in common with music," Althea announced out of a fresh desire to be one of the discussion and one of the family. The Blacks listened with surprised attentiveness. "I think they both have been moving toward a more in-

ternational style and a more muscular style. Judy said the
Romantics liked to swoon. There was a Swiss painter named
Arnold Boecklin. He liked to swoon. And he painted scenes
from Wagner's operas. He was all the rage. Now nobody, but
nobody, outside of Switzerland ever heard of him. At about
the same time Cézanne was changing the style of all painting,
all serious painting. He looked underneath surfaces, and he was
tough. He asked hard questions of everything he painted. We
have forgotten about Boecklin, he was only for his day, but
Cézanne is the beginning of modern art."

It was a valiant effort, and one of the Blacks appreciated it.
Warts patted her hand. "You make me see things better. You
always did. The need for a more critical attitude. I can follow
that."

Judith had soon stopped listening to Althea, except perhaps
as a producer of lengthy sounds. "I don't know about painting,"
she said, as if that settled the matter. "Stravinsky was as tough
as Schoenberg, and he had more animal vigor. Times were
changing. His alert musical ear was listening. A more sensitive,
a more dissonant style was needed, if he was to wake up St.
Petersburg and Paris and catch the spirit of a world that was
breaking up. The world was moving toward revolutions, in
music as well as politics. He didn't like the political revolution
when it came to his country. But he fought for the musical
one."

Her manner of ignoring Althea annoyed me, and I found my-
self saying: "Aren't you overlooking something? He was more
than just a musician. He had an inquiring mind. It was discover-
ies of archaeology and anthropology that inspired his *Sacre
du Printemps*. No one had done a ballet about primitive times."

She accepted expansion of her musical world more readily
from me than from her stepmother. "That's true. It was im-
possible for him to take his own tiny portion of *Weltschmerz*
as seriously as the Romantics did. Large collective forms ap-
pealed to him more than the symphony, which had degener-
ated into the petty tribulations and huge sonorities of windbags.
Also he was a man of the theatre."

"And what theatre!" her brother exclaimed.

"So he wrote ballets and oratorios in a style that is amazingly

impersonal. Later on he made the symphony impersonal too —in the *Symphonie des Psaumes*. He doesn't call attention to *himself*. He has the art that conceals art. And then he takes the schmalziest composer of all, and gives us the *Baiser de la Fée*. Tchaikovsky purged of all his gripes and hamming. He was saying that in music everything had to be refelt, rethought, rewritten."

While she talked she seemed now and then to be drawing upon lectures she had given in school, as much in the vernacular as she could, to stimulate her young composers.

This time she stimulated her brother to remark, as he pointed to me: "This man says that other workers in the arts and sciences were doing a similar thing. It was a time of peace in Europe that permitted a new talent to raise new questions and work out the answers slowly. Naturally, most people hated any innovations, they always do, but there were some who could cope with them. And now we Americans, more than half a century later, are still trying to cope with them."

"Let's get back to music," his father suggested. "I won't fall asleep at the next concert I go to."

Judith surprised me by asking me a question, a question that seemed inconsistent with her own indifference to extramusical matters. "Do you think, Mr. Sykes, there will ever be a common culture in all the arts again? That's the chief problem of the students I see. They're so eager to make a name for themselves that they don't read anything, or look at anything that won't help them to get ahead. They have tremendous vitality, but they're terribly uncultured. They're almost as bad as the musicians who play in big orchestras. Of course, they're not that bad. During rehearsals they don't read the comics or the sports page as soon as it's not their turn to play. But—"

"Culture is now regarded as something that might injure an artist. If they thought it would help them, they'd make a tribal deity of Matthew Arnold. Now their deity is Marilyn Monroe. And for very practical reasons."

"It's worst of all in music," she said.

"No," said Althea, "it's just as bad in painting. They only know Rembrandt because his name is on paint tubes and cigars."

"It's worst in psychology," Tommy said decisively. "All

they're thinking about is those broads who are going to come and tell them that their husbands can't perform."

"I want to hear about music," his father reminded him with admirable restraint.

A plump and pretty maid, who seemed by her speech to have left the lakes of Killarney only a few weeks before, appeared with a muted message for Judith. "There's someone to see you, Miss Judith." It was meant to be private, but the anxiety on the listener's face made us all listen too. "It's Dr. Muhlhauser."

It was plain at once that Judith had no wish to see him, but before she had any chance to head him off an unbelievably golden giant entered the room in a dress suit, white tie, gleaming patent leather shoes. I did not understand his clothing until I heard his name again, and recognized in him a European composer-conductor, young but already prominent, of whom I had read a column or so in the Sunday *Times*. He was conducting one of our best orchestras that night in a concert that offered new music as well as old. After introductions were over—and he responded to each of them with a punctilio that was somehow overwhelming—he insisted in excellent English, against the protests of Judith, whose body seemed to contract like a frightened kitten's, that she had promised to go with him to his concert. "Always before a concert I wish to be alone, but with you with me I shall do better. Better than ever before. Right? So, my musical friend, the one I respect the most, come!"

"But I never said I would come. And I'm not dressed. I have an early class tomorrow."

Each of her objéctions he hacked aside with a Nibelung sweep. The dark-haired, olive-skinned priestess, who now looked more Mediterranean than before, and more terrified, must yield to his Norse grandeur.

Her discomfiture was painful to see. As much as Artemis she detested an intrusion of male authority into her sacred grove, and would gladly have turned him, or so it seemed to me, into a beast that was consumed by his own strings, brasses, woodwinds and percussion. "No," she told him firmly, though her hands trembled while she spoke, "I did not promise to go to your concert with you tonight. I am greatly honored, but I cannot accept, Dr. Muhlhauser."

"Dr. Muhlhauser!" he scoffed. "We spoke together this morning, and then you called me Siegfried. This is America. We use our real names, not those of our clan! It is like the music of Ives. So direct, so inventive. I am playing him tonight, without a score. I want you to hear what he meant. *You* will understand it. Come! I will not—how do you say it?—I will not take nix for an answer!"

The quivering priestess stood her ground. "I am very sorry, Dr. Muhlhauser, but much as I should like to hear your interpretation of the Ives symphony, I cannot go to your concert. And I *never* promised to go."

He was treated with equal iciness by the rest of the family— by Warts as if he were Hermann Goering returned from the grave, by Tommy as if his straight Nordic nose would look best if it covered his starched white shirtfront with blood, by Althea (whose hand he had kissed three inches above it, with a heelclick) as if he had come at a singularly inappropriate moment, exactly when some much-needed fellow-feeling was being established at last between her and her stepchildren.

The family's coldness had no discernible effect on the dauntless conductor, who was used to turning his back without fear to audiences which some day might include a fanatic who would punish him for the sins of his tribe with a bullet. Siegfried Mulhauser, as I had read on Sunday, had been learning his alphabet when the leaders of his country perished in bunkers, or were put on trial in Nuremberg, or went into hiding, and he saw no reason why he should feel any guilt for what they had done. He made it clear that he disagreed with their actions as inhuman and barbarous. "I am a man of music," he told a reporter. "I love beautiful sounds wherever they originate. I try to make beautiful sounds of my own. I am sorry, I am only a musician. Do you feel crushed by what the Americans are doing in Viet Nam?"

It was not his nationality, I thought, that Judith objected to, but his sex. And the grandiose way he flaunted it. He was well over six feet tall, and his full figure had not been allowed to run to fat. He was a vast male Goldilocks whose curls almost looked as if they had been protected at night by a net. His fingers shone with the manicurist's art. His body smelt as if it were rebaptized hourly in waters prepared at Cologne. He glowed with

spotlessness and self-assurance, but the more he insisted that he needed the presence of Judith at his concert ("You alone can tell me how it *sounds*. I have no faith in the critics."), the more obdurately she refused. At last, since his gold wristwatch told him it was a little after eight o'clock, and his concert began at eight-thirty ("I have never made such a sacrifice for any woman!"), he said goodbye to her with tears in his manly eyes, bowed formally to the rest of us (too deeply moved to go through the full ceremony) and returned with *Goetter-daemmerung* gloom to the long dark limousine that, as Tommy and I hastened to see from a window, had been waiting for him, with a Jewish-looking chauffeur at its side in a black uniform and cap that did not entirely fit him.

Siegfried went forth to battle without a blessing from the chaste priestess whose hands still trembled for minutes after he had left. To my masculine eye he seemed to be resolving to arrange to meet her again at a place where she was not supported so staunchly by the presence of her family. The hero, or so I thought, did not accept his defeat.

"Who is he?" asked Warts coolly when he had gone.

"Oh he's a good conductor, very good, but I don't care for the music he writes. Webern has said it all before him, and better. And I never promised to go to his concert. I give you my—"

"It will be a big event, won't it?" Tommy said.

"Oh yes. But—"

"You must stay for dinner," Warts told me.

When I protested that I also must go, though without any flickers from the twilight of the gods, Althea supported her husband with dexterity. "We wouldn't dream of letting you go. You almost seem like one of the family!"

So I agreed, as one who had been with the family while it withstood a siege, and the Killarney maid was told to set another place for me.

"I've got to go. My God! Leon said," Tommy remembered, "*the big thing has already started.*"

"What was the name of that American that's going to be played tonight?" Warts asked Judith.

Tommy answered for her. "Ives. But it's one of his sym-

phonies. I don't like them as much as his songs. They wander all over the place."

"Is this Ives avantgarde?" Warts asked her.

"He's dead now, but he was really avantgarde," she said, "though I hate that word. He worked completely alone, without any thought of performance, at least of his big works. He was years ahead of the most advanced Europeans. He composed the first serial music, the first aleatory music." She was now speaking as if we were all musicians. "He invented block forms and free forms. He used tone clusters and structural densities. He wrote in polymeters and polytempi. He wrote spatial music and music that could be realized in many different ways. He improvised in a way that young composers are just beginning to do. And he also did what you people in the art world call assemblages and Pop Art," she remarked to Althea, to whom she had been drawn closer, though very slightly, by the intrusion of Siegfried Muhlhauser.

"I don't understand a word of it," Warts remarked.

Tommy sat down. The discussion was again luring him away from his campus commitments. "What she's saying is this: Ives was a musical introvert. In his daily life he ran his insurance business, a big one, downtown, around William Street, I think. But every night he went home to Danbury like any other commuter, and composed. And did nothing to get his music played. Successful schizophrenia. It worked. His music got better. And better."

"Wallace Stevens was another Connecticut insurance man who practised an art," I remarked.

"The poet?" asked Warts, and I nodded.

The pedagogical enthusiasm of Judith had been engaged. "Ives anticipated some of the most interesting technical devices of Debussy, Schoenberg and Stravinsky. And our own Carl Ruggles, Henry Cowell and John Cage. He was the son of a musician, and a student of Horatio Parker at Yale. But he kept away from the musical world. Music meant more to him than anything else, naturally, but he didn't like the professionalism that went with it. He felt at home in the deals of the business world, but not in the deals of musical world. I can understand that. He wasn't a Siegfried Muhlhauser, crashing in where no-

body wants him. And striking gorgeous poses for the ladies in the audience. Ives just went home and composed."

"A strange kind of introversion," Tommy repeated. "Artistically turned inward, economically turned outward. He poured all his libido into music, and wasted none of it on getting it played. He was as free as a mystic. But a mystic with discipline. He was relieved of New England guilt by his job, and relieved of the strains of showmanship by his withdrawal."

"So other musicians had to discover him and see that his music got played," Judith went on. "We should be very grateful to them. I don't know whether Ives was an introvert. I don't understand such words. But I think he had a philosophy, and it went something like this: 'Life is a rough business, an ugly business, a terrifying business, with all sorts of temptations, but music is sacred, and I for one am going to keep it that way. No publicity stunts! No carefully cultivated friendships with the people who have power. I will make my music as good as my talent permits it to be, but I will not drag it into the world of business, which I know only too well.' "

While she talked I wondered, "Is she really composing music of her own in secret, but fearing a rebuff shows it to no one?" Then the thought vanished.

"Do you agree with that?" Tommy asked me.

"I do. Your sister has described a typical avantgarde philosophy. It's not the only one, in fact it's rare. But Joyce said something similar in words, and Cézanne in pictures. They were not, however, brought up in the great American loneliness, which must have had something to do with the secretiveness of Ives. As Europeans they expected communication with their peers, and they got it. They also expected to influence posterity, and they did. Ives didn't act as if he did. He seems to me more like the old artificers who put their best work into a bottle and then threw it into the sea. Or the Eastern sages who believed they would change the world by whispering the accumulated wisdom of a lifetime into the ground."

Warts looked startled. "Did anyone ever do that?" he cried.

"Oh yes," I said. "There have been other times when great spirits despaired of reaching anyone else. But our world is more complex and demanding. It drains off the essential energy of our exceptional talents."

"Right," said Tommy, "their libido."

"The Victorian world of Ives was collapsing, but it had not openly collapsed into wars, revolutions and one crisis after another that cannot be overlooked. Our composers now have a still harder time than Ives had. They seem to be given a well-organized world to work with—individual computers that can create electronic music and cost only about four thousand dollars—but actually they don't. Stravinsky told a friend of mine," I said, "that the musical material at Bach's command was as big as Carnegie Hall. They were sitting there, talking. 'But the musical material that a composer has to work with today,' Stravinsky said, 'is only as big as this.' And he held up the head of his cane."

"He said that to Paul Rosenfeld," Judith said. "Did you know him?"

"Paul was a good friend of mine. We went to many concerts together."

"He's my favorite music critic. He's been dead over twenty years, but his books stand up. I like the way he championed Varèse."

"Varèse," her father repeated. "That's the man whose records you're going to show me. Is he really avantgarde?" he asked me.

"Oh yes. But your daughter knows more about him than I do. She's a musician and I'm not."

"Varèse was not introverted like Ives," Tommy said. "Judy took me down to his house on Sullivan Street before he died. What a wonderful-looking man he was, even then! He had the elemental vigor that this guy Muhlhauser is pretending to have. The women must have fallen for him!"

"He was devoted to his wife, who is an excellent translator."

"Did you know him?" Judith asked.

"There was a time when I saw quite a bit of him. Then I moved out of the city."

"He would most likely have had a more successful career," Judith said, "if he had stayed in France. But I don't think his music would have been as good. His music is not only new in form. It represents the collision of an amazing European talent with America. He gave up a lot when he came here," she told her father. "In Paris he knew everyone, Debussy, Ravel, Picasso.

He introduced Jean Cocteau to Picasso. He was on his way to success. Then World War I came, and he fought in the trenches, but got sick and was discharged. He came here in 1915. And it was here that he found a way to write music that was totally new. At first he made an impression on the musical world, then he was squeezed out by the career-makers, and nothing of his got played for almost twenty years. After World War II his *Hyperprism* was played, and people began to realize how good he was.

"Then in the late 1950s Le Corbusier insisted that he be commissioned to write his *Poème Electronique* for the Brussels Worlds Fair in 1959. Le Corbusier did the building. Remember, I made you and Mummy take me to it? Remember the four hundred loudspeakers? I was terribly excited. But he was almost eighty years old then, time had slipped away without the kind of attention he would have received in Paris, and soon afterwards he died."

"When I hear *Hyperprism*," I confessed, "I think of the Port of New York. It seems to me to record the approach of a very sensitive immigrant to this city on a boat. The sounds he hears are appalling and magnificent."

"I don't like that way of listening to music," Judith told me severely. "Music should be heard as music, not literature or imagery. I hate programme music."

"I feel the same way about painting," said Althea. "Don't read meanings into it! Just appreciate it for what it is."

"I've heard that kind of talk before," I told both of them, "and I know from history what it leads to. It leads to a take-over of all art by barbarians."

"I'm not interested in speculations of that kind," Judith said sharply. "We were talking about Varèse. He organized sound in a style that did without traditional forms—sonatas, fugues, canons, variations and all the rest. He puts one sound after another, not in the patterns we are used to but according to the effect he wants to create."

"And I think the effect he wants to create is mystery, wonder." She started to speak, but I went on. "That's my interpretation, of course, but I at least am trying to find a common language that we can all share. You two want to continue to

speak of the arts in private languages, and I say we've had too much of that. We've had as much as they had in Weimar, before the Nazis came. We'd better reform the house of art from within, by recognizing its need to be tested from *all* points of view, or we may lose the right to practise it. There are envious people all around us who want to do us in. We are highly privileged, and we must justify our privilege. We can easily desacralize art by making it too special, too precious.

"I'm not reading as much into Varèse as you think. I am merely seeing him as one more man, this time extraordinarily gifted, who had to experience the modern world with very imaginative ears. His purpose in *Poème Electronique* is indeed inscrutable, but it is not beyond analysis. Its juxtapositions are as abrupt and arbitrary as those of a newspaper. Toward the end of it there is a single moment of song, strange, impossible to place exactly. And after that song come hisses of steam and blasts from an organ of the kind used in movie houses. I think it all expresses the saddened wisdom of an aging man. 'This is what I have to live with,' he seems to me to be saying, 'song and banality. The world is more disgusting than ever, but if one can take it, it is beautiful too.' "

"I *hate* that way of listening to music," Judith repeated.

"And I think you musicians are killing the thing you love. You refuse to recognize it as just one more language among the many we speak. You're hugging and kissing it to death. Varèse was healthier. He drew directly upon life as it is, not the art that reshapes it to make it more acceptable. And you're right, he probably wouldn't have seen as much of it, he wouldn't have had to let so much of it reach him, if he had stayed in France. The French are protected by many traditions from a full experience of the hidden chaos of modern life. Here he had to live in the melting pot and get cooked with the rest of us. But he possessed a skill that could record what had happened to him.

"And he discovered what endures. He discovered the sacred. The world is as full of the sacred as it was in the days of the Scriptures or the Vedas, or in the days of Bach. Everywhere sacredness rustles. We only have to wait, we only have to listen. We only have to be worthy of it. In times it will burst into song.

Some day it will be heard even in the theatre, even in the most profane—"

My impromptu response to Judith's purism was interrupted by the Irish maid, who came in and told Althea that dinner was served. She also told Tommy that he was wanted on the telephone.

"Hold it!" Tommy commanded us as we rose to go to the dining room. "He said the word theatre. This is getting up my alley again."

After we had all sat down and put our napkins in our laps, he came into the dining room and took his place among us. "It was Leon," he said derisively, "babbling about Kronstadt sailors in Hamilton Hall. Just because he called me I'm going to stay here and eat with you. There's still plenty of time."

INTERLUDE: WHAT ENDURES IN MUSIC?

For several months I lived one floor above a composer while he was writing a piece for the piano. I heard almost every note of that piece while it was being composed, as well as a great deal of other piano music that he also played. Although I was writing a book, the music did not distract me, as conversation most certainly would have. On the contrary, I enjoyed it. My enjoyment was increased by the composer's frequent and articulate discussion of his music and that of others.

If I had been more sharply focussed on my own art, I would never have given so much time and thought to music. But I was not long out of college and thought that my education should be extended. I naively believed that I could absorb all kinds of experience (a short while before I had been a courthouse reporter, and a short while after I worked in a laboratory) and put them into my writing. It was the kind of romantic fantasy that has been known to fill our mental institutions. In my case it led to this book. A line was underscored in my copy of Blake: "If the fool would persist in his folly he would become wise."

It was the only justification I could find for behavior that my parents, friends and the girl I was supposed to marry all deplored. (She fled me to take a medical degree and marry a surgeon.)

The months of hearing so much piano music helped a musical education which also benefited, during those years, from hearing as many as five concerts a week. The composer, Aaron Copland, in addition to being one of the best musicians I have ever met, was also one of the best teachers. He prepared systematically for his own piece. He went over some very simple music of the fourteenth and fifteenth centuries, as arranged for piano, and then moved on to later works by such composers, I seem to remember, as Palestrina, Schütz, Vivaldi and Bach, also as arranged for piano. So far it was a review of challenging moments in European music that, I suppose, he thought might stimulate him. Then he moved on to the standard piano repertoire of the eighteenth, nineteenth and twentieth centuries.

I made a discovery. After a long stretch of Mozart I felt a distinct pleasure when he moved on to Beethoven. (It was really just about as chronological as that.) Beethoven seemed to me a natural growth after Mozart. And after a long stretch of nineteenth-century music by Liszt, Schumann and Brahms I felt a distinct pleasure when he moved on to Debussy, Ravel, Satie, Stravinsky, Gabriel Fauré, Milhaud, Prokofiev, Ives. The work of our own century also seemed a natural growth out of its predecessors. I understood, I had heard with my own ears, the inevitability of modern music.

There has been an organic progression in this art, and in the other arts as well. We all know this, and we all wonder what the organic, the enduring progression of our own period will prove to be. We listen to music, we look at paintings, we read novels, we study philosophy, and we ask of each work: does this also follow in the great tradition (which goes on even in periods like the present when most people stop reading and listening and looking) of the spirit's mastery of nature? Is this both meaningful for our own day and likely to be of use to men of the future? Out of how deep a life does it spring? Out of how broad a sympathy? Has the artist transcended his original limitations? Has he given us something that we *need?*

The answers depend not only upon the artist's talent but upon the myth that sustains him. How organic is his myth? How well has it enabled him to surpass himself? How truly *new* is it?

This last is the avantgarde question, which is so often confused

with mere novelty or up-to-dateness. For example, in music we hear: "It's electronic; you know, avantgarde." (Meanwhile most new electronic music is an over-loud bore.) What all this implies is: if the work is truly new, it must also be organic, able to surprise us but also to meet the most demanding tests—and inevitable product of both past and present.

The myths that sustain music, the deep faiths that make it possible for composers to give us music that meet our most demanding tests: are they different from the myths that sustain other artists whom we find of value? (Plainly I am not speaking here of the dubious myths that sustain collectors and audiences, as I did in the last interlude, *Myths that Sell Paintings,* but of the genuine myths that sustain genuine artists.) This question will come back at us for an answer after we have extended our survey to other arts, as well as to other things that bear directly on the arts.

Unfortunately for both the reader and myself, a broad overview of the present human condition is essential. Even for an understanding of a few notes on the piano.

SIX

THEATRE AND THE PROFANE

"Now then," said Tommy while we were eating some excellent turtle soup. Althea's house was as well run as her gallery. And I felt more at home in her dining room than in the formalities of what she called her drawing room. We were sitting on French Provincial chairs and eating off a table of the same style: more congenial to modern senses than the grandeur of the Bourbons. "Why do you think music is sacred and theatre profane?" He snorted indignantly. "Theatre! That includes movies. I don't want to do anything profane!"

"You sound like the Soviet commissar of music just after the Revolution," his sister remarked with a slight touch of malice, the first I had observed in her. "He asked Koussevitzky what he had in his orchestra. 'Well, I have thirty first violins, twenty-four second violins—' 'Stop right there, Citizen Koussevitzky,' said the commissar. 'After the Revolution we have no more *second* violins. From now on they are all *first* violins.'"

"Very funny," her brother commented without laughing. He prodded me again: "Why?"

I was hungry and would have liked to enjoy the meal for a while with nothing more demanding than small talk. In time I knew his ferocious curiosity, or desire for a brand-new way of life, would drag me into another tense dialogue, but for the moment I wished to slacken the pace amid animal contentments. I am a simple physical man. I enjoy food when it is cooked well, know something about buying and preparing it, have been asked to do a cookbook. Before my marriage my life was certainly not austere, as the presence of Althea's coccyx on her own upholstery reminded me. I have had the good fortune to marry a woman who is as fleshly as I am. After painting, her greatest love is dancing. In the morning I give a brief glance at

107

the front page of the *Times* and turn at once, not to books but to sports, where I enjoy once again the baseball, football and other activities that consumed almost all of my adolescence. My father was a famous English athlete. If I had been a bit taller and heavier, and he a bit more successful in his adopted country, I might never have fallen in love with words, sounds, images, ideas. Or so I like to tell myself.

"Later," I said. "Just now soup comes before the sacred."

Fortunately, I was spared a defense of that irreverence by the abrupt entry of a woman into the dining room. She forced her way in, right after the over-nice Irish lass, with a sureness of being welcomed that made Siegfried Muhlhauser seem modest and retiring. Her hair was fair, her face Athena-like and familiar, but at first I could not remember her name, though I knew I had seen her both on the stage and on the screen. She looked as if she were in her late twenties or early thirties, probably the latter, and did not need the full, almost bronze maquillage that she wore on a skin that was unwrinkled and smooth. Her large bony structure, her tallness, her opulent breasts and rounded thighs, in a deceptively simple white silk dress that must have been cut for her by a very good couturier, had been kept under strict control. She could not weigh more than a hundred and fifteen pounds, though nature had designed her to be a hundred and forty. Her hollow cheeks and slender legs made me think of a similar strength of will that had been shown by the once-plump Marlene Dietrich. The speech of the newcomer had nothing European about it, however; it suggested origins in the Deep South with an overlay of Broadway Oxford.

"Mrs. Black," she said to Althea, who looked as if she wished she had *men*servants who could remove this intruder by force, "please forgive me for dropping in on you all like this, but I just had to see your son." She turned to Tommy, who was already on his feet with a smile of well-planned triumph on his face. "Are you Thomas Black?"

"Yes," he said with instant energy and charm, "and you're Eunice Knox." He grabbed a chair from a corner of the room and put it next to his. "Sit down, Eunice Knox. We've just begun to eat. Why don't you eat with us? This is my father, this is—" He introduced all of us, taking care to mention that Althea was not his mother but his stepmother.

"Say," said Warts to Eunice Knox, "I've seen you. I've seen you on the stage. In that play by Ionesco. We wanted to publish it, but somebody else got there first."

"You've seen her in other things too, Dad. Sit down, Eunice Knox," he repeated, making her name sound like an incantation. "My God, you're beautiful. More beautiful here than you were on the screen. They didn't photograph you right. Let me take that thing you've got in your hand."

"No," she said, "that's your script, and I want to read it again. I *think* you may have something there," she became businesslike, "but it will need a lot of work. Mrs. Black, I did want to talk to your son while I'm in town, and I fly to the Coast early tomorrow. I hope you will forgive me for barging in on you like this." With everything said that politeness required, she sat down firmly in the chair that was offered her by Tommy, with his film treatment in her hand.

"So Chuck gave you the script," Tommy said. "I didn't think he really knew you."

Althea said nothing. The intrusion was now a fact, and could only be dealt with as circumstances suggested.

Eunice Knox studied Tommy. "You're pretty young to know so much about girls. And not queer, or at least you don't look like it. Of course the title would have to be changed. *She Couldn't Come*—that's not the way to bring people into the theatres. It's all about a frigid woman, Mrs. Black, one of those unfortunate creatures who have never experienced the full satisfaction of love but are constantly looking for it. The things she does! That scene with the tree! That scene with the dope pusher! Always hoping she will get it."

She rolled her lovely eyes, while Judith lowered hers. I could have answered Tommy's question about the sacredness of music and the profanations of the theatre by merely pointing at the two young women who sat in that room and embodied so vividly a major difference between their arts.

Althea, as the representative of an art that had long been considered sacred (and only recently been compromised by its popular profanations) spoke up for the dignity of the Muses. Since she could not throw out the intruder, who had quickly endeared herself to one member of the family, she might at least do all that was possible to put her in a bad light.

"*She Couldn't Come*—I don't see anything wrong with that. It's fresh, it's original, it's avantgarde. We're not living in the reign of Queen Victoria. Dear Tommy, I hope you are not going to let them turn your script into one more of those boring compromises that American films always turn out to be." Since he had moved his chair closer to hers, to make room for Eunice Knox, Althea was able to flick back one of his dark curls possessively with a gardenia hand.

Eunice Knox eyed her antagonist coolly. "I'm as avantgarde as the next person, Mrs. Black."

"In the world of art I am known as Althea Lovelace."

"Loveless! Hey! He wasn't writing about you, was he?"

"L-o-v-e-l-a-c-e." Althea fiercely spelt it out for her. "It is a name known in literature. Also, if I may say so, in art. No, he was *not* writing about me." Her red hair seemed to confirm her statement, and I of course could have gone on the stand for her.

"I took the story from a case history in our clinic," Tommy explained quickly, to calm the two women. "It's the actual story of a woman who came to me for help." He clarified that at once. "Professional help."

"So you're a professional at it, are you?" Eunice Knox went into a Mae West leer, and swished her backside ever so slightly on polished French wood. She turned to Althea. "I'm just as avantgarde as you or anybody, Miss Love*less*. I've done plays by Beckett, Brecht, Genet—you name it. That's the way I got where I am. And I had to live on avantgarde food when I was doin' them." She began to lapse into Southern, as a device for putting more homespun energy into her speech.

"But now that I'm a-doin' a little better, I gotta get a little more careful about the titles I appear in. *She Couldn't Come*— if I did a picture called that, they'd be a-laughin' about me on the late late show way into the twenty-first century. I'd be tagged as Ol' Miss Frigidaire herself. No, thank ye, ma'am! There's got to be some place in that there picture where that there girl comes. It ought to be near the end. And when that great big beautiful event occurs she understands at last how glorious the whole creation of the Lord really is. She gets religion, the *new*-time religion, the kind that all the kids are looking for.

"Listen, if that's what happened to Lady Chatterley, why can't it happen to this poor girl? You anti-democrat? It would make all them folks out there in the drive-ins feel close together. That's why they go to the movies now, so they can go home and turn the trick again. Or right there in the car if they can get away with it." She turned to Tommy. "You don't think you're better than D. J. Lawrence, do you?"

"Go on talking, go on talking," Tommy told her. He turned to his father with enthusiasm. "Did you ever hear anyone like her? This is the happiest day of my life. She's a force of nature." He told this last to Judith, who looked as if she were far away in a difficult passage by Webern.

"I'll do anything you say," Tommy told Eunice Knox. "Within reason, of course. You've got the feel of the character already. You're right inside her. If you think she should be rewarded in the end for all her effort, maybe you're right. It didn't happen like that in the clinic, but maybe it *would* make a better film. There's a time when people get tired of looking at pathology. They want that big mug up there on the screen to become healthy, even if they can't."

I had never heard a writer respond so readily to a fundamental change in his story. Nor had I heard such a neat justification of the happy ending. I looked more closely at Tommy. He seemed as transfigured as the Schoenberg night of which his sister had spoken. The Dionysian mood that so many youngsters have sought ever since Nietzsche first wrote about it almost a century ago—clear evidence of the effect of avantgarde ideas on impressionable minds, above all in traditionless America—had taken hold of him. Though he had drunk almost no alcohol, and had spoken scornfully of students who need drugs, he was as much under the spell of Dionysus as the bacchantes who become blindly heedless of consequences in the play by Euripides about them. He had been tracked down by a prominent actress because he had knocked out an idea for a film during a weekend and then shown it to a friend who boasted of his connections with Broadway. Aside from the fame and money she might help him to acquire, she had emotional power of an intensity he had never before experienced. And she was beautiful. And she was trying to take him away from his stepmother.

Althea did not like the change that had come over him. She

did not like the strange woman, of many dialects, who had forced an entry into her home and in a few minutes made a stronger impression on him than she had been able to make in years. "It seems to me," she told him slowly and pointedly, "you are willing to sacrifice your personal vision awfully fast. If a young painter took my ideas so fast, and was willing to repaint his pictures the way I told him to—a thing I would never dream of doing—I'd get very suspicious of him. I'd think he was a mere opportunist. I'd think he didn't have a vision of his own."

At another time her spleen might have infuriated him, but now he shook it off with the cool assurance of a mental scientist who knew that its emotional origins prevented it from possessing any truth. "The vision of a writer is different. Especially a writer of films. He must keep his ears open. He must learn from others. Above all, he must be able to learn from those who will interpret his work. They may see some things more clearly than he does. And when they are *inspired,* as Eunice Knox obviously is, he must be all humility, he must listen."

"Oh Miss Knox is inspired," Althea said, "but I think she's more inspired by box office than anything else."

Eunice Knox studied her. The redhead was a more sinewy antagonist than she had expected. "Now I remember who you are," she said, although I am sure she had known all along. "You're Althea Love*less,* and you run a gallery. You get a lot of publicity and you sell a lot of pictures." She pointed to a picture that hung in the dining room, a Pop portrait of a nude male who had the muscles of Lionel Strongfort. "Is that by one of your artists?"

"Yes."

"May I point out to you, Miss Loveless, that that's porno for queers? It's called art, but it's really turned out for a quick sale, like a lot of shows and movies I've seen. You've got your eye on the box office, and so have I. Only I admit it, and you don't. I have no illusions about the business I'm in, Miss Loveless. I'm not a phony, but you are."

"Miss Knox, I wish you wouldn't talk like that to my wife," said Warts, as if he felt that it was expected of him. Actually, I believe he was enjoying the verbal duel of two exceptional women, and wanted nothing less than to bring it to an end.

"I *am* sorry, Mr. Black." Enuice Knox said at once with another lick of Southern accent on her tongue, which seemed to appear when she was displaying her manners. "And I apologize, Mrs. Black—I mean, Miss Loveless. But you are a publisher, aren't you, Mr. Black?"

"I am." He looked slightly apprehensive, as if he had made a dangerous admission to opposing counsel in court. This woman might say anything. If I understand him correctly, his chief regret was that she had not come to visit him, in search of a mature wisdom, but was there to see his young and handsome son. He put a hand to his face, to cover his warts, and his bad eye, and so spoke less distinctly than usual.

"Well, I read a lot of books, Mr. Black. I buy everything that sounds any good at all in the reviews. The maid can't clean my bedroom properly, there are so many stacks of literature. I am on the lookout for genius, Mr. Black, twenty-four hours a day. You might say I don't sleep well because I am ever on the alert for the divine afflatus.

"And you know what I find, Mr. Black? Most of your books were meant to be shitpaper in an outhouse. They have been excreted by insects, bookworms, with no blood in them, no marrow in their bones, no experience in their lives, and no poetry in their souls. Oh they simulate blood, marrow, experience and poetry—in formulas. By this time I guess I know every formula in the storyteller's art. An actor catches on. Dumb as we are, we catch on. And my preacher pappy had a real ear for language. But your books, Mr. Black—no wonder they call 'em non-books. Something tells me, Mr. Black, that you give a thought now and then to the box office too. Why aren't you honest then? Why don't you admit it?"

"We publish *some* good books, don't we?"

"Yes, so you can hold up your head. I like to hold up my head too. That's why I do something avantgarde whenever I can. But I don't kid myself. I'm a whore most of the time, and I know it. You and your wife are whores, but you pretend to be respectable. That's why you'll go on bein' whores. Some day I won't have to be a whore. I'll have made it so big that I can do whatever I please. And then I won't do anything but *the* best!"

So many inflammatory statements had been made by her dur-

ing this reasoned arraignment, which she delivered with as much skill as I had seen her employ on the stage, that Tommy felt it best to do some pacification. And as before, when he wished to divert attention from controversy, he turned to me—before his stepmother could order the intruder out of the house. "You ought to talk to this man, Eunice Knox," he told her quickly. "He's been around the theatre. I've been digging his story out of an old friend of his. When he was my age he was associated with the Group Theater."

"The Group, eh?" she turned her attention to me for the first time, while I wondered what denunciation was going to be hurled at me by her eloquent father's ghost through a ventriloquist daughter.

"Yes," said Tommy. "He knew Harold Clurman, Lee Strasberg and all those guys. He also knew a lot of other people in the less revolutionary part of Broadway."

His damnable trick worked. He succeeded in diverting her attention away from his family, which would surely make him pay for her savage analysis of them for years to come, and toward me. After all, he might never see me again. And I, who had grown up in Kentucky amid high-powered· Southern women (though none like her) waited for her attack to begin.

"I know them all of course," she said. "What did you do with them?"

"I just looked on. It was part of my education." I was determined to give her no sticks to beat me with.

"You must have learned a lot. What did you learn? What was the chief lesson you learned about the theatre?" She asked it in the same tone of voice she had used to describe her sleepless quest of genius in books.

I knew I should not open the door of discussion a crack, but I respected her determination to succeed in the most inhospitable of arts, and found myself saying: "I can't speak about other theatres. But I have learned this about the American theatre. It is colonial and pathogenic."

"What the *hell* do you mean by that?"

I thought quickly. "All right," I said to myself, "I'll tell her what I think, as fast as possible, and then I'll get out. We're already on dessert, they've brought her some black coffee, I'll leave as soon as I speak. I'll enrage her, and then I'll run. She's

been riding roughshod over them, but she's not going to do it to me. If I don't speak, she'll blast me worse than if I do."

Aloud I said to her, "You are passionately devoted to the theatre. Some of my friends have been passionately devoted to the theatre. I admire you for it. I admire them. And I agree, the other arts are also guided by box office, more and more. But theatre is a more social art than the others, except architecture. Literature, painting, sculpture, music are not *entirely* dependent on box office. There the loners still have a chance. Theatre depends instantly upon its audience, and its audience is not living a life that will make it love real theatre or pay for real theatre. On the contrary, it lives a life that makes it sick. It lives in a pathogenic culture."

"Pathogenic. The rest is old stuff, but what does that mean?" She had been able to follow my argument, which was not new, until that word.

"Something that makes you sick. Our people have been dehumanized by their success, their prosperity, their superior technology. That's becoming old stuff too—to everyone except them. The non-books you talked about are only one sign of it. Almost no American is doing work he really believes in. His ancestors never asked themselves such questions, but he does. Honest craftsmanship is discouraged. He is excellent as a part of a marvellously effective new instrument that works with great efficiency, but he is almost nothing in himself. He lacks a faith that sustains him. He has been spared loneliness, to a degree that was impossible to his ancestors. He is pelted with information and entertainment. And so he never really has to face the big questions that are gnawing at him all the time: is his life worthless? does it have any meaning at all? He never faces the tragedy of his existence, which is the first prerequisite of a good theatre-goer. He can forget about his real concerns by buying new things, seeing new places, and telling himself that everyone is making progress. If anything is wrong, and a few things obviously are, his children are getting an education, better than his, supposedly, and in time they will change the world."

"You mean our theatre is sick because our people are like Crackers, Crackers who have dough?"

"You could put it that way."

"But people are wonderful!"

"Potentially, yes. But they seldom realize their potentialities. And that's what artists help them to do. Good theatre makes them at least remember their potentialities. Shakespeare reminds them that they can be noble and poetic, Molière reminds them of their wit, their intelligence, Sophocles their profundity. That's why good people like you want a good theatre to exist. It would remind people of their best capacities, which their day-to-day work makes them forget."

"Why don't we have a real theatre then, right now?"

"Because the good people are being outvoted right now by other people who resent theatre and all the things it might remind them of. You're not as lucky as Miss Black is." Judith gave no sign of recognition when I mentioned her.

"You're in theatre, she's in music. She's protected against the people who secretly hate the arts. Music is still considered sacred, so it is subsidized. It can't make money, it needs help. But theatre *can* make money. It is a profane art that has to support itself. So all Americans in the theatre, sooner or later, have to conduct a business.

"Theatre people in England, France and a lot of other countries are given a little help by the state to let them take their minds off business now and then. Not so much money is needed to put on a show, and a flop doesn't ruin your reputation. A director can have three flops in a row, and still be respected."

"No one would give him a script over here."

"Exactly. He doesn't have to retreat into criticism or teaching. He can go right on with his real work. It's not *all or nothing* over there. There is a respect for human beings and talent. Beckett could develop his talent in an out-of-the-way theatre in Paris with almost no audience at all. Ionesco too. English, French, Russian, German, Italian actors get a chance to acquire a solid technique that almost no American actors get over here any more."

"Why is that?"

"I don't know enough about it," I admitted. "Maybe the older countries are just lazier than we are. They were born into a humanist tradition, and they prefer to go on with it, rather than question it, even when it is plainly decrepit or cor-

rupt. It's their laziness that enables our businessmen to go on taking markets away from them, even when our cost of living is much higher. It's their laziness that created The American Challenge. They're not quite ready to treat human beings as mere instruments of production, though some of them would obviously like to."

"What's all that got to do with the theatre?"

"In the theatre it means that there are still Europeans who think that actors should be taken seriously as craftsmen, performers of the classics, continuators of culture, aids to tourism and so forth. The Third Programme of the BBC, which offers only the best, reaches only one percent of the BBC audience, but it is part of the BBC charter that lack of popularity must never be permitted to put an end to quality. There is no such legal protection of quality in the much richer U.S.A. Lincoln Center shows are supposed to do as well as Broadway."

"You know, I feel that every time I see a BBC show. Why? Why? This is important."

"I think the reason goes back to our colonial origins."

"It isn't our fear of socialism?" asked Tommy.

"That's part of it, but I think it began with a deep popular mistrust of anything that seems like play. This country was first put together in the seventeenth century, in the face of fierce opposition that required a stern suppression of personal enjoyment in the interests of the community. The only good Indian was dead, the only good tree was down. This mistrust of play persists among us today, especially in those who have done well and run the show (though they prefer to be photographed playing golf or patting a dog). At last they are being opposed by a younger generation that believes in fun, not repression. And the younger generation got its ideas from artists who first spoke up for play. All our good artists have been anti-Puritan. Walt Whitman and Henry James disagreed about everything else, but not that."

"If it hadn't been for the hardshell bluenoses in my pappy's congregation, I wouldn't have run away with that road company of *Tobacco Road*," Eunice Knox remarked.

"The vengeful ants are still having their day, in spite of the student protests," I began, but Tommy interrupted me.

"They won't have it forever," he said grimly.

"They're still telling the grasshoppers to dance, at least while they are in college. Because they know that when the grasshoppers get out of college, they will have to work just as hard as the ants, if they want to get any of the new plunder. The ants count on the discipline of money. If you want the things it can buy, you have to play ball—ant ball, not grasshopper ball. And ant ball has got to be disgusting. The theatre they look at now and then has got to tell them, with a total absence of brilliance or style, that everything is going along just fine. Or if a play is not quite as simple as that, and manages to bring off a serious minority point of view—a homosexual reminding the heterosexuals of their brutal smugness, a Jew reminding the Christians of theirs, a black reminding the whites of theirs—it is all regarded as a useful sermon that is something like rhubarb and soda in the springtime. The expense account ants applaud it, and crawl back to the office the next day as if nothing had happened."

"And we bow and feel so happy while they are applauding us," Eunice Knox observed. "It doesn't mean anything at all to them?"

"Who can say?" I asked. "I'm not trying to suggest that everything you do is useless. A good action remains important, even if nobody pays any attention to it."

"But if you don't get good publicity for it in the theatre, and good publicity all the time, you're finished."

"That's why I said you were not as fortunate as Miss Black." Judith still gave no sign of recognition.

"Tell me this," said Eunice Knox, "why did you say our theatre is colonial? I never heard that one before."

"Nobody thinks of us as a colony any longer. We got rid of the British a long time ago, and we've built a new melting-pot culture that is more vigorous than that of Canada for example. Our way of life and our arts have had a tremendous effect on the rest of the world, in some cases as great as the rest of the world has had on us. Our plays get performed everywhere. Our movies once dominated the world. But today our movies are slipping badly, they're not free or talented enough to say what they should say—they have been overwhelmed by mass media clichés. People laugh at them abroad. And in the

theatre we still get more ideas from Stanislavski, Vakhtangov, Artaud, Beckett, Brecht, Genet than from any comparable Americans, if there are any. We have lots of theatre talent, but because we lack a powerful intelligentsia to support it, it gets thrown to the ants or to protests against the ants. In terms of world culture it remains colonial. Its originality comes from its subject matter, not its command of its subject matter. Or to put it in plain English, our theatre people are scared. They want applause and prestige so much that they lack guts. I have found little or none of the quiet heroism in them that I have found in poets, novelists, painters, sculptors, composers. They usually stop being fearless grasshoppers. As soon as winter comes, they try to act as much like ants as the people who pay them. Mind you," I added as tactfully as possible, "there are exceptions, and you must be one of them."

"Thanks," she said grimly. "I'm glad I'm not one of the Crackers who went to Harvard."

"I don't think the actors who become ants should be judged harshly. We treat them the way we treated unmarried mothers in Victorian days."

"Oh," said Warts instantly, with the interest of one who paid real estate taxes for the support of a million fellow-New Yorkers on relief. "The unmarried mothers are now supported by the City. And they lose the money if they get married."

"But we don't get any support," said Eunice Knox with some bitterness. "Why don't they treat us with dignity?"

"You know the answer better than I do. You're alive, the ants are dead. They want you to be as dead as they are."

"So they use the press to kid us along? All that space we get in the papers, the magazines, all that time on the air?"

"You help them sell things, don't you? You're glamourous, you're exciting, you took a chance. So you increase profits."

"If I really believed a word you were sayin'," she remarked suddenly, "I'd smack you one. Or report you to the FBI. But let's jus' play along with the idea that you're right, which you aren't. I know what you mean. I look at BBC productions on TV. When I was in Italy I saw a lot of Italian pictures. You know, it's important there, even the smallest bit part. It's *dignified*. I'd rather act for Fellini than anybody else! Only I

didn't have the luck to be born a wop. All right then, I understand your diagnosis, doctor. Get out your little pad. What's your prescription? What's your cure?"

Small lines and tiny blemishes were beginning to show under her metallic maquillage. Her black coffee had been followed by an offer of brandy from Warts, and she took a balloon glass of it in both hands, which I noticed wore no rings. There was no ornament on her white dress, or around her neck.

"There's no cure," I said. "We're not going to get a real theatre. Unless someone with a lot more ability and tenacity than has appeared to date comes on and shows us how."

"We're not going to get a real theatre?" She looked startled.

"No. There is a time for everything. This is a time for mechanical improvement and the temporary extinction of human fulfilment. It is not a time for real theatre, theatre that displays more than interesting personalities, theatre that presents sacred dramas, mysterious, passionate, insoluble conflicts."

"Why not?" she asked challengingly. She no longer looked startled. She had regained her poise and confidence.

"It's hard enough now to bring off individual works of art. In the arts that involve words, poetry comes off best, at least in form, because it states one man's view authentically, in the best possible language, on a matter of great concern to him. He has given up hope of a sizeable audience, so the audience that he does get must come to him, look up his words in the dictionaries, ponder his symbolic references, and so forth. Theatre comes off worst in the verbal arts, because it must go out to its audience and make all its points *instantly* clear to them. Therefore just now, until its savior comes along, it cannot find a fresh new language for the profound communal mysteries it was meant to celebrate."

"I hate pessimism of that kind. It's destructive!" She glared at me. And asked for more brandy.

"I'm not pessimistic. In time I'm sure we'll have real theatre, the most profound, the most exciting theatre in the modern world. Right here in New York. It will go beyond the truncations of Beckett, Ionesco, Benêt, Brecht and the other Europeans we respect so much. It will embrace a much larger world. Because we are exposed more than anyone else to modern re-

alities. And we feel compelled to put them into form. But now we're just pregnant, we haven't produced the baby."

"And I'm supposed to sit around and wait?"

"Why wait? There is valuable work for you to do, to prepare the way for those who come after, with better theatre luck than yours. That's what you're doing now."

She looked at me as if she wished I would disappear into the air. "I'm not that patient. Or that gloomy. There must be something wrong with you! All you've said are *your* opinions. Who are *you* to speak?"

"I have expressed only one opinion, an optimistic one about the future. I've merely repeated some well-known facts, and you don't like them. You come up against them every day, but when they're put into words you get depressed. You want *your* will to be done, not that of reality." This last line I put in because she had referred to a preacher father.

Tommy shouted at me. Rage made his voice break. "What sort of a psychologist are you? How do you expect a talented actress like Eunice Knox to go on acting when you talk like that? She's in a state of *despair*. Despair that you created in her!"

I apologized to her. "I'm sorry. I have no right to speak. The theatre is a fabulous invalid, a phoenix that will rise any day, tomorrow, from its ashes."

She apologized to me. "I shouldn't have said that. But I haven't felt so low since Lee Strasberg told me I played a scene all wrong in the Actors Studio. I cried. Then I walked out of the building and made a bigger name for myself than any of those sheep. But I can't walk out on this. We *are* up against something impersonal, historical. 'To everything there is a season, and a time to every purpose under the sun.' "

She recited the line from Ecclesiastes with a feeling, a sense of its meaning, such as it rarely gets in church. "Hell! Why don't I get a chance to do the scripts that Vanessa Redgrave does? I wanted to do *The Seagull* years ago. And now she's doing the life of Isadora Duncan. When I said let's do that, five years ago, they laughed at me. 'In the movies? They wouldn't even book it in the Village!' She's good, but I'm better. Unfortunately, I happen to be American."

She drained off her last sip of brandy and stood up. "I've got to get hold of myself. I didn't need those four hundred and eighty-eight calories. Tomorrow I'm up, up and away. I'll take your script along," she told Tommy, "and let you know what I think of it. Good night, Mrs. Black. Thank you for your hospitality, and forgive me for talking like I did. You have a lovely house, and I admire your pictures very much. *Especially* that one." She did her best to mend the damage she had done when she called the male nude porno. "Hey! I wonder what kind of breakfast food *he* eats! Good night, Mr. Black, Miss Black. You've all been very tolerant of this poor wayfarin' stranger."

At last her departing hand reached mine, which she shook with these words: "I'm going to forget everything you said."

"I'll show you to the door," said Tommy and left with her, which I and, I believe, the others had expected him to do.

Before she was altogether out of the room, in a voice that she must have heard, Althea said: "Well! What did we do to deserve *that!*" She then turned to her husband. "I don't think Tommy will be going to Columbia tonight."

"He'd be a fool if he did," said his father, "with the job of selling that lies ahead of him." He sighed as if he had just been obliged to confront the thirty years of flabbiness that wishing would not remove from his aging body.

Judith held out a hand to me. "Good night, I must go upstairs and prepare tomorrow's work. Music *is* sacred, and it must stay sacred."

She kissed her father on his warty cheek. The cheek was unhealthily pale. His eyes were closed with fatigue, and he looked as if he needed all the love he could get.

INTERLUDE: THE AUDIENCE CREATES THE THEATRE

We begin to understand theatre, I think, when we get rid of footlight delusions and realize that the audience really creates it. Playwright, director, actors, producer and all the others either serve the audience directly by giving it entertainment it will pay for (commercial theatre) or they serve it indirectly, and more honorably, by giving it another kind of performance that it— the audience, the group that gave them birth, sustenance, educa- tion—calls forth from them (real theatre). This other kind of performance is both entertaining, and in the unchurchly sense of the word, religious. Some of us have been permitted to catch moments of it, and we have never forgotten them. (I must thank Harold Clurman for guiding me to some of these moments. I have been fortunate in my mentors.)

If we disregard the publicity stunts of literary historians, who nearly always identify with the great writers of the past, with whom they frequently confuse themselves, we see that the great playwrights of the past were first of all great public servants who had the perceptiveness to sense what their people silently needed and the patient cunning to give it to them with an awesome overplus of wit, pageant, dance, wisdom, music, astonishment, recognition and revel. Theatre is a public art—quite different from those we have been discussing heretofore—which can (or could) be expected to rise to the occasion of the spiritual demands put upon it by people out front who want *their* drama acted out (as much as any patient of our own day ever wanted his dilemma reconstructed and resolved for him by an analyst).

In certain periods of the past the inner drama of the audience summoned up and directed the many individual talents that were needed to satisfy a social will. The audience's desire for fulfilment communicated itself to artists who, after we have made allow- ances for their idiosyncrasies—as unimportant in the long run as Shakespeare's supposed preoccupation with a dark woman or blond boy or whoever it was—are now seen correctly as mere

midwives to the uncreated conscience of their time and place.

The value of seeing theatre as ultimately the product and measure of its audience (an idea which should not be pushed too far in theory, though it can be useful in practice) is that it helps us to understand why we are concerned about our own theatre. And what we might do about it. When we look closely at *our* people we discover that they do not possess a deep unconscious will that *desires* enactment. Their unconscious will is *not* one that they wish to see put into words and acted out. They feel a graveyard chill when they catch sight of their real fears and their real desires, as they do now and then in unguarded moments; and they will not look or listen if their true state of mind is so much as hinted at. We lack a prime ingredient of theatre: an audience that wants a mirror held up to its nature. (Was there ever such an audience? Shakespeare plainly believed so.)

And when that ingredient is lacking, our best theatre talent is sure to be wasted—or merely bought. It cannot serve humanity as it was meant to. So it feels guilty and tries to make amends by serving humanitarian causes, which is not at all the same as serving the deepest needs of its audience and its talent.

What kind of audience do we have? Our audience is economically fortunate, or at first glance it seems so. It has been permitted by unprecedented prosperity to take its eyes off its day-to-day chores of subsistence and to acquaint itself with the greatest achievements of the theatres of the past. (There was never before such an intensive study of them in the universities, it is only rivalled by the study of art by new collectors.) Our audience has been permitted to dream of emulating or surpassing the theatres of the past, only to discover that the prosperity which makes these dreams possible is of an anxious and demanding kind which also makes their realization impossible. The new money must be watched all the time or someone else grabs it. The lucky heir who turns everything over to attorneys and banks soon finds himself unlucky indeed. The slightest tendency towards *dolce far niente* or loafing and inviting one's soul, however canonical in letters, is rudely and swiftly punished Any theatre-lover who imitated the leisureliness of the Moscow Art Theatre, which travelled a year in Italy, to soak in the atmosphere, before it even settled down for its first reading of a play by Goldoni, might soon find it difficult to raise the price of a seat in the gallery.

Our audience does not bring its soul to the theatre. It brings its transactions (most of the best seats are sold to businessmen who are entertaining for reasons of commerce and are indispensable to the success or failure of a play) its fatigue (alleviated by alcohol) and its fear of missing out (the producer Roger Stevens once reported that a study of theatre audiences had shown that most of his customers went to see a play not because they expected to enjoy it but because they wanted to be able to go home and say they had seen such and such *hit*).

Such an audience does not encourage the best possible scripts or the best possible performances. It has no desire to act as a collaborator in the production of plays that deal with its own hidden dramas. If there is anything it has no wish to see, it is its own hidden dramas. It thus refuses to play its part in the creation of a theatre. And conscience money is mailed off to some worthy cause. Right now blacks are getting a bit of it. Let the blacks be helped to get the education and prosperity that can be depended on to raise their hopes and break their hearts. The real ruler is money.

But, someone will say, were not all audiences preoccupied with money? Even in the Golden Age? Has not every man in every age had "business and desire"? Of course.

But there have been periods when the clock did not exist or made a dimmer impression, when there were more hours for contemplation, when there was time for men to consider, over and beyond money, their search for meaning. And some of this search desired enactment on the stage. There have been *few* great periods of theatre, as theatre historians have made clear, and these came only after many centuries of provincial ignorance or churchly suppression; but a glance at the great periods will show a substantial difference between their audiences and ours.

Three of the best theatres in the West, by common consent, have been those of Athens in the fifth century B.C., of London in the sixteenth and seventeenth centuries of our own era, of Paris of the seventeenth century. Each was followed by a splendid theatrical tradition that lasted for a long time, and in some ways may be said to exist even now; but in each case the moment of generation, when the plays were written that created the traditions, was brief.

The brevity of these great periods, which means the brevity of the periods *when audiences were able and willing to help bring great theatre into being,* is suggested first by the dates 499-405

B.C., which represent the year when Aeschylus entered his first dramatic competition and the year when Sophocles, outlasting Euripides by a few months, came to an end that was also the end of the tragic theatre of his city. Why it was the end is suggested by the fact that Plato, born in 428 B.C., sought first to be a dramatist in the same tradition but discovered that the Athenian audience had turned inhospitable to the tragic form that had once pleased it. (Euripides had had to struggle with a similar inhospitality when he changed the tragic form to suit his own views, which were new, more humane, more liberal. He won few prizes, was regarded with suspicion, and died in exile.) Plato found no encouragement from an audience that now, he complained in the *Gorgias* and the *Laws,* wanted only to be pleased. In his disillusionment with an audience that feared truth he invented a quasi-dramatic form, the philosophic dialogue, which approached theatre as an entertainment but did not depend upon public approval. No great tragedians ever appeared again in Athens. The audience could not take them.

Why did theatre flourish for a while in Athens? Why did it flourish for a while in the London of Marlowe and Shakespeare, in the Paris of Molière and Racine? To attribute it entirely to the playwrights, as we usually do, is a lazy kind of hero-worship. In each city a collaborating audience (never a large one, it is true, never the whole populace, but sufficiently sizeable and representative to bring forth the historic efforts of these and other playwrights) was made willing to face the darkest truth of existence by the skill of the poets and its own brief readiness for the tragic experience. Each of these extraordinary audiences appeared at a time when the city it lived in had reached a temporary and precarious summit of political leadership and aesthetic awareness. Each played the role of *femme inspiratrice* in an intercourse that had more sexual ambiguity and mediumship than conventional minds like to admit. Each responded to a demand for true *noblesse oblige.*

All thoughtful men of the theatre, in my experience, recognize the value of a good collaborating audience, but they hardly expect to find one. (How an actor responds when the house is even moderately alert!) They are happy when they find one that is reasonably discriminating. They know only too well the new economic strains that an audience, however well-educated and well-intentioned, brings with it to the theatre. They suffer from them themselves. And they realize that the best new playwrights

do not respond to some deep collective need of the audience but can only be expected to dramatize a truncated personal view that may succeed if it appeals to enough persons who share the same truncations. Fortunately, in a large rich population, and in an art with the elemental appeal of theatre (how profoundly we want to come together!) a fractional minority can make a solid hit.

What can be done in such a situation? That is the question all of us are asking. There are many answers.

The commercial answer is to continue to treat theatre as a business which must pay its own way. The result of this policy has been a decline in the theatre that dismays even the businessmen. Not to mention the talent that it corrupts or destroys. With an indifference that amounts to a hatred of life, or a cold refusal to recognize the consequences of our actions, we write off some of our most gifted human beings. Actors are not much better treated than boxers. Our usual excuse is that if they are so gifted they can find a living in television or teaching, which is a further indication of how far our audience has moved from mental health.

The political answer is to reinstate the Federal Theatre, which cost little and in spite of its mistakes awakened millions of people to what a theatre could mean to them. I wish there were some chance of this, but I fear that the popularity of television and the hatred of life which is one of the strangest but most certain side-effects of prosperity will veto it. It is something, however, that all people who want a full life, for themselves and others, will fight for. Where there are approximations of it, as in Lincoln Center, they also should be fought for. Sooner or later, most likely after sharp economic disasters, a subsidized national theatre will come, and of course it will have many faults; the wrong people will be in it, and the right people will be out of it; but it will still be an important step, along with the national awakening that will lead to it, toward resacralizing our talent and our audience. Catastrophe is our hope.

There are two avantgarde answers. One of them, embodied most eloquently among living playwrights by Samuel Beckett and Eugene Ionesco, has been content with distinctly personal visions that had to find and create an audience pretty much as poets do. They expected and got no help from a collaborating audience of any size, but managed to find a tiny one that saw them through some very lean years in Paris (which had a real avantgarde tradition in Jarry and Artaud), years that surely would have meant their end if they had lived in the wealth and urgency of New

York. There have been several attempts to create an avantgarde theatre in New York. None has been really new, if we apply the standards we use in other arts, but their efforts have deserved encouragement. In time some playwrights will create a genuine avantgarde theatre in New York, if only because there is so much against them.

The second avantgarde answer would forget about playwrights and improvise a new theatre according to the inspiration of the performers and their leaders. So far such efforts have been commendable but after a while boring to all but an "in" group. The audience that encouraged such theatre was happy to be at ease among similarly "alienated" people of its own kind, but they were too indulgent toward the performers and themselves. Even in a social art there is no substitute for a personal experience of loneliness, sorrow, age, death, injustice—or love and happiness. We are still dependent on playwrights to give us this core of personal experience, as well as the action and words that make the most of it, for a living theatre. There is still a division of labor and an inequity of talent.

Therefore we still hope that the experience of one man, or one woman, helped by all the beauty of a great art, can awaken a response in an audience. But our audience is not in a position to respond just now. There is no play in it, and so there is no play for us.

This is one of the chief complaints of our rebellious youth, that their parents and teachers are not free, not able to realize how short their lives are and what might be done to fill them with meaning and beauty. The creation of a national theatre is one of the first items on the agenda of our brightest youth, and we shall return to it in the last Commentary, when we come to the problems that face them.

Meanwhile our young people might remember that the best collaborating audience of contemporary times appeared in Italy after World War II. A people that had been overrun for centuries by its conquerors, silenced for decades by its government, defeated bloodily by both its allies and its enemies: this people was at last free to speak. At the same time it was given a new kind of theatre, the film.

What kind of films did the beaten, impoverished Italians make? Cautious moneymakers like those of the victorious Americans, which they knew by heart? Yes, most of their films were just as bad as anything from Hollywood. But they also made a few

others—and now we only remember the others—that put the Americans and almost all the other film-makers to shame.

And where did these honest, courageous and *new* films come from? From the brilliant directors, writers, actors, designers, cameramen, producers whose names appeared on *La Dolce Vita, Mafioso, Two Women, Divorce Italian Style* and others that should be mentioned here? From them alone?

They also came from the audience that demanded them.

Obviously, the only hope for the American theatre is a great humiliation for the American people. Or is this kind of logic as absurd as it seems? A peaceful alternative would be an audience able to un-Midas itself.

SEVEN

ARCHITECTURE AND ARCHETYPES

I was saying good night to Althea and Warts, and they were accepting my thanks with some relief. The strain of the last few hours had plainly exhausted them. She was saying with a barely concealed yawn: "We must get together soon. I'm dying to see your wife again. She's a very good painter." He was saying with all the earnestness left at his command, while his errant eye wandered: "You'll get a contract from me before the end of the week." And I was observing the greyness of his skin and wondering if it meant a serious malady.

Then we heard voices and realized—Warts with a visible shudder—that the same persons who had barely left the room were returning and bringing others with them, certainly two and perhaps three. Tommy and Eunice Knox reappeared. Eunice had her arm in that of Michelangelo Jones, and was laughing hard at something he had said. Tommy was frowning. Behind them came Deborah with a special smile for Althea: she had found Angie by going to his favorite bar and delivered him to her boss. After her, gallantly making room for her, walked a tall, slender man with elegantly cut grey hair and a forensic smile who wore a dark grey suit that made all the other men in the room look shabby. (Angie looked shabbiest in frayed and glossy black.) His voice suggested to me, accurately as it turned out, that he was used to addressing boards of corporations and trustees of institutions. Raindrops had fallen on his shoulders, on Angie's steel-rimmed glasses (which made him resemble what he was least like, a German professor) and on the short yellow skirt of Deborah. An April shower must have begun. Later I learned that they had been wetted not by rain but by water from some balcony.

Angie was the center of attention. His health, his vigor aston-

131

ished me. Some three months or so earlier I had eaten New Year's Day dinner with him and his family in their house on Long Island, and he had been so feeble that he had had to leave the table and lie down. And after he lay down he had not been able to talk for long. We drove away early, so that he might sleep and gather the strength that we feared would never return to him. There were whispers that his disease was incurable. Now after a vacation from teaching and an almost miraculously revivifying visit to Greece (the only thing about him that interested Judith, who disappeared soon), he looked almost as well as he did eighteen years earlier, when I first met him.

Quickly he told me that he was no longer taking any medicines. His voice was as high-pitched as Althea had described it, his beard as grey, and he had lost none of the weight he had put on during the last anxious decade, but he was now able to talk at length, could make his words effective, and his belly gave them weight. At times his voice dropped from head-tones to chest-tones. Above all, he seemed animated by a strong new will to live, to enjoy the fruits of his recent victories, to accomplish more. Mischievous, confident eyes smiled through his heavy lenses. This had not been true in January.

Next to him, the person who interested me most was, of course, the newcomer, the elegant, silvery newcomer whose name I had heard many times, Leonidas Shaft. His face had appeared on the cover of *Time* long before Angie had achieved that distinction. He symbolized, in the pantheon of publicity, the enlightened wealth of still youthful executives—he was born three years later than Angie—who had inherited great businesses, extended their power and at the same time extended their public usefulness, through foundations, as aids to education, art and science.

Though not as famous or as rich as the Rockefellers, the Fords, the Guggenheims, the Mellons, he had ably continued the work they had begun, the work of making private capital more effective than socialist bureaucracy as a stimulant of mass instruction, laboratory research and new art. He was especially interested in art, and had acquired for his home in Ohio, as well as for a museum and a university in his city, some of the best

works of modern painting and sculpture outside of New York. This fascinated me, since I had grown up on the southern banks of the Ohio River, not far from his city, at a time when there could hardly have been less interest in modern art. The symphony orchestra refused to play Berlioz or César Franck, not to mention composers of our own century. So great had been the influence of Leonidas Shaft and others, after I moved away, that Miro and Tobey had replaced Bouguereau and Remington in the museum, and now there was a movement, led by Leonidas Shaft, to cellar the "classical" sculpture of Lorado Taft and replace it with the "minimal" sculpture of Michelangelo Jones. I was therefore predisposed to like Leonidas Shaft.

To my surprise Angie was quarrelling with his patron when they came in. That day he had received from Shaft a check for $175,000 as the first payment on two large steel constructions that were to be made from Angie's models—neither of which was much bigger than a matchbox—and he was to receive a like amount when the constructions were delivered in Ohio. The costs of construction and shipment were to be borne by Shaft. It was by far the highest pay Angie had ever received for any of his work. During the previous year, soon after his national publicity began, he had been paid $25,000 for a work he had to have made into steel from plywood models and also to deliver. His profit was almost nothing. He may have lost money on the transaction. But now that his publicity had had time to sink in, Leonidas Shaft had sought him out and given him more generous payment than he had dreamed of asking. (His dealer arranged it.) And yet he was obviously punishing Shaft with almost every word he addressed to him.

I had had a chance to observe before that Angie was quixotic about money. Three times when he designed houses for friends of mine—one of which he helped with his own hands to build, as I saw for myself one day—he had refused any fee. The houses were soon exhibited in smart magazines as beautifully fresh in conception and detail. Once a fee was forced on him. It was winter and he had holes in his shoes. His father had been rich during his childhood. His brothers and sisters still had some money, but they gave none of it to him. As a child he had been tubercular for a while, and was kept separate from

the other children in a little house on the family property on Long Island, where he still lived without being able to repair it or to rebuild it as he desired. In his solitude he must have developed untypical ideas of *noblesse oblige*, ideas of a natural princeliness that were later magnified by his zealous study of Stephen Dedalus and Michael Robartes. He was a lace-curtain Irish aristocrat who now had to work hard as a teacher, diplomaless but respected, rundown but beloved, to bring up a family of five children. And now at last he had received a piece of paper that made him poor no longer. And he was abusing the person who gave it to him.

"My work in a room full of Dalis!" he squeaked, and I knew from the high notes in his voice that he was upset and not at his best. "I can't imagine anything worse!"

"They'll balance each other," Shaft said. "Your things are so austere. Dali is so flamboyant."

"Ugh! You don't know *anything*. I never heard of an idea so preposterous."

Althea and Deborah began at once to distract Angie's attention. He must not be permitted to insult the goose who had laid such a very golden egg. (Word of the check spread awfully fast.)

Althea was delighted that the clever Deborah had brought in the artist she most wanted to see, and quickly regained the energy that a few minutes earlier, while she yawned in my face, had seemed wholly drained.

"Let's go to my studio!" Althea proposed. She had no wish to hear any more of Angie's acidulous comments on her Louis XV drawing room, and she knew that her studio was spacious enough to accommodate all of us. And neat because she had no time to paint in it.

Deborah co-operated with her instantly by herding us toward the single flight of stairs that led to the studio. And the studio proved to be sufficiently unusual to divert Angie's attention from his quarrel with Leonidas Shaft. I saw this at once when I re-entered the studio after excusing myself briefly to telephone my wife. I thought she might like to join us, and Althea welcomed the idea, since she was a good friend of Angie's. But no one answered our telephone.

The studio had been constructed as a large greenhouse; the building code of New York City required that if it was to be added to the building. The greenhouse grew only a few flowers, however, and was devoted chiefly to the display of painting and sculpture that Althea genuinely admired, rather than those she praised and sold in her gallery. It was her retreat from the stresses that had obliged her to become a wife and a dealer.

One of her own paintings hung there, along with better known ones by Kandinsky, Matisse, Miro, Picasso, Klee, Braque, Dove, Demuth, Marin and living Americans whose names, since I know most of the artists and do not wish to offend others who were left out, I would rather not mention. For much the same reason I have given an absurd name to Michelangelo Jones, and altered some details of his life and work. There is indeed no resemblance to any person, living or dead, in this deliberately distorted report on real people in real situations. It is all a fiction, utterly unlibelous and without invasion of privacy, that is drawn as closely from life as the laws of the land and of decency will permit.

Angie fell in love with the ingenious greenhouse-studio, which had not been spoiled by Montmorency pretensions, and forgot his quarrel with Leonidas Shaft. He became his best self again, eager to encourage everyone, to share beauty with them, to point out details that might have escaped other eyes, to enjoy his windfall without the complications of a lace-curtain prince. "I've never seen these painters look better! You know as much as Jim Sweeney about placing them. The whole thing is wonderful!" he told Althea, and she glowed at the praise of one who was ordinarily hard to please.

"Look at that Kandinsky!" he told Leonidas Shaft. He put his arm around him warmly as he guided him about the exhibition. "She's lit it perfectly. She has a real eye. There's the old so-and-so at his best. He lost something after that. And that Brancusi—the perfect place for it!"

On his other arm hung Eunice Knox, who had been attracted to him, as she told everyone, the instant she laid eyes on him. "He has the look of genius," she told us. "I can spot it anywhere. And they tell me he knows so much about architec-

ture. I want him to explain it to me. I'm going to build my own theatre some day, and it has to be just as beautiful—no, better —than that one in Houston."

Althea for once was in accord with her, and welcomed her emphasis on Angie's first art, rather than his second. Anything was better than a possible return to Salvador Dali and a renewed quarrel with Leonidas Shaft. So she backed up Eunice Knox when she persisted in drawing him away from painting and toward architecture.

"Come on over here and sit down," Eunice Knox said to him. "Tell me all about blueprints."

"You worked with Frank Lloyd Wright, didn't you?" Althea asked him.

"Yes, I worked with Mr. Wright," Angie began, "and—"

"Who was he?" Eunice Knox interrupted.

"He was our greatest architect," Tommy explained fiercely. He was annoyed with her for deserting him so quickly, and seemed to be searching desperately to redirect her attention to him and his film script. "He built—"

"Let Angie speak," Althea said. She seemed glad of a chance to put Tommy in his place. She had taken a bad verbal beating from him during her squabble with Eunice Knox, and whatever amorous designs she may have had on him were not nearly as important as coaxing Angie into his favorite role of lecturer— and coaxing him out of his misguided quarrel with Mr. Shaft. She knew, and I knew also, that if there were not too many interruptions, Angie could be led into a brilliant improvisation on architecture—whatever he was thinking about it at the moment. And architecture, just then, was a safer subject than any other art.

Warts looked on with a brave show of admiration while Althea received praise for her studio but prodded Angie to talk about other things just when he had come to her own painting, the only one she exhibited there. Warts appreciated her self-denial in the interests of peace, and flopped into a large canvas chair as soon as he could, looking more exhausted than ever. Althea's energy had returned, but not his. Meanwhile she asked Angie: "Was Mr. Wright really your master?"

"Yes, he was my *lieber meister*, almost as much as Louis

Sullivan was his. That's what he called Sullivan, you know," he remarked to Eunice Knox who, having enticed him to sit down next to her, had caught on that she was not supposed to ask ignorant questions but to listen like the dog on the Victrola record, as if she understood every word in her master's voice. By such familiar feminine devices she would please him. She wanted to please him, to get, as she said to me later, "some of his genius to rub off on me." Perhaps she also wanted to take the scene away from Althea, who had made such a favorable impression on him with her studio.

Deborah, although she sat on the other side of him and had originally lured him to the house by her suggestion of banana-like availability, was content to see him forget her as soon as he beheld the more extraordinary and the more famous beauty of Eunice Knox. Her mission had been accomplished. Her employer was pleased. A profit to the gallery might ensue. In due time Deborah would get her reward. Now she was willing to remain in the background, while she studied the quasi-royal parleys of a great dealer, a great collector and a great artist. She was only twenty-two, just out of the art department of Queens College. She had much to learn. She could wait.

Judith seized the occasion of the ascent to the studio to escape unnoticed from the party to her own room on a higher floor. All she had listened to was doubtless too profane for her ears. Soon afterwards I heard a piano playing upstairs, faintly. The piece seemed to be an arrangement of the young nun's chief aria in Poulenc's *Dialogues of the Carmelites.*

"What would you say was Mr. Wright's big period?" Althea fed Angie as a leading question.

"Do you mean his big *moment?*" Angie answered in the deeper tones that he used when he felt composed and ready to talk. "That came in Boston in 1940. He was seventy-one years old, officially. Personally I think he lied about his age and was really eighty-one. Anyway, he had almost twenty more years to live, and that was as big a period as any of the others. He was still doing work that nobody else could touch, and he was being honored in Boston at last for what he had already done.

"The tribute came late, very late, and he knew it. All those very important people thought they and their recognition were

making him what he was." Angie glanced scornfully at Shaft. "He said this. 'They killed Sullivan, and they almost killed me!'

"They of course were the 'mobocracy' which he said always wanted to destroy genius—and he was right—and he didn't love them for killing his *lieber meister* and almost killing him too."

"His first job was with Sullivan, wasn't it?" Althea asked.

"Yes, back there in Chicago in the 1890s, when he was a teenage dropout from the University of Wisconsin. It's amazing how many of our first-rate talents have been dropouts. If they didn't get good teachers, they taught themselves. Your avantgarde is full of them," he told me with a look that meant he had read my article about it in *The New York Times Book Review*.

He turned to Eunice Knox with less admiration than he had shown her before. "You said something to me downstairs. You said, 'The public is healthy, isn't it?' Mr. Wright didn't share your illusions about the public. That's why he was so good. He was an aristocrat. He did great things because he believed in being great."

Eunice Knox remained discreetly silent, and he went on: "This is what he thought of the public. He had won out over the public, over its ignorance and spite, but he was still bitter. His beloved master had died unrecognized, on borrowed money that he never paid back. Mr. Wright didn't care much about his own popularity with the public, which I guess began when his hotel in Tokyo stood up in that earthquake and all the other buildings around it were destroyed. What he wanted was to have good architecture understood and appreciated. My wife was once an actress like you. They told her the show must go on, the public had to be amused. Mr. Wright didn't swallow any of that nonsense. He didn't make a move until he had thought out the whole problem—land, water, beauty, usefulness, enjoyment, everything. Then he developed his organic structures. There was too much bad building, too much show business."

"I wish I didn't have to be in it," Eunice Knox protested. "But what else can I do?"

"If you can be as strong as he was, you'll get the plays you

want to do, and you'll get the theatre you want to put them on in. I'll design it for you myself. But you have to be *clear*. And strong."

"You make me feel as bad as he diu." She pointed at me.

"Are you afraid of being free?" he asked her suspiciously. "What does it matter what he says to you? Or what anyone else says to you? Mr. Wright couldn't have cared less about other people's opinions, once he was sure he was right. He never took any satisfaction in the tributes that were paid him, even by good architects. He was always thinking of the future. And how it affected everyone.

"He wrote a book that said the same forces that almost killed him were still bent on killing civilization. He wanted to save civilization and redirect it. He wrote: 'The artificiality of our mechanized society is helplessly drifting toward a bureaucracy so top-heavy that the bureaucracy of Soviet Russia will seem honest and innocent by comparison.'

"I know that almost by heart, I've quoted it so often to my students. They don't drop out on me! He didn't slip off to some safe place in Europe, where they would have made a hero of him thirty years earlier. He worked right here in his own country. He was active up to the end. They say he died at ninety, but I say it was really a hundred. He worked for the return of 'the great mother-art of architecture.'

"And every new building of his astonished us all with its originality. Here's something else he wrote, not long before he died: 'Timely building no less than timely man must be courageously *affirmative*. Affirmation is infinitely more difficult than negation. To bring architecture alive again, negation has had its place. But its place is no longer creative. The time for affirmation is now. *Nor can architecture thrive on the present.* If it is not dated at least a decade ahead of its time, it is born to be and stay behind its time.' "

Warts called out my name and said to me earnestly: "You could put that in your book. It helps me to understand what the avantgarde is all about. Sorry!" He closed his eyes again and relapsed into his pallid fatigue.

Angie stopped speaking. The interruption had apparently made him lose the thread of his thought.

Eunice Knox, who looked at him with the reverent expectation she must have given her directors, at least at the beginning of rehearsals, tried to coax him once again into speech. She had been made still more eager to draw him out after he challenged her strength of purpose. "Tell me about architecture. You know, the new buildings. The ones I see on Park Avenue and Sixth Avenue. Would my theatre look like that?"

Angie laughed sardonically. "You can't ever judge the future by the past. *Or* the present. How do I know what your theatre would look like? It would have to grow into what it was supposed to be, the same way a piece of sculpture has to grow. Real things can't be predicted. I share an office with a guy who teaches philosophy. Is he going to rewrite Emerson? Emerson meant a lot to Mr. Wright, but this guy is not going to repeat Emerson, if he writes anything good. And I'm not going to repeat Mr. Wright. If I did a theatre for you, you'd just have to take your chances. Maybe all your money would be wasted."

"No. I have faith in you."

"So do I," said Leonidas Shaft, who had been silent for a long time.

"I'm glad to hear it," Angie commented with an ambiguous smile. He was offered a second Scotch and water by Deborah, and he sipped it. From long experience I knew that he must have been drinking steadily from the afternoon on, but he showed no sign of it. His health *had* come back, and alcohol did it no apparent injury. By that time he may have become so accustomed to alcohol that his body felt a need for it. Certainly it increased his affability and responsiveness, but he lapsed again into a sphinxlike silence that the faith of Eunice Knox and Leonidas Shaft did not unriddle.

It was a question from Tommy that got him started talking again. Tommy had watched him take Eunice Knox away by his mere presence. I think Tommy wanted to do two things: to get Eunice back and to make Angie look bad. "I read a book about architecture," he told Angie. "It was called *Space, Time and Architecture*. It was by a man named Giedion. Is it any good?"

"You couldn't have read anything better," Angie said with

a paternal smile that made Tommy wince. "It's the Bible of young architects. They still have to read it—even if it's now utterly pointless."

"Pointless?" Tommy perked up. A neck had been stuck out, and it might be chopped off.

"Pointless. Giedion was very useful a generation ago. He was one of the first Europeans to understand what Sullivan and Mr. Wright had been doing. He gave the Bauhaus a great many ideas. He knew that Mr. Wright worked at the very time when American architecture was in a bad state of reaction. The Beaux-Arts fashions of the turn of the century had nothing to do with real tradition. They were lazy imitations of Classic and Gothic. Buildings like the Metropolitan Museum and the 42nd Street Library were an attempt to give an artificial backbone to people who were copying Europe. Look at St. Pat's— it's not a place I want to go to mass in. We built our miniature Versailles, our Tuscan villas, our medieval manors. Even our skyscrapers had to have the look of Chartres. Why? Henry Adams was writing about it. If you were an architect, you were obliged to give the public what it wanted—or give up." He stressed the word *public* for the benefit of Eunice Knox, whose bronze maquillage was revealing still more minor crevices and imperfections in her classic features.

"Mr. Wright didn't give up. He was an exile in his own country. As much as Joyce was an exile in his. But he had to stay here, pick up commissions where he could, fight on.

"Then one day when he was an old, old man it was obvious to everyone that he had won. The Classic and Gothic imitations looked awful, but his buildings looked better every day. We were getting our first Brain Drain—architects like Mies van der Rohe, Gropius, Aalto, painters like Mondrian and Léger. The stock of the puritans had to face the visual arts. The effect was more revolutionary than the invasion of European writers and scholars that took place about the same time. Protestants don't fear the intellect as much as they fear the eye.

"Then our businessmen caught on. One of my brothers sells paint, God help him. He found there was more money in modern architecture than in the old stuff. He sells more paint and other building materials now because "modren"—he still calls

it that—means more upkeep. It has to look spick and span, or you can't get anybody to pay rent for it. The building boom began. Almost none of it had anything to do with what a good architect could want, but it changed this city fast. No more Woolworth Gothic now. Lever Building style. Seagram Building style. Elegance. More upkeep. Higher rents. Bull market. Strikes. Higher wages. Cheap mortgages. Inflation. Tight money.

"You know more about all that than I do," he said to Leonidas Shaft, "but somebody said something about the avantgarde. Well, the avantgarde has triumphed in architecture. The old phony buildings had to be torn down and replaced with new ones that looked avantgarde. Everything had to be modren. Only modren became a formula too. What was supposed to be avantgarde architecture looked almost as dreary as anything it took the place of. I know good architects who go around New York admiring the old buildings that didn't get torn down. Now we're fighting to save some of them. Even the Library and the Met look better.

"We have some really beautiful new skyscrapers, but they usually make me think of prisons. I'm always looking to see if they have bars on their windows, like asylums. I guess that's because the people who work in them are so nutty. You have to be crazy to feel that hard up for money.

"I can understand why Mr. Wright refused to do a skyscraper. And why he did only one building in New York, which he thought was doomed. Now a lot of people say it, but he said it first. New York is for people who want to die. I don't. It almost killed me, but now I'm going to live." He turned to Eunice Knox and shut off something that Tommy started to say. In spite of his protests to the contrary, Angie liked to talk, and the silent attentiveness that had been given him was a rare thing at parties. "If I design a theatre for you, it won't be like anything on Park Avenue. Make your mind a blank and expect nothing."

Tommy worked in his newest effort to trap Angie. "But didn't Giedion foresee all this in his book?"

"No. Giedion was too hopeful. He said that architecture had ceased to be the concern of passive and businesslike specialists

who gave their clients what they bargained for. He said architects had gained the courage to deal actively with life, to help mold it. He said they would help people to have a life worthy of the name. He said architects would give us surroundings that would open up our lives and make them more beautiful.

"That's all hooey. It hasn't worked out like that at all. We've built a lot of modren buildings, and there are more rapes than ever in them and almost as many rats under the beds. Giedion expected people and architects to be nobler than they are. Also, he overlooked little things like the relationship of land and water to buildings—something that Mr. Wright never forgot. Long Island once had more good groundwater than it knew what to do with. Now we've built so thickly and cut down so many trees that it's almost all gone. I taste detergents in my tea. No, Giedion made typical *European* mistakes. He was an ideologist who forgot everyday realities. Now we have to pick up the pieces he left. I don't want to do it. That's why I turned to sculpture."

"You won't build any more buildings? You won't design my theatre?" Eunice Knox asked, as if he were welshing on a contract.

"Maybe I will, maybe I won't." He flirted with her again. "I'm still hopelessly caught by architecture, even if it does mean that you have to work with public benefactors. I'd like to discover what can make it good again. I'd like to try my hand at making our cities liveable."

"It's awfully kind of you to give a thought now and then to our ghettos," Tommy remarked, "but some of us—"

"Oh," said Angie, who could summon his vocal energy when he was attacked, "you're an activist. I have quite a few of them in my classes. You know what I tell them? I tell them that Corbu didn't go to college, Nervi never took a degree in architecture, and Mr. Wright left college before he was a sophomore. I didn't go at all. Maybe you should drop out, I tell my activists. You'll get a good technical education here, but if you were out on your own you'd learn more than you'll ever learn here, in the state of mind you're in. You'd get personal experience. And then if you felt like it, you could come back here later."

"What do they say to that?" Tommy asked.

"They stay in class. They say they'll get their diplomas first, and then they'll go out and prove that I'm all wrong. I tell them, go ahead." Angie turned to me, to my surprise. "You knew Giedion, didn't you?"

"Yes, I met him in Zurich."

"What did you think of him?"

"I liked him. He was interested in a lot of things besides architecture. He and his wife saw everything from an aesthetic point of view. Just the opposite of what I was getting from Jung, whom I was also seeing because I was writing a book about psychology."

"Isn't his wife Carola Giedion-Welcker?" Althea asked.

"Yes. She's written about Klee and about sculpture. Also about Joyce, who spent the first world war in Zurich."

"She's a good art critic," said Althea. "That's rare."

"So far as I could see, the Giedions had only one blind spot. They had no interest at all in psychology. They detested Jung. And Jung had his blind spot. Most scientists do. It was about art. He detested modern painting. He said that when a patient of his showed a tendency to paint like Picasso, it always meant something psychopathic. 'When I see that,' he told me, 'I throttle it.' He didn't understand Giedion's concept of space-time, which he got from studying painters, especially the cubism of Picasso and Braque." I turned to Althea. "There was a picture in Jung's house by the Swiss artist you were talking about. Arnold Boecklin."

"No!" she said, as if he had committed a felony.

"But Giedion was just as blind about psychology. He expected the new architecture to change people's lives. Angie is right, he couldn't see that any change must come from the person himself. And *that* Jung did understand, as well as anyone in our time."

"Wait a minute!" Tommy said. "Better than Freud?"

"I didn't say 'better than,'" I reminded him. "They both realized that self-confrontation must precede any genuine change. They had no faith in institutions. And certainly none in new buildings."

"I must admit, Gerald," Angie said to me, "I have no interest

at all in psychology. Analysis has done more harm than good to artists. Beautiful things—they're all that counts."

Tommy saw his chance. "There won't be any more of your precious beautiful things if we overlook psychology. Why—!"

"I know, I know," Angie told him lightly. "The world is going to hell, and I don't give a damn. But before it blows up I'm going to try to make a few things that will look good among the ruins."

This remark got the response he expected and no doubt desired: general horror. It was most evident in Leonidas Shaft and Eunice Knox. "You don't really mean that," Shaft protested with a clear loss of silvery composure.

"That's pessimistic. That's destructive," said Eunice Knox. She took her arm out of Angie's, and Tommy smiled. His strategy was finally beginning to work.

"Of course I mean it," Angie repeated to Shaft, this time with a nasty rasp in his voice. "Anyone who thinks that things can go on the way they are without a disaster is a fool."

"Then I'm a fool," Shaft said with dignity. "I'm stupid enough to believe that, great as our problems are, we are going to find solutions for them."

"I believe that too," Tommy announced with a youthful cheeriness that Angie seemed to regard as an automatic disqualification. Shaft also appeared to regard it with suspicion. (How disunited the United States has become, I thought, on all essential issues.) Tommy continued as the spokesman for his generation, in the face of silent senior opposition: "I'm committed to *action*. But the action must come from a sound psychology. We'll find solutions when we're all clear about ourselves."

Angie chuckled. "And when is that going to happen?"

"Sooner than you think! The situation will require it. You've lost your faith in humanity!"

"I never had much. I'm a Catholic. If we are going to be saved, it will be through faith in God, not humanity. If we look for God—I pray to Him when I work—then He will tell us what to do. The first thing He told me was, never expect anything from anyone else. And never expect anything good from a world that has lost its faith."

"I respect your religion," said Shaft, "but I don't accept

your despair. This country was built up by men who believed in what they could accomplish with their own brains and their own hands. It will be saved by men who have the same kind of faith." Although he tried to minimize his deep disagreement with Angie by speaking formally, it was clear that he had been disturbed and disappointed.

"I don't believe it," Angie said. "And I don't believe in any of the institutions you keep going with your cockeyed ideas —your foundations, your universities, your museums. They seek me out now, but I never sought them." Once again his Irish was up, and he was finding with uncanny insight the very words that were best calculated to antagonize his patron.

Althea, with a worried look on her face, turned to me and said lightly, in an almost laughing tone that was meant to cool the argument: "You write about these things, don't you? I hear this debate every day in the gallery. What do you think?"

I knew Angie well enough to be alarmed. His lace-curtain pride, if goaded by Tommy, could force a break with the first man of wealth who had sought him out and paid him a large sum of money for his work. I knew he was in debt, that his children wore hand-me-downs, that his furniture was falling down for lack of repair, that his wife never complained but wore such a brave smile that it distressed me to see her.

"You both have the same ideas, really," I told Angie and Shaft. "You believe in the creation of beautiful things, and you want as many people as possible to enjoy them." My words had no visible effect on Angie, so I continued quickly: "You were right about Giedion. He *was* too optimistic. But Jung, even if he had his blind spots about modern art, developed an important idea. If we used it, it might save us from disaster. It would surely help us to communicate with each other. I mean his theory of the archetypes."

"What's that?" Shaft asked at once with relief.

"Briefly, it's this. We'll be at the mercy of day-to-day events, and we'll drift inevitably toward disaster, unless we interpret our narrow personal experience in the light of the deep inner experiences that we share with everyone else. All our brains bear the imprints of the most important psychic events in the lives of our ancestors. These common imprints can be the source of community."

"You're talking about the collective unconscious," Tommy announced with instant dislike of my efforts toward pacification. "I never could go for that."

"Too bad. The movies you want to make would be better if you drew upon the deep collective experiences that move audiences."

"Tell us about it," said Leonidas Shaft with a tone of authority that silenced Tommy, at least for a while.

"I'll have to try to put it in the idiom of our time and place. Most Americans reject the archetypes, because they seem too remote, too esoteric. Actually they are part of everyday life, and the most familiar, down-to-earth part of it."

"Tell us!" Eunice Knox commanded impatiently. "In a theatre the audience would have walked out on you."

Angie asked Deborah, who hovered near him like an ancient cupbearer, to fill his glass again with Scotch and water. Some of his last drink remained on his frosty beard as droplets. When she gave it to him he put his arm around her knees and thighs, which came to the height of his shoulders as he reclined in a comfortable canvas chair. His other arm was now far from the body of Eunice Knox. When I finally spoke he looked as if he were not listening. He closed his eyes and leaned his head against the yellow hips of Deborah with a blissful smile.

"Go on," I was told by Althea, who was also on the side of peace.

Meanwhile I thought how grey indeed the charred bush of theory was beside the green tree of life. (If I had been sitting among scientists, I might have found more beauties in grey.) "We now have the beginnings of scientific proof of the archetypes, of the imprints of earlier common experience on contemporary life. A baby chick, just hatched, will run for cover if it sees a hawk overhead, or an accurate copy of the hawk. But if the copy is inaccurate, ever so slightly, the chick stands stockstill, unafraid, with its eggshell on its rump. This is called *innate* by biologists because it indicates a preparation for experience that the chick must have received before it was born."

"Fascinating!" said Leonidas Shaft, but Angie made no response.

"What does this mean to us? How can it help us organize the chaotic experiences that threaten us with disaster, that separate

us into opposing armed camps, black against white, young against old, rich against poor, and vice versa? The chaos that makes Angie Jones turn away from architecture, because it is too social, and toward sculpture, because there are still art-lovers who can appreciate it?"

No response from Angie. Only the blithe smile of a spoiled priest *in flagrante delicto*.

"Our scientific discoveries make it pretty clear that human life is a biochemical accident that has most likely not been repeated—in the same form, at least—on any other planet. We are thrust into a world of chaos, or as some people call it, of absurdity. But our world evolved according to organic principles of life, and so did we. We have inherited brains and spirits that can find order in our world. We can decide whether we want order or disorder in our lives. We can choose whether or not to impose order on the life that surrounds us. We can vote for wonder or horror. We can vote for success or failure, in the real sense, not the popular sense, of those words."

"You really do believe in the new heroism, don't you?" said Tommy. "Neither sick, helpless aestheticism," he glanced with scorn at Angie, "nor compulsive, joyless pragmatism," he turned toward Shaft, "but—"

"Yes, I believe in it. I'm quite willing to say that no order is inherent and all order is created. And we have very short lives that come off best when we build intelligently on the order that has been created before us by our ancestors. We have to throw out much that they taught us—the preliminary negativism that Wright talked about—but we also have to cherish the traditions that are still useful.

"Wright was a good architect. He knew how to throw out the Renaissance tradition that was turning nearly all his colleagues into colonial imitators of Athens, Rome, Florence or London. He found other traditions, more native—some of them seem to a layman to owe a great deal to our Indians—that helped to release his enormous originality. He found his archetypes in the land, through his close study of water, trees, rocks, flowers—and new building materials, of course. And these archetypes helped him to create a new style of architecture.

"But he lived in a totally different time. Most of us have to

live in the cities that he as a proud patrician could afford to shun. We live under new urban strains that he joked about in the magnificent houses that he built for himself in Wisconsin and Arizona. Some of our architects think they can control these new urban strains with intelligent planning. Some of them don't—and turn away from architecture to other arts that don't require public approval but can be supported by connoisseurs." Even this last remark, which was aimed directly at Angie, did not cause him to open his eyes. He snuggled his head more admiringly into the softer parts of Deborah.

"If any of our architects are to help in establishing a better social order—and that would require more than social justice, it would mean giving our individual talents a chance to grow (*one* law for the lion and the ox is still oppression)—our architects will have to detrivialize themselves, denewspaper themselves, and resacralize themselves." Leonidas Shaft looked puzzled by the penultimate word, but I pushed on without explaining it. "The way to resacralize oneself is to stop being at the mercy of day-to-day chaos, of one-damn-thing-after-another. If we are to find the sacred again, the real, the enduring, it will be by finding the archetypes—or if you prefer, the Ideas—in everyday life."

At last Angie opened his eyes and spoke. "And how is the architect going to do that? He is surrounded by 'playboy architecture.' That's Giedion's word for it. He is surrounded by pop culture. And mom culture. At last I know what you mean by the archetypes. They are what Corbu found when he was designing his chapel in Ronchamps. What Nervi found when he did his stadium in Rome. But every good artist knows all about these things, without dragging in pretentious words like archetypes."

He sat up straight and spoke in a sharper voice. "Look! *Nobody* is going to save our cities. They are death-traps, and the best thing is to pass through them only when you have to. I got well by going to a really simple place in Greece. Which is now doing its best to copy New York. Look! The world *is* going to hell, and it's pointless to worry about it any more. Architecture—it's too impermanent! What you should do is leave as many good, true, beautiful, magnificent things as you can behind you, so that some day they will be discovered by the archaeologists."

He opened his wallet, and took out a piece of paper.

"I simply cannot accept that idea," said Leonidas Shaft.

"That's because you'll never understand anything. You're the guy that wants to put my sculpture in a room full of Dalis. Here!" He held out the paper he had found in his wallet. "Here's your check. I'm not going to let you have my sculpture."

"We needn't get worked up," Leonidas Shaft said quickly. "You're a great artist, and I want your sculpture. If you object so much to the Dalis, maybe we can put your work somewhere else. I'm never dogmatic about anything. We can work it all out." He put a friendly hand on Angie's shoulder.

"No!" Before anyone could stop him, Angie tore up the check and, when Shaft failed to take the pieces from him, put them into an ashtray and stood up. We all stared at a sacrifice, truly heroic, that made ancient hecatombs of cattle seem trifling. Angie put his arm around Deborah and said: "Come on, kid, let's get out of here." And without a word to any of the rest of us he walked out of the studio with her on remarkably steady legs. His legs were mere pipestems that supported a hogshead draped in shiny, soupstained black. He looked absurd, but he also had dignity.

"He's insane," said Warts in half his normal voice. He was the only one among us who had not risen to his feet at some time during the sudden gesture of Angie. And then Warts closed his unparallel eyes again, as if the utterance of two words had been too much for him. The lowered intensity of his sighs suggested that he was dropping his resistance to an internal enemy that we could not observe.

INTERLUDE: NO COMMENT

This chapter ends upon an action that only the Architect-Sculptor seems qualified to interpret. There is therefore no commentary here. If we can catch him, let us hear what he has to say.

EIGHT

THE PHILOSOPHY OF THE 8-BALL

Among the people in that room, all of whom had the habit of taking money into consideration in nearly every action of the day, Angie's deed caused more genuine wonder, I think, than they would have felt about a landing on the moon. It was a deed also that they had witnessed with their own eyes. But above all it upset all their calculations about human behavior. The outcry of those disciplined Americans, seasoned by a century of surprises but caught offguard by the latest, was shrill.

"Why?" exclaimed Leonidas Shaft, almost as if he had just been informed that the stock of his soap company had dropped fifty points. His cosmos was in disarray. He turned to me. "You seem to know him. Why did he do it?"

"I can't say," I admitted, "but one reason may be that no other artist would have done it."

"Why?" exclaimed Eunice Knox, as if she had not listened to me, in the high-pitched voice that she used when she wanted to whip an audience into a panic. "He seemed so solid, so wise!"

"It's always possible," I said, "that he thinks it was wise."

Althea's first outcries had now dropped to a quieter tone. "It's true," she said soberly. "All the other artists think of nothing now but money. They used to be interesting, carefree. Now they know more about investments than I do. And when they get a check in their hot little hands, they don't tear it up."

"There's more to it than that," said Tommy who, now that Angie had departed, seemed eager to regain his position as a *Wunderkind* in the eyes of Eunice Knox. He scowled like a great psychologist, thinking. Plumbing depths that no one else could imagine. "It wasn't only a gesture. I got the impression that he's very complex, psychologically." He addressed this

last remark to me as if I were his consultant on a particularly difficult case.

"Yes," I said. "He has to top everybody else—in not giving a damn about the things that mean most to them."

"Hmmm," Tommy mused learnedly. He also looked at his watch and at Eunice Knox. Apparently he was still trying to decide whether to make a dash for Columbia or make a play for her.

The Greek profile of Eunice Knox relented in my direction. "Hey, you know him! Does he always do things like this? Hey! That check would have put on a Broadway show! Is he nuts?"

"No, just a little grand. Tomorrow he'll wake up in his broken-down house, with the electricity turned off because he didn't pay the bill, and the garbage not collected because he didn't pay for that either. His wife will ask him for the check, and then he'll have to tell her that he doesn't have it. She's expecting her sixth baby."

"He did call her up the minute I gave it to him," Leonidas Shaft remembered. "He said it was the happiest day of his life, and he wanted her to share it with him."

"He'll wake up *in his own house?*" Eunice Knox jeered. "He'll wake up in that girl's apartment!"

"No," I said, "my guess is that he'll have a few more drinks with her and then kiss her good night and go home." Although I was not at all sure of this, I made it sound convincing.

"Maybe you were right about him," Althea admitted to me. "Maybe he's more harmless with girls than I thought."

"I believe he is. He's got what he calls a religious complex. He's attracted to girls, but then he drinks himself into a stupor, so he can't do anything to them." Once again, loyalty made me purify him, perhaps to protect his wife, whom I pitied.

"I'm glad he got out of here!" said Eunice Knox. "He looked so interesting. I thought he was a real tomcat genius." She put her hand on that of Tommy, who instantly looked happier.

Althea was having an idea. "Mr. Shaft," she said, "don't give up hope about that sculpture by Michelangelo Jones. I know how much it means to you. I think I can get him to deliver it to you after all!"

"Do you really believe there's a chance?"

"A very good chance!" She seized the opportunity to build herself up in his eyes as a dealer. "What he needs is a dealer who understands him. One who can prevent him from doing irresponsible things."

She had found the word that appealed most to Leonidas Shaft. "It *was* irresponsible, wasn't it?"

"It couldn't have been more irresponsible," she assured the great collector. "It came out of a childish attitude toward the public."

"I thought he said some very childish things."

"So did I."

The love-feast between great collector and great dealer was too much for Tommy, who no longer looked at his watch now that Eunice Knox had put her hand on his. Instead, he wanted to show her how very perceptive, even profound, he could be. "No. I disagreed with a lot he said. But I have to respect his integrity. He isn't the kind of architect who cares about humanity. He disregards the ghettos, he's an aristocrat, so he turns to sculpture. All right, he's limited, he lacks a social vision, *but* he does have an artistic one. We all admit he's a good sculptor. He's the most original man in sculpture in some time. He can't be nuts. Everything indicates that he's working from some strange philosophy of life." Tommy turned to me once again as his consultant on a difficult case. "What do you think?"

"Oh yes. He has a philosophy of life. I heard him spell it out once, at the Artists' Club on 23rd Street. He had to get tanked up before he spoke, and he had to wait a long time while some of the artists shouted him down—that happens all the time there—but at least he said his piece."

"What did he say?"

"It's too long, and I don't remember all of it."

"What was the gist of it?" Tommy persisted. So did the others. They had all been perplexed by him. I had expected the party to break up soon after Angie left, but instead it had been united by bearing common witness to an extraordinary act which everyone wanted to understand.

Even Warts roused himself to ask me to explain Angie's be-

havior. New strength seemed to flow back into him, as if he had caught his second wind. He stood up and stretched himself. "I'd like to hear the philosophy of a man like that," he said.

"Don't you think you'd better go to bed?" Althea asked him anxiously. "You look tired."

"No, I feel better now. Go on," he begged me, "tell me." He sat down again.

"I think Angie began by telling us that he never went to college but later took some adult courses in philosophy. One of them was with the man he shares an office with. The courses bored him, but he said he had been reading philosophers all his life. Of course to him philosophers meant poets and novel-ists—Joyce, Yeats, Lawrence and a lot of others—as well as Aquinas, Aristotle, Plato, Kierkegaard and Heidegger. He said an artist has to read for whatever helps *him*, not for informa-tion. The man who shares an office with him is an expert on linguistic analysis, and that seemed meaningless to Angie. He stopped going after two lectures. But he gave us a picture of that professor of philosophy that I'll never forget.

"This professor would not have torn up a check. He kept an exact record, down to the last penny, of everything he spent every day. He sent birthday cards every year to the presi-dent of the university, the deans, the head of every department, and all of the trustees. He had once been married. His wife committed suicide, by refusing to eat any food, and he left her favorite flowers on her grave every year on her birthday. At vacation-time he went home to live with his mother. When his wife's dog died (of natural causes, I'm sure, though Angie insisted the dog killed himself) the professor felt emotionally upset, so he left a note for himself on his desk: "Remember to forget dog." Kant had left a similar note for himself about a departed servant.

" 'You can always tell a real philosopher from a teacher of philosophy,' Angie told us. 'The first one talks about things, the second one talks about ideas. My roommate talks about ideas. He's what's called a Technical Philosopher. The only time he ever laughed was when I asked him what his existential picture of the world was. He said I didn't understand anything. Why had I asked such a stupid question? If my question were analyzed, it would turn out to have no meaning at all. Linguisti-

cally it just didn't stand up. You could only begin to understand philosophy if you realized how exact you have to be about words. Especially the copula, which must not be confused with copulation. Copulation could not be understood, but copulas, since they were words, could. Never ask big questions, only little ones. Then you could get some solid answers.

" 'My roommate told me that every paper about philosophy had to be short, so that it could be read in office hours. It must never interfere with weekends, when one went over checkbooks or sent cards. He was always reading papers when students came to have conferences with him. He would shout at them, "Not now, not now, go away!" Sometimes they would look in on me, and we'd talk about art. Or about girls.' "

"I know the kind of professor he was talking about," said Tommy.

"So do I," I said. "Angie thinks he is much more serious about philosophy than his roommate. When he clarifies things, he says, he can do better work. He thinks Pollock would be alive today if he had not been so inarticulate. Verbal clarity, he says, is essential to artistic clarity. A lot of artists started shouting when he said that, but he just waited until they let him speak again. 'I know, I know,' he said, 'it's a nuisance, but it's a necessity. Even when the thing you are doing can't be put into words. Instead of blocking your demon, verbal clarity releases it. An artist can't just feel, or make things, he also has to think.'

"Angie liked to talk about his demon, which he called *el duende*, a Spanish word that he got from a flamenco singer. She wanted to have a baby by him. Angie doesn't believe in psychology, or he says he doesn't, but he does believe in philosophy as a way of releasing *el duende* so that the work of art will be new, spontaneous, genuine. He admitted that if he hadn't been so preoccupied with philosophy he might have been successful earlier, but he thinks his success will last longer because it grew out of a dialogue with others. That's why he talks so much, he says. He wants others to make him talk better. And sculpt better."

"I must admit he talked well," said Leonidas Shaft, "even when he said things that I couldn't accept at all."

"He's worked out a philosophy for *himself*. Not for anyone

else. Not even for his wife, who just shuts up and goes to mass. She's a convert, so she works extra hard at it. He never goes, though he insists that he's still a Catholic. He says he doesn't like the new way of saying mass in English. He'd rather it were still in Latin, remote, grand, mysterious.

"When Angie spoke at the Club he talked at first as if it were made up of architects, not artists. Actually, I saw only three or four architects there, and about two hundred painters and sculptors. But for a while he pretended that you can't say as much to artists as you can to architects. Artists often confuse a vision they once had, years ago, with their actual accomplishment. They also remember only the good things that were said about them. And even when they die, if they have not been successful, they are still hoping for posthumous vindication. But architects either get buildings to do or they don't. Everyone knows whether they are successes or failures. Anyway, at first he talked a lot about architecture and not very much about sculpture. He did the same thing here."

"I noticed that," said Althea.

"He must be obsessed with his guilt about not being able to do anything about the ghettos," Tommy said magnanimously, while he clung to the hand of Eunice Knox and sought to impress her with his maturity of judgment. "Poor guy, I'm beginning to understand him better."

"That's the way to talk," Eunice said with approval. "Accentuate the positive. Don't be too critical. He does have genius, even if he is frustrating it with alcohol. You could see that at a glance."

"The strange thing about Angie's speech," I remarked to Tommy, "was that he kept talking about the need to recognize your sickness before you could hope to be healthy. 'And you're all sick,' he told the artists. 'If you don't know it, if you don't realize how much you've been affected by a sick culture, you'll never do anything worth looking at.'"

"That's what every good psychologist believes," said Tommy.

"But Angie said he got it from Nietzsche, whom he loves."

"Nietzsche was violently anti-Christian!"

"I know, but Angie loves him. He likes him all the better for his attack on Christianity. 'If you believe in God,' he told

those artists, and they really shouted then, 'you *enjoy* hearing Him attacked. *O God, I believe; help Thou my unbelief.*' He quoted that from a saint, and said it would make artists work harder and better if they understood it. After that there was bedlam for five minutes, while he took a beating from most of the artists, who hate religion, and even the few who like it.

"When they were quiet again he said, 'We don't like to admit that the Great White Death has caught up with us, and we all have to heal ourselves. If you flaunt your sickness, like Dali— (his special hatred, Mr. Shaft)—you'll only speak to the dying. If you want to speak to the living, or to those who are not in love with death, you'll ask yourself tough questions and you'll get well. You'll throw away everything that is not first-rate and start all over again.

" 'Look out the window and you'll see the philosophy of most architects. The copycat, sheephuddle buildings that insult your eyes—and most of our misery starts right there in those gruesome piles—they came out of a cheap philosophy. Willingness to do only what the law requires. The architects have given their customers what they bargained for—no more and usually less. The specifications and the building code have been met, with bribes to the inspectors. Whenever builders could skimp and get away with it, they have skimped and gotten away with it. The floors creak underfoot. The windows leak air and sometimes water. The insulation loses heat in winter and invites it in summer. But the poor customer overlooks all this. He feels only the primordial glow of a nest against weather. Not to mention the new gadgets that put him in a contented stupor.

" 'Most architects have forgotten about all this. They merely want to profit on the customer's ignorance. But there are some who take on the cares of Harlem and the other ghettos. They know they can do as much as anyone to relieve our shocking urban disorders and injustices. I have great respect for them.' "

"Very decent of him," Tommy murmured with some sarcasm. Eunice moved her hand away.

" 'But I'm not one of them,' Angie admitted. 'Something has been left out of me. I don't have enough time to try to help solve our social problems and also create the works of art that

have been obsessing me ever since I was a child. So I have turned to sculpture.' "

"Thank God he did," Althea said fervently.

"And then he began to talk to the artists, not the architects. He had planned it all very carefully, and when he used big words it was probably because he was quoting some lecture he had given before. 'I've been looking for a long time,' he said, 'for a philosophy of art. Not one for anyone else, just for me. And this is what I've found. This is what I tell myself every day. This is my post-Existential message.

" 'Get yourself in hot water. Keep yourself in hot water. Don't play it cool. Commit yourself to your own fulfilment. Fight for that every day. If you begin to make it in architecture, turn to sculpture—or anything that forces you to *extend* yourself. Your chief problem is not poverty. It is prosperity. The poor you have always with you, but the new prosperity means that very few artists, fewer than ever, are going to come off. Things are too easy, too soft. Make them tough for *you.*

" 'What do I mean by hot water? Well, I could have gone to college. My dad had enough money, and I was an A student in school. But that would have made my life too simple. You have to foul things up to get any understanding. (If I'd been black, I wouldn't have had to.) I had to put myself behind the 8-ball to open up my eyes to what was really going on. In rotation pool, if you get behind the 8-ball, which happens to be black, you can't win. I arranged things from the start so that I couldn't win. I had to work as a *designer*, not an architect— without a license. I had to find my clients among people who were as screwy as I was, that is, the most interesting people around. I couldn't afford to have an office. I never did things the right way. So I had to do them better than the right way. I had to invent. And when my clients liked what I did and wanted to pay me, I almost always found some excuse for not taking their money. It would have been all wrong to win. I had to lose.

" 'My roommate the philosopher has tenure. I don't. They can fire me whenever they want. He gets about twice as much money as I do. His students take his courses because they are required. Mine come to my house, where there isn't a chair for

them to sit down on, and beg me to tell them more. So they sit on the floor, and we talk.

" 'My roommate played safe. I couldn't.

" 'I couldn't because I had what they call a religious complex. I took Christianity seriously. I almost became a priest. But I couldn't keep my hands off women. And all the time I kept comparing my life to Christ's, the way that tramp in *Godot* does. My life looked terrible. I couldn't be a eunuch. Or humble. Then I compared my life to Socrates'. I told myself, you have to equal Socrates or you are nothing. What was it that made Socrates different from the other philosophers? He died for his ideas. You see, I'm nutty. I'm trying to die, in this ridiculous, alcoholic way, for what I believe in.' "

"What did I tell you!" Tommy exclaimed. "He does have a philosophy of life. It's weird, but he believes in it."

"Yes, he believes in it. If he got to know you, and he thought you had something special, he'd tell you not to take your doctorate but take your chances. Never play safe. Don't do the thing that's expected of you. In that way life itself would force you to become a better psychologist than Freud. You would be obliged to draw upon your unconscious talents. You'd be in hot water, and you'd have to fight your way out of it."

"I wouldn't get a single patient to practise on. Besides, his life is not a model!"

"No. but it has forced him to produce whatever good work he has done. It's all a question of whether or not you take a radical attitude toward quality. He has sacrificed his health and his family, of course, to his dream of perfection. He has sacrificed any number of girls who probably broke their hearts over him.

"He hates the word archetype, but the best way to understand him, I think, is to see him as a man possessed by an archetype. The archetype of creation, of newness, of unborn beauty. 'The uncreated conscience of my race.' He has been at the mercy of that archetype. It made him give up a life that might have been happy."

This stung the pride of Eunice Knox. "Who wants to be happy!" she exclaimed, the first voice in a chorus that soon responded to Angie's ideas and example. "The pursuit of happi-

ness—that's for hack playwrights, hack directors, theatre own-
ers, critics, press agents, ticket salesmen. I'm possessed by an
archetype too. In a way no mere man ever possessed me." She
picked up the unfamiliar world brilliantly, with an actor's fa-
cility that suggested she had been thinking about it all her life.
"The archetype of unborn theatre!"

" 'Don't do the thing that's expected of you,' " Leonidas
Shaft quoted from Angie: the second voice in a responding
chorus of wounded pride. "That's what I'm always telling my
trustees. Do something new, original. That's why our museum
has gone ahead. I must be possessed by the archetype of unborn
beauty too." His face lost some of its habitual reserve. He ap-
peared to be saying words that meant very much to him. It was
as if he were speaking solemnly to Mrs. Shaft in bed. "Now I
understand why he tore up that check. He was expected to
deposit it. So he refused to do what was expected. I used to sur-
prise my parents in the same way. I was always doing the un-
expected. They wanted me to go to a local school of business
administration. I went to the Harvard School of Business Ad-
ministration!"

"I'm always astonishing the art world by the new painters
I pick up," said Althea. "I take chances on the unknown, the
unbelievable!" Then she turned in a more practical, less boast-
ing mood to Mr. Shaft. "Don't worry about Angie. I've been
listening to his own words. Now I know how to handle him.
You'll get that sculpture!"

"All right, I'll take next year off, stay away from graduate
school, concentrate on movies. We'll see what happens, if I
don't get caught in the draft," Tommy said. He also had been
caught momentarily by the philosophy of the 8-ball, but I did
not take his plan seriously.

"So that's what the avantgarde is all about," his father mur-
mured, his eyes closed. "You're possessed by this arch-type, or
whatever it is, of unborn—" His voice trailed off.

Tommy, confronting himself with the threat of military
service, found himself also confronted by a question. "It's all
very well to be possessed by an archetype, but how do you
make the most of it? That's what counts. What do you do with
it?"

"I can't speak for Angie," I said, "but I can tell you what he told the Club. By this time the Club was subsiding a little. Most of them hadn't the foggiest idea of what he was talking about, but some did, and they were the most influential members, with the biggest names. They made the others listen to him."

"What did he *say?*" Tommy demanded.

"He said, 'Study the philosophers, especially the Existentialists. They've stolen all of their best ideas from us artists, as Nietzsche admitted, but it's good to get our own stuff back in another language. If you learn their lingo, you will be more impressive with dealers, curators, collectors. They'll think you know a lot more than they do. Which you do, if you have a new vision. There's no danger then that you will just get slick. But remember, you're talking about something that can't be put into words.

" 'Stay behind the 8-ball. Most existentialism is already a gimmick for getting a chair in a college or a lot of patients. Most art is a gimmick too. Most art is aimed at getting publicity that will sell it to the hicks. At last I'm reaching the hicks, and I'm worried. The museum retrospectives I see get handsomer and emptier every year.

" 'You have to make a choice. If you come out from behind the 8-ball, the chances are you will win. But if you stay behind it, you will see things that you can't see any other way. Your work will get better and better, and finally nobody at all will understand it. That's when you'll really succeed.' "

"But I stay behind the 8-ball," Eunice Knox cried. "That's been my whole life. I never take the easy way. I get myself into one jam after another."

"The history of my relations with my trustees is exactly what Michelangelo Jones was talking about," said Leonidas Shaft. "I've been misunderstood all along the line. I think I can safely say that we've been slowly winning a fight that few will ever understand. Not just now, anyway."

Eunice Knox had an idea. "That money goes back to you, doesn't it?" she said to Mr. Shaft and lowered her voice. "I've been offered a chance to do a low-budget film that would interest you very much. Really avantgarde. And it might need no

more than that hundred and seventy-five. It's the sort of film that will be shown some day in the museums. Both exciting and educational." She directed all her charm in the direction of Leonidas Shaft, whom until then she had, apparently to her present surprise, ignored.

"You mean my script, don't you?" Tommy said to her.

She patted his hand to silence him, while she turned her full attention toward Mr. Shaft. "It's original, it's daring. It's art. And yet I think it would make a lot of money."

Althea was not ready to tolerate such an intrusion from a mass medium. "Now wait a second," she said firmly, "I'm going to deliver that sculpture to Mr. Shaft and Angie is going to get that money after all. Don't try to horn in on this!" she warned both Tommy and Eunice Knox. "Sculpture like Angie's is on a higher level than any movie. It's—" she sought the right word, the most impressive word. "It's sacred."

A low moan that became a loud moan broke forth from Warts, whom no one else had been noticing. He stood on his feet with a look of terror on his face, and clutched his throat, his chest, his stomach, as if his death were travelling inside him. His moan turned almost into a shout. It could surely be heard outside, on the street. And then before we could reach him, he fell down to the floor, his head a few inches away from a brass sculpture by Noguchi.

"No, no!" Althea cried, the first to reach him. "I begged him to go upstairs and rest! The poor thing! The poor thing! Tommy, go get his medicine! Call Dr. Neville." She undid the soft collar of Warts' shirt. He seemed unconscious.

Judith appeared in the doorway in a dressing gown. "What—?" She saw her father on the floor, and rushed to him. "Papa! Papa!"

Tommy ran upstairs to get the medicine.

INTERLUDE: WHO IS THE ESCAPIST—
THE ARTIST OR THE BUSINESSMAN?

When a highbrow radio station in West Berlin (RIAS) asked me to speak on Present-Day Modes of Escapism I described the foregoing scene, as my empirical data, and offered the following commentary (in my best effort toward a "Germanic" manner).

Except for the exhausted Publisher, who chose that moment to have a heart attack, the scene had become openly comic. I must turn away from it if I am to try to discover the modern kinds of escapism it reveals. The psychological mechanism of escape is defined in Webster's Dictionary as "a mode of behavior or thinking adopted to evade unpleasant facts or responsibilities." What kinds of escapism have been demonstrated here? How do they differ from those of other days?

They differ chiefly, I think, in the various ways they have been affected by the new prosperity that surrounds and changes these people. Except for the weary Publisher, they do not practise the escapism that has been most characteristic of Americans since they first joined together in the seventeenth century to clear a wilderness, kill the natives and establish a new society. They do not practise the escapism of work. They do not seek to evade unpleasant facts, responsibilities or *thoughts* by filling their days with busyness. They are not righteously determined to shut out truth, beauty and all disquieting questions with a grim devotion to duty.

On the contrary, these present-day Americans show how subtly they—and a great many others in less prominent walks of life— have opened themselves up to questions and values that earlier thrift might have obliged them to exclude. They debate the importance of works of art, they debate issues of social obligation, they debate metaphysics.

With one exception their debate is not rigorous. The Patron, most of whose wealth has been handed on to him by industrious forebears, is trying to pass from the escapism-through-work that

dominated his childhood to a love of beauty. His new love is not quite that of a passionate amateur. It is closer to a fairly self-indulgent escapism-through-checkbook that has been promoted by the new Keynesian prosperity, with considerable help from income tax laws that permit deductions for gifts to museums. Love of favorable publicity, popular justification, is at least as important to him as love of beauty.

Both the Dealer and the Actress are trying to profit by the new escapism-through-art that ensnares rich men like the Patron. As recently liberated women, they practise the new escapism-through-career that serves as effectively as the older escapism-through-work to shut out disquieting questions. But both of them are talented (the Dealer is also a painter) and suffer acutely from conflicting desires for money, busyness and artistic fulfilment.

The Student is still "hung up," in his jargon, on the escapism-of-good-intentions. He delays getting to Columbia in time for the beginning of the strike, because he is not really as committed to social revolution as he thinks he is. He has yet to discover where his true talents lie.

The Sculptor alone has faced with rigor his natural desires for escape. He has recognized them and cannily sought a way to defeat them. He has worked out his highly personal "Philosophy of the 8-Ball" as a device for outwitting *his own* tendencies toward slackness and complacency. He has developed an almost flagellant style of life, because he does not wish to surrender weakly to the new commands of prosperity. His strange "philosophy," if it may be called that, suggests the depth of intuition, the strength of character, the suppleness of mind that are required to defeat new modes of escapism that, in a new Golden Age, proliferate every day.

NINE

~

SCIENCE AND ART

While we waited nervously in a hospital room for word of the stricken publisher, my chief impression was of timelessness. The room was up-to-date enough, from its white "princess" telephone to its over-red copy of a newly Americanized Monet, from its fresh off-white paint to its echoes of tranquillizing music which with some difficulty I had a nurse turn off, after desperate pleas from Judith. But the possible death of a man hung over wife, son, daughter and stranger (I came along only at the urgent request of the wife, to give her moral support with her stepchildren) and this was enough to strip the scene of contemporary distractions and restore its eternality. We were defenseless before what might happen. Our mood was solemn.

The re-establishment of silence was not sufficient to calm the nerves of Judith, who when she heard that no report on her father's condition would be given us soon excused herself to go for a stroll in the neighborhood, which was not far from her home and therefore familiar to her. I sat with Althea and Tommy in a room that smelled of housepaint, an odor I do not like, and listened to them discuss the man who had collapsed. What they said interested me, but I also felt a strong desire to go home, since the hour was late and I had a heavy schedule the next day.

"You see," Tommy said, more to me than to Althea, who sat, or half-lay, on a couch behind him, "Dad grew up in a tank town in Indiana. He was a mixture of Catholic mother and Protestant father, but he didn't go to any church after he was sixteen. He hated all religions. He still does. Sometimes I wonder why he gets so vehement about it. The poor dumb churchgoers in our clinic at least have something to hang onto. But Dad says it was different in his day. He had to break free from all family ties.

165

The thing that impressed him most was the express between Chicago and New York. It whistled through his town every night about nine-thirty. He used to go down to the tracks and look at it, at the dining car where they were still drinking coffee and lighting up cigars. The train meant power. It meant getting away. He was ugly, so he studied hard. When he went to the state university they wanted him to teach English. But he worked as a newspaper reporter in Indianapolis and earned money to go to New York.

"That was back in the 1920s. He felt literary and carried a cane and wore a hat like the one Sinclair Lewis wore. He went to all the newspapers and magazines and asked them for books to review. Finally he wangled a job with a publisher, after writing a lot of reports on manuscripts for almost nothing. He wrote a book about his home town, and got it published, but it was too respectful, not dirty enough, not nasty enough about the old families, he says, to get much attention. He decided he wasn't meant to be a writer. But as an editor he made good fast. He brought a best-selling author from the Midwest into the firm. He got drunk with this author and other grassroots best-sellers every night. People began to trust him. In the twenties he was strong on the Midwest and the pioneers, in the thirties on the proletariat and the Revolution. When the war came along he switched to pure literature, without any political implications. He's always been able to spot a trend. That's why he's interested in you. He thinks you represent a new trend. The movement that will take over when pure literature dries up. It won't be popular right away, he says, but sooner or later there will be a big public for a mixture of people, action and ideas, for your kind of complexity."

"Strange," I commented, "I thought he really didn't like what I say."

"It doesn't matter whether he likes it personally or not. Is it going to catch on? Are readers going to want it? That's what he asks."

While we talked, with Althea offering hardly a word, I noticed that she, who had been sitting on a couch in a slightly darker part of the room, arranged her body so as to lie down on it, half on her side and half prone, with the front part of her

on the couch and the rear part uppermost. Tommy rudely sat on a chair in front of her, with his back to her, and could not see her without turning completely around. But since I faced him on another chair, I could see her over his shoulder.

She gave the impression of listening to him and of watching carefully in case he should make a move to look in her direction. And then silently but deliberately she raised her beige skirt and put a long, tapering, redtipped finger into the front part of her body, from the rear, and stroked herself regularly. She stared at me meanwhile, in a manner that embarrassed me, as if encouraging me to look at her with both forgiveness and desire. It may also have been that my eyes made her action bolder and more exciting. I realized how tense she must have become after the many events of the evening and how much she desired release from them. I remembered that her lovemaking had been more instantaneous, more clitoral than that of most women. Her regular self-fingering went on, while we talked, with Tommy able to say more than I could.

"But remember," Tommy told me, "Dad is not just an opportunist. He has to make a living, of course, but he's been looking for an education all his life. When you consider his beginnings you have to admit he's come a long way. He's trying to see what matters and what doesn't."

"I'm sure he is," I murmured in a tone that came somewhat, I confess, from a *de mortuis* tact.

"He really is. That book he wrote is crude, but it has some good passages. If anything were to happen to him, I'd try to get it published again."

There was silence, and silence was not as pleased as if a nightingale had sung. We both knew how difficult it is to arrange for the republication of a book after the author's death, unless he has recently received some extraordinary publicity in a land that finds so little time for unjournalistic reading.

In the silence, which must have made her nervous, Althea continued to caress herself rhythmically and silently, with her mouth half-open and her eyes half-closed, but ever on guard against a move in her direction by her stepson. I was permitted to observe her secret rite, but he was not. I sympathized with her, and admired her ingenuity, but I was grate-

ful for his presence in the little room. If he had gone out to get a cigarette, I might have had demands made on me, in the name of an old friendship that I, or at least a majority of me, no longer desired from her.

To give her a protective cover of talk, assist her consummation and selfishly defend myself against any unwelcome importunities, I threw out the first thought that came into my mind—more incoherently than the discipline of frequent lectures ordinarily permits me to speak. "Your father takes a real interest in the avantgarde," I informed Tommy redundantly. "Actually, the avantgarde bores me. I mean, most of the time. Of course it *is* important. We *are* dependent on what our most original minds discover. But—" My improvisations floundered. I remembered a racehorse, seen in childhood, that fell down on a muddy track. How it struggled to get out of the mire! I too struggled. "In all fields, of course. I'll try to write a good book for him!"

While I delivered these non sequiturs, which cost me any reputation for common sense I may have established with Tommy, his stepmother muffled a cry of relief from between tight lips. She then closed her red-lashed eyes, moved her guilty finger to a harmless place at her side, and stretched both legs and arms with catlike pleasure.

I said, "Excuse me!" abruptly and left the room. If I had had my wits about me, I would have done it sooner. But my mind had been befuddled by her, and I had been taken by surprise. Now, delivered from her tacit conspiracy, I walked as briskly as possible to an elevator, and when it reached the ground floor I sought the lucidity of the night air.

At the front door I saw an elderly man with a white mustache, an oversize, grease-stained hat, a heavy cane and a battered cardboard valise being helped by a taxi driver into the hospital. It helped me to open the door for them. The shock on the man's face, when he found it beyond his strength to hold a lightweight glass door with his own hand, erased from my mind the scene I had witnessed upstairs. The man seemed all alone. No wife or family accompanied him. In mild weather he wore a heavy blue overcoat that reached below his knees. I thought, "His last days are near." He had come to the hospital, however,

on his own legs, at a minimum of expense, not like Warts, in an ambulance. Shabby Thanatos banished rich, confusing Eros from my mind. The sight of suffering delivered me from the spell of the unhappy woman upstairs.

I would have gone home at once without any further word, if I had not feared that so rude a departure would wound Althea. In a mood of resignation I went indoors again, took an elevator to the floor I had left and walked toward the room in which the Blacks waited. My intention was to say good night firmly to them, and then leave. Surely by that time I had discharged any obligations to look after Althea in a time of need.

As I walked along the corridor a man's voice called out my name. It came from one of two men in white whom I was about to pass without examining their faces. When I did look at them I recognized the darker of them as a young Greek physician whom I had met a few years before on a French boat that was taking us from Le Havre to New York. His name was Vassily Ventris. He brought a letter of introduction to my wife and myself from a mutual friend in the American embassy in Paris who asked us to do what we could to make him feel at home in America, where he was going to start his medical career all over again.

Vassily Ventris came from a prominent family in Athens, and had been working in the Institut Pasteur in Paris. A distant cousin by marriage was the Michael Ventris who had changed many opinions in archaeology when he deciphered the famous Linear B code of old Cretan tablets and proved that it was an archaic form of Greek. So Vassily had anglicized his last name. Vassily also desired to make an international name for himself in medical research, and moved to Paris from Athens for that reason. Now he believed, after a painful French divorce, that he could do better work and succeed more easily in New York. On the boat we liked him very much, and after he landed, while he was serving his internship in a New York hospital and taking his New York State medical examinations, which he passed brilliantly, he visited us several times in East Hampton, where we lived then.

Now a few years later he was licensed to practise medicine in our state, and served as an anaesthesiologist in the same hospital where Warts was taken. (I had forgotten that, although he had visited us once in our new house in New York City.) He

was earning large fees and saving his money, he said, so that he would have some when he landed a job at a lower rate of pay in research. There was one particular appointment, in the field of genetics, that he wanted, and he was willing to wait until he got it.

I knew that he had taken care not to marry again, although he had made an extraordinary impression on three free women whom he met in our house. With two of them, each older than himself, he had had brief love affairs, unless I am mistaken; but most of his spare time, he told us more than once, went into writing a book in English. "It's not good writing in Greek," he said. "Nobody reads you. Look at Cavafy and Seferis." His English, which he had learned first from a Lancashire nanny and polished later at Oxford, was excellent. So also were his French and Italian. His linguistic achievements meant nothing to him, however, next to his desire to establish himself as an author, after he had also established himself as a scientist. "If Chekhov could do it, why can't I? And what about your own William Carlos Williams?"

He wore his dark hair longer than most doctors permit themselves. By this time he had reached his mid-thirties, but he looked and behaved as if he were ten years younger. "The time of the longhairs has arrived!" he said. "It is a good thing you Americans are not any longer so shorthaired and so practical. You're wearing brighter colors every year, and you're dancing! Whenever my book bogs down I go to a *discothèque*. You can't do the new dances in short hair, you really can't." He pronounced the word cahn't. "I love New York!"

His reddish cheeks were always clean-shaven. He must have used a razor twice a day to keep his beard from showing. "The minute I start working in that lab, I'll let my beard grow!" When he laughed his long white teeth showed no fillings or cavities at all. "It's because of the Greek olive oil I had as a baby. And yaourti and retsina!"

He was not content to shake hands with me. He kissed me on both cheeks, more warmly than the French do, and I of course kissed him back. "Gerald! Gerald! What are you doing here, in the house of death? Don't tell me that Buffie—!"

I assured him that my wife was well, and I was only there

at that late hour because a publisher whom I scarcely knew had been—. He interrupted my tedious explanation. "Thank God! She's well. Mr. Sykes has the most marvellous wife," he said to the other man in white, while introducing us.

The name of the other man in white was (and here I am not seeking an equivalent for his real name) Dr. White. His first name, Homer, may have recommended him to Vassily, but a greater recommendation must have come from his thin lips, his narrow eyes, his close-cropped hair, his nasal midwestern voice, his general grimness. I assumed at once, because I had had time to become acquainted with Vassily, that he had sought out Homer White as a friend because he conformed to the American type that is most antipathetic to Europeans. Either Vassily was studying him for his book, out of malice, or he was trying to fathom a new continent through one of its least loveable anthropoids, trying to understand a subhuman byproduct of the puritan ethic that no other European would bother to consider. Homer White seemed to me an exaggeration of all our worst traits, a frozen Calvinist life-hater if I ever saw one, and not a physician to whom one would voluntarily submit. But on the other hand human beings were always surprising me, and perhaps he would surprise me too. I confess I looked forward to a clash that I regarded as inevitable between him, as a representative of a great hinterland plurality and the more volatile metropolitans who awaited me in the off-white room. Once again my departure had been delayed. "Come and meet my friends," I said.

I especially wanted to witness the reaction of Tommy Black to Homer White, who seemed as square, as crewcut, as prudent, as free of animal charm as it was possible for a physician to be and still dream that patients would come to him without orders from the police. Tommy, I felt sure, would recognize him at once as bearing a distinct resemblance to Secretary McNamara, who was blamed by many students for the escalation of the war in Viet Nam. I could not help thinking that if Homer White had wandered onto almost any campus, during those Gene McCarthy days, he might have been taken for a younger brother of the former Secretary and lynched summarily as a warning to the Establishment.

Homer White would be to Tommy Black, I was sure, what

the cautious professor of philosophy was to Angie Jones, a constant reminder of all he detested and an indicator, by contrast, of all he loved. So through a misguided taste for comedy I let myself be drawn once again into the drama of the Blacks, opened the door to the room in which Althea and Tommy waited, and brought Vassily Ventris and Homer White with me. They were off duty at the moment, and had been on their way to drink coffee together.

To awaken the interest of Vassily I had only to mention that the husband of Althea and the father of Tommy was a publisher. Every day Vassily returned to his apartment to work on his manuscript. It was almost ready to be seen, but as yet he had made no connection with the men who read manuscripts and, when they like them, get them printed, reviewed, advertised and sold. In my house he had mentioned a desire to meet such men, but I had told him to wait until he had finished his book and then to let me see it. After that I might have some suggestions for him.

Now, when he heard the name of the prominent firm of which Warts was editor-in-chief, Vassily seemed to feel that at last he was making the kind of professional contact he needed. He inquired solicitously after Warts, and was as charming as he could be, which was very charming indeed, to Althea and Tommy. They forgot their anxiety while they talked to him, and instinctively turned away from Dr. White, who might have had the opposite effect on them. The off-white room, which a few minutes before had made me flee it, now took on the vitality that Vassily felt, with justification, set him apart from other men. From the first time I saw him in the tourist class bar of the old *Liberté* I had been delighted by his exuberance, his skill with words, his capacity to make every moment seem important. His exuberance, in fact, was so bountiful that it caused me some misgivings about his literary expectations. He might be too spendthrift, I feared, with the god of frenzy in conversation, and forget to garner his best verbal discoveries for his desk. He might be too freely dionysian, and not sufficiently a cool student of effects, not sufficiently a professional observer who was willing to sacrifice social triumphs for those

more modest ones that can only be obtained on the written page.

But this was not a time to worry about him as a writer. It was a time to enjoy him as a performer. In a moment he changed the mood of the tense Tommy and the prone, lethargic Althea. Tommy put aside a paperback by a new Scots psychiatrist that he had slipped into a pocket while we awaited the ambulance that came for his father. Althea sat up and perked up.

"You can't be American," Vassily told Althea. It was evident at once that her ripe beauty attracted him. I prepared myself for an exhibition of his talents. "There's something languid, mysterious about you. You must be Mediterranean."

Homer White looked on with what seemed admiration at this brilliant gambit. Out in the swaying cornfields no one had taught him to talk to a woman like that.

"Well, I am half-French," she confessed, dropping her eyes as if she were also half her age.

"I knew it!" Vassily began to worship her as if she were the only woman left on a doomed planet. "I like Americans. They are always so simple, so clear. And they work so hard." He glanced respectfully at Homer White as he said this, and then returned to his apotheosis of her. "But you—you are like an ancient goddess. You have something that I do not understand, that I would never understand." He searched his mind for an appropriate phrase and found one that unfortunately we had all heard. "You are a riddle wrapped in a mystery inside an enigma."

Tommy liked Vassily, but he knew more about erotic gambits than Homer White, and he was not inclined to let this one pass unchallenged. "I'll bet you say that to all the girls," he remarked rather cattily.

"I am merely quoting an English poet to your mother."

"She is not my mother, and the English poet is Winston Churchill—on the subject of Russia, where my real mother was born."

"Forgive me!" Vassily turned to Althea and apologized. "But I am glad to hear you are not related to this—this marvellous quiz kid!"

"I'm related to him all right," she said drily. "I'm his step-mother, and he's never forgiven me. But how did you know he was a quiz kid?"

"I am not!" Tommy protested.

"Why be so modest?" she said. "I've seen the photographs. Your father showed them to me while he was courting me. When you were only eleven years old you began appearing on quiz kid programs, and you kept on appearing on them until you were seventeen. The only question you ever missed was, 'Who said "Know thyself"?' You said it was Sigmund Freud, but the book said it was Anon."

"Anon was a Greek," Vassily remarked, and added generously to the embarrassed Tommy: "Freud revived the question brilliantly. And nobody knows who said it first, Socrates, Plato, Pythagoras or some woman poet who lived before Homer. Not you, Homer, the other one."

Homer Smith followed this dialogue with an intent expression on his face which may have meant that he understood every nuance of it. I decided that I had over-hastily misjudged him when I had dismissed him as a frozen Calvinist life-hater.

Tommy revised his judgment of Vassily, and returned to his original favorable impression. "Are you interested in modern psychology?"

"Very much. Greeks pretend they don't need it, but they do. They think they have inherited the wisdom of the great poets and philosophers of antiquity without effort, but of course they haven't. Greece was the cradle of civilization, and the modern Greeks have stayed in the cradle."

Tommy laughed. "I must admit I thought something like that when I was on Mykonos."

Vassily now had a chance to display his brilliance to both the stepson and the stepmother. "Every Greek thinks he is the center of the world, the *omphalos*. That's why he actually *prefers* a dictatorship, to protect him against all the other Greeks who he knows are thinking the same thing. He is aware that they are just as childish as he is, and he hates to imagine what they would do to him if they were given half a chance. Some day of course Greece will be forced to accept modern democracy and modern psychology. They will have to argue out every

political issue and take a good look at themselves. But not just now. *Know thyself* started in Greece, but now it is only a phrase in the anthologies."

He ended on such a bitter note that I remarked: "You're in a worse mood than the last time I saw you."

He laughed. "No! I'm not in a bad mood. At last I've found the great theme of my book. Everyone around the hospital calls me Zorba. Why? Because I'm Greek, and they've seen a not very good movie called *Zorba the Greek*. It's not Kazantzakis or Cacoyannis or the actors at their best, but it's caught on, it's made a lot of money, and it's helped the nurses and the orderlies to find a name for me.

"Very well, I'm Zorba, and I have got my theme. I'm going to show the world what Greeks are really like. They are *not* carefree peasants like Zorba, they are *not* the Dionysians that they borrowed from Nietzsche, and they are *not*," he looked at me, "like your friend the Colossus of Maroussi either. They are potentially the most interesting people in the world, but first they have to look at themselves, forget all about Zorba, Dionysus and the Colossus, and realize that to be worthy of their great heritage they have to give it up. They have to forget the glorious past and learn from the present—above all from the Americans, whom they pretend to despise. That's why the real action was in New York, and I wanted to see it."

Homer Smith looked on with what seemed approval of this favorable reference to his own country. Once again I was sure I had misjudged him.

"What do you mean by the real action?" Tommy asked.

"The transformation of people by technology. What we used to call the mechanization of humanity. Even Freud didn't see that coming. But now it is the chief psychological fact about people, in Athens, Paris, London, but above all here. I see it every day in my patients. New York is the center of the real world revolution."

"This man wrote a book about that," Tommy said, pointing to me. "You're almost quoting him."

"Of course I'm quoting him. Why do you think I go see him? Because of his shrimps and okra? I can cook just as well as he does. Better! But he makes a typically American mistake. He

doesn't understand how much all people in old countries live off the past. He doesn't know in his bones how hard it is to forget about Socrates, Phidias, Zeus, Dante, Pascal, Chardin, Shakespeare, Bach—forget all about the *grandeur* of the past, so it's easier for you. But we have to do it too, and it's not going to be eas—Forgive me, madame," Vassily said to Althea, although he had never taken his eyes off her and must have noticed that she had yawned. "I hope I haven't offended you by attacking your French heritage. It *is* great of course. But Sartre was right. A Frenchman can only find an authentic life for himself if he forgets his heritage and commits himself to the present." And when she still looked bored he said: "All those ideas mean nothing when I look at you."

She perked up again. "When you look at me?" she asked, as if the statement perplexed her.

"Yes! You have the marvellous ripeness of the past, and yet you look as if you live very much in the present. You are *beyond* the ideas we are discussing so stupidly. You have *solved* them. You combine the mature grace that we expect of culture with the keenness, the hope that we find among the new conquerors. You unite Europe and America."

I could not understand the expression on the face of Homer White. Was he pleased or displeased by this juxtaposition of the Old and the New Worlds?

Tommy studied his stepmother with a new wonder, as if he were asking mentally: "Are you really all that remarkable? Have I failed to appreciate you? Have I denied myself some erotic vitamin that I need? *Should* I lock my bedroom door against you? Or is he just doing a snow job, so that he can unlock yours?" The verbal skill of the supple Greek, who had bravely stripped himself of all the many consolations of the Old World and faced the many confusions of the New, made a visible impression, or so I imagined, on the young American student. Aloud he merely said, and as if he had reservations about it, "That's quite a tribute, Althea."

"I don't deserve it," she said curtly, as if mindful that she must not be flirting while her husband lay nearby, perhaps in his last agonies. "I love the art of the past, and I am on the lookout all the time for the art of the present, *if* I can sell it.

I'm just a shopkeeper. I have failed in what I set out to do. Nobody even looks at *my* pictures. And now I guess I have failed to look after my husband's health—though I did keep after him to take his medicine."

As a statement it was as courageous as the earlier one she had made in her own house, her other confession of failure. I had to admire her once again for a freedom from illusion that I would not have expected after her fantasies about Lovelace, Sussex, Montmorency and Santayana. She appeared to be stuck with those, as youthful contrivances that she could not now renounce publicly without unendurable loss of face, but on more important matters she was able to look squarely at the truth. Her frank quest of physical composure on the couch, her open violation of all tabus had also been part of her new freedom from illusion. To me there seemed nothing sordid or dirty about it. It had helped her to face a difficult situation, after a trying day, amid conditions that might have caused another woman to collapse. It commanded my respect. Without knowing exactly what I was doing, but acting as instinctively as when I had fled the room, I crossed over to her and took her head in both hands and kissed her on both cheeks. My act was solemn, almost reverent. "Althea," I said, "you are *not* a failure."

Everyone else looked puzzled, but she understood, and kissed me back, on the mouth lightly. "Thanks," she said.

"Why did you do that?" Tommy demanded of me. I had become his latest teacher, and therefore had to justify every word and every act to him.

"Because your *step*mother is a really extraordinary woman. She is one of the few people I have ever met who could *learn*. Who could *change*. When you've gone a little further in psychology you'll find out how rare that is. And how important. Althea, I'm *very* glad I had a chance to see you again, but I think I'd better be running along now."

"Please don't!" she begged me. "Stay until we have word about *him*." Looking helpless again, she moved her shoulders toward the room where her husband had been taken.

I couldn't think of him as Warts any longer. It was too jocular, too insulting. I remembered that his first name was Aloy-

sius, and thereafter tried to forget the unpleasant nickname I
had cruelly given him in my mind after my first sight of his
disfigured face.

"Why don't you let me send for some coffee?" Vassily offered
gallantly. "Dr. White and I were on our way to—"

"I've ordered some," Althea said. "And some food too. When
they bring it I'll order some for you. Don't go away. You make
me feel better," she told Vassily, as if to soften the curtness with
which she had received his tribute.

We all sat down with her and waited for the food, four
men and a woman. No one said anything, not even Vassily,
who could usually be counted on to breach an awkward si-
lence. I remarked to him: "I was in Athens a few months ago,
with Buffie, on my way to Beirut."

"Oh yes, I got your card. I meant to ring you up, but I no
longer have any time. My book gets more and more exciting.
When I an not working here or on the book I have to be
cultivating important scientists who might help me to get the
right job in research. So you saw Katsimbalis? How is he?"

"As colossal as ever. And his wife just as nice. We had dinner,
all four of us, in the Plaka."

"You mean *George* Katsimbalis? The Colossus of Maroussi?"
Tommy asked. He had missed an earlier reference to the man,
but now caught this one and looked truly impressed. And when
he heard it was the same person he said: "Why, he's why I went
to Greece! I read about him in that great book by Henry
Miller. Now that's avantgarde."

"It is indeed," I said, and turned to Vassily. "I didn't under-
stand what you said about Katsimbalis. He's not living off the
Greek past. He's a man of the present. He does his best talking
about food, wine, peasants, roosters, war, islands, old wounds,
new poetry."

"You're right," Vassily admitted. "I was only thinking of
what others do with him, how they confuse him with Diony-
sus. He's wonderful—for *his* generation. Now we have to go
beyond him. That's what I'm doing in my book."

"Do you think your book will be better than his conversa-
tion, as reported by Miller and Durrell?" Tommy asked with
open disbelief.

"Yes! He *is* wonderful, but he's an old-fashioned romantic. He has no use for science, and he hates the new technology. But I've learnt that we have to live with them. We have to become poetic in a new way, Dinoysian in a new way, *after* we've assimilated the worst that science and technology can throw at us. And business too. We can't pretend they don't exist, or they are no good, the way Lawrence and Miller and Durrell did. We have to take them in our stride, conquer the new mechanical environment with our minds, our souls, not ignore it. You said something about the avantgarde—that's the new job of the avantgarde, to take in all that we naturally hate. Do you think Shakespeare liked Claudius as much as he liked Hamlet? Of course not, but he presented that businessman king just as sympathetically as he presented the poet prince. Sophocles did the same thing with Creon and Oedipus. Why are we so afraid of science? Because we are afraid of drama. We're afraid to consider *all* the points of view. We can't take our enemies as seriously as we take ourselves. That's why we moderns become so thin in our art. And why," he turned to Tommy, "we have to think so much about psychology. The minute we stop accepting other points of view, the minute we fear real drama, real tragedy, we become sick. We become schizophrenic, or paranoiac or manic-depressive, or maybe all three. If we're lucky, we get off with minor neuroses. If we're not, we become psychotic.

"I've moved from a country that is still sane to a country that is going insane. Yes, America is going under, Homer, and your attempts to overlook it will do no good."

Homer White glared at him but said nothing.

"The American insanity will finally produce a great culture," Vassily continued. "Of that I am sure. But first there will be the worst, the most meaningless holocausts ever seen. Meaningless except that finally they will lead to a new meaning. A fusion of art and science. This means more to me than anything else. I am a scientist, and I am also a poet. I was born to sing, dance, write, but my family was bourgeois, very bourgeois—they owned a kind of palace on an island, beautiful, white, nice enough to stay in all one's life—and they said to me, 'No, you've got to be a doctor first. Do something useful. You always have

to earn money. Then if you make money, sing, dance, write
as much as you please.'

"I disagreed with them, with every word of it, but I obeyed
And now I am glad I did. My life is ten times harder than if
had insisted on being a singer or a dancer or a writer, or if I had
stayed on the island and made love to the tourists. Now I see
things that other writers apparently don't notice. I see things
scientifically as well as poetically, in the round. I make enough
money to keep going, and I am able to help a few people who
get sick. And some day I'll put it all down in a book, and the
world will read it in time, and realize that true literature must
come from living with one's opposites, one's enemies, from rec
onciling the irreconcilable."

Tommy turned to me. His only comment on the long state
ment by Vassily was one that Vassily could not comprehend
"Is he one of the new heroes you were talking about in the
bar this afternoon? God, how long ago that was!"

"I don't know," I admitted. "He's just made an eloquent
statement of his position—really, it was terrific, Vassily—but
now everything depends on how good his book is. If he can
live up to his vision, if he can live as tragically as it requires
if he can put it all down, then he will be a real hero. He will
have done things that even the best writers of our century
didn't do. He will have bridged the tensions between science
and art. The odds are all against him, but who can say he
won't do it? Vassily, you talked like a master. Even if you
fail with your book, you will still be a hero."

"I'm not Vassily any more. From now on call me Basil.'
He opened his white jacket and showed his white shirt under-
neath. "See? Nobody could pronounce Vassily. So I've taken the
English equivalent. I should have done it years ago, in Oxford
It still means king." The initials on his shirt, which looked new
read B.V. "Basil Ventris," he murmured with enthusiasm. "I
can see it on the door of my lab. No one will know I am Greek
They will think I am Anglo-Saxon. As for the accent and the
dark hair, that will mean that perhaps I am an English Jew. In
New York they will love me. They will trust me. They will
know how to say my name. And in time they will read me."

Coffee, rolls and butter were brought in. All we needed were

two more cups and two more knives, and a nurse went to fetch them. I gave my cup to Homer White because I was afraid to drink coffee at that hour. He accepted it with his now impressive silence. I still believed I was going to get some sleep that night, so that I would not feel exhausted when I lectured for four hours and saw almost a hundred students the next day. For some reason I felt no fatigue at all just then, and wanted to ask Vassily (I couldn't call him Basil) a question that had been on my mind for months.

"There's something you could help me with," I told him. "At that conference in Beirut there were a lot of scientists from Asia and Africa. The conference was called Science and Technology in the Developing Countries."

"Developing!" He jeered the word "Why didn't they come out with it and say Backward? Thirty-five percent of their children are sure to be mentally retarded for lack of proteins and amino acids in their diet."

"People have to have their euphemisms. We have plenty of them over here. The Clean Bomb was worse than Developing Countries. Anyway, one of the heads of the Brookhaven National Laboratory read a paper, and the gist of it was that scientists need a rich, complex cultural background, with more than a nodding acquaintance with the humanities, a background that takes in more than one narrow specialty, if they are to make any new scientific discoveries. When he had finished speaking I asked him a question. He's connected with one of our most highly regarded labs, and—"

"I know," said Vassily.

"Some of our best young talent among the nuclear scientists is recruited there. I asked him: 'How would you evaluate the young scientists who come to your lab?' And he replied that the young talent that came there was very low in quality, so badly educated that one candidate revealed upon questioning that he thought the moon was larger than the earth.

"Now," I said to Vassily, "how does that fit in with what you have discovered since you came to New York?"

"It fits in," Vassily said. "The old scientists are old fogies, and the young scientists are young fogies. If I had come to America for intellectual stimulation, I'd have gone back

long ago. Fortunately, I came here as a spy, to observe how dull the reign of science has made Americans, and the total collapse they are sure to undergo. My book will be addressed to Europeans who want to avoid collapse, once their continent has been completely Americanized."

It was a strong statement, rich in hitherto concealed disappointments, and it called forth from Homer Smith the first response of any kind he had made. "Hold on!" he said. We looked at him expectantly, as if a stone monster in the desert had broken the silence of centuries and condescended to instruct a garrulous humanity. "Do I understand you to say that you have found no intellectual stimulation in this country? Are you completely ungrateful for the opportunities that have been offered you here?" His voice was twangy, but it was resonant, and it seemed to be strengthened by a slow amassment of righteous indignation. His narrow eyes took on the unanswerability of a Roundhead.

"I'm not ungrateful, Homer," Vassily said instantly. "Whatever made you think that?" He flung a warm embrace affectionately around the shoulders that held themselves rigidly aloof from his placations. "I appreciate the chance to work here, and I want to do still more."

"You're already making over thirty-five thousand dollars a year. Perhaps fifty. I'm your assistant. I know," Homer Smith told him, and looked him fiercely in the eye while he spoke. "For a person who's been here such a short time, that's not bad. In Greece you would only make a fraction of it. You said so yourself. In France they wouldn't even give you working papers. You had to do your job on the sly. I fail to see what you have to complain about."

"I wasn't complaining. I was merely discussing the cultural climate with this writer. I love America. I've taken out my first papers. I'm devoting my life to bridging the gap between the two continents. But—"

"But meanwhile you're biting the hand that feeds you!"

"That is simply not the case. I do my work, I pay my taxes, I study the life here not only with scientific detachment but with love. What's more, you don't have enough doctors here, and

I've added one to the supply. You don't have enough scientists, especially scientists who are not over-specialized, and I've offered myself to that supply too, at a considerable reduction in pay. What more do you want?" Vassily's arm had been shrugged off Homer's shoulders, and now fell to his side. He moved a step back and regarded his assistant as an antagonist with whom he must speak coldly and logically.

"What do we want? We want more respect from you. When you make snide remarks about our intellectual incompetence, you insult us. You fail to appreciate all the hard driving work that made your scientific playground possible. The Brain Drain! I wish we could tip it the other way!" The emotion, the thin-lipped illogic of Homer Smith seemed to me to proceed from an old unplumbed grievance against all those whom he considered better educated, better prepared for contemporary existence than himself. He looked a few years older than Vassily, and yet he was serving as his assistant. But more important, he had none of the *joie de vivre* that came so naturally to the Greek. He was quite unable to be gallant with women, and when he spoke he sputtered resentment.

The superior training of Vassily continued to mow Homer down. "I think you are taking an offhand remark too personally. God knows I wasn't talking about you. *You* stimulate me very much. You embody the essence of America. I try to understand you better every day. I tell myself, 'If I can understand Homer, I shall understand America. He's everything I am not. He was born into political freedom. And into a rich soil, a thriving economy, a magnificent faith in the future. He doesn't come from a poor country with no soil to speak of, nothing but bare mountains and sea. He's never known dictatorship. He's never known invasion. Every time he speaks I can hear the golden cornfields of Nebraska rustling in the sun. I can—"

"Oh so I'm corny too!"

"Homer! You know I didn't mean that!"

Homer put down his coffee cup, found a quarter in his pocket, put that next to it, and rose to his feet. "You've taken out your first papers," he told Vassily. "I wouldn't be so sure

of the final ones." He bowed to us stiffly, said "Good night!" as if we also had betrayed him and his country, and left the room.

We stared at the door that he closed quietly. "Whew!" said Tommy. "And that nut is allowed to treat patients?"

Vassily turned to me. For the first time he looked disturbed. "He was threatening me! Is he going to go to the FBI? What will he do?"

Though without any special knowledge in the matter, I re-assured him. "The FBI must be used to cranks who denounce everyone. What can he say against you? That you don't find American scientists intellectually stimulating? This is the kind of complaint that gets marked File and Forget."

Vassily reflected on his association with Homer White. "We've worked together for almost a year. One night I took him out on a blind date, picked by a computer. The computer told him the girl was just right for him. You should have seen her. She was Greek-American. Maybe they mixed up his number with mine. In Athens that kind of girl never gets married, even when her father owns *two* shipping lines. She had blon-dined her hair, and you could see the black roots. She must have spent as much on razor blades as I do. She weighed about eighty-five kilos—that's over 185 pounds—but her dress looked like something that a baby wears. You know, rompers. With a pale blue ribbon in her hair. And when Homer didn't warm up to her she began to tell him what was wrong with him. 'You don't know how to dance. You say you're a doctor, so why don't you give me a prescription for something? Or an injec-tion? Why don't you say something?' I slipped away with my girl, who came from Nebraska. Homer never forgave me, he said I changed the numbers. That's why he let fly at me tonight."

"He never forgave you for existing," Tommy told him. "You're full of life and he's full of death."

Vassily turned to Althea. "Forgive me, madame. I must apolo-gize for exposing you to this awful scene. But when I came here with Dr. White I had no reason to—"

"I enjoyed every moment of it," she told him. "I haven't seen a real hundred percenter for years. The Grant Wood types stay away from my gallery." She smiled at me. "Here we've

been talking about painting, sculpture, books, music, theatre, architecture and philosophy all night, and then this American Gothic walks in and shows us what a tiny market we are. There are millions like him, and only a few like us." She turned back to Vassily. "You really mustn't worry about him. He outnumbers us, but he can't do you any harm. If he does go to the FBI, he may end by getting into trouble himself. I'll write both my Senators and my Representative if you like."

"Would you? I knew you were beautiful, but I had no idea you would be so kind—and so resourceful!"

The door opened. Judith entered with dark eyes shining with newly acquired information—and a greater willingness to be the center of attention than she usually permitted herself to display. Her free hand bore a copy of an early edition of *The New York Times,* so fresh from the presses that it left ink smudges where she had held it. "Guess what happened!" she cried to Tommy with none of her usual reserve.

"Did they review the Muhlhauser concert?"

"Yes but that's not it. I was sitting in a diner, working on my lecture notes for tomorrow. Any news about Papa?" she interrupted herself anxiously.

"No. Go on! What happened?"

"They were playing the radio. Rock. I just tuned it out. And then there was a news bulletin. What do you think?"

She said it almost as if she were a schoolgirl again, playing on his dislike of suspense.

"What happened?"

Her news was no anticlimax to him. "There's a strike at Columbia. That's what they called it. Some students have seized Hamilton Hall."

"Oh God," he almost wept. "It's happened, and I wasn't there!"

"Did you know about it?"

"Of course! But I couldn't go. I got so caught up in things, and then Dad got sick—" He glowered at me. Obviously I had been responsible for his absence.

The door opened again. A whitehaired jovial man, looking rosy and comfortable in a long white smock, went straight to Althea.

She stared at him anxiously.

"Mrs. Black," Dr. Neville patted her hand. He was not used to treating patients at night, but Aloysius Black was an old friend. "Your husband is resting comfortably. I think we can get him out of here in the next few days."

"Thank God! I'll stay here with him. Will you get a room for me, next to his?"

"Of course, my dear. But I want you to take something before you go to bed. You're not to worry. You're not to worry about anything!"

INTERLUDE: UP-TO-DATENESS IN ART

More and more readers try to keep up with the arts and sciences, usually in newspapers and magazines. Newness of thought is now almost as sure to be news, though not as easy to report, as recency of action. Readers of some education do want to know if the Pill is dangerous, if the latest explanation of youth is plausible (and palatable), if the latest developments in metallurgy may alter the military situation in the Far East or the Near East.

Up-to-dateness has saved many lives in wartime. Some refugees are alive because they kept up with what was happening in the land of their birth. Up-to-dateness has also created many fortunes in peacetime. New millionaires owe much to new technologies.

Up-to-dateness is essential in the sciences. It is *not* essential, though it can be useful, in the arts. The sciences win their final assent from the cortex, the newest part of the brain, capable of reason. The arts must also win the assent of the instincts and the emotions, which come from an earlier part of the brain, the diencephalon. That is why debates continue among artists that do not continue among scientists. In science the satisfaction of empirically informed reason is enough. In art it is not. Questions of style, taste, depth, wholeness, relevancy cause constant reversals of judgment.

Newness was by no means the sole criterion of the masters of

the aesthetic avantgarde. They had a sure sense of what was new because they also had a sure knowledge of what had been done before. They were never without culture. To see them as traditionless provincials is to miss the point altogether. It was the organic solidity of their culture that made them able to know what, in terms of their talents, *had to come next*. If Cézanne had not understood more about the past in painting than, say, a professor of art history at the Beaux-Arts, he would not have been able to give its present and future an ineluctable direction. If Nietzsche had not understood more about the past in philosophy, than his colleagues at the University of Basel, he would not figure now in the curriculum of the university as they do not. Both of them drew upon their instincts and their emotions as well as upon their cortical powers of reason. And so, since they brought off an all but impossible marriage of warring parts of the mind, they have posthumously, and after almost no applause in their own time affected the future.

Such saintly (if unintentional) consecration to posterity—after all, what *did* it ever do for us?—has become rare in our own day. Our artists live in an overcrowded, overcompetitive *souk*, with flashbulbs ready to pop as soon as they do anything that can coax a grunt of astonishment (or derision) out of an apprehensive public that is as bored as a vaudeville booking agent. So they are best understood in the context of the pressures put on them: more economic strain than ever before (a market geared to a leisure class that has no leisure, and an end to the days of easygoing WPA poverty); more need for publicity if they are to survive ("artdealers have ears, not eyes"); more demands than ever before, from students, that they meet the highest standards of past, present and future.

Of no other workers is so much required. Only the compulsions of talent would put up with such conditions. In the circumstances, the qualitative demands are those most frequently jettisoned. Any lingering perfectionism, any desire for more than simplistic effect is professionally regarded as a pathological impediment to impact. Yet this is asking those born close to the soul to renounce the soul. It is asking bold Prometheans to become tame Epimetheans. If ever a class of people deserved our sympathy, our support out of enlightened self-interest—yes, more than the poor do! (our real problem is *not* poverty, horrible though that remains; it is prosperity)—it is our artists.

Yet because they remind us of our own spiritual defeats and

over-prompt renunciations we are usually rougher on them than on anyone else. They are scapegoats we can drive out but cannot tranquilly forget.

Today our artists, no matter how injurious it may be to their work, find they *have* to keep up-to-date. For example, in the year 1970 they have to know that in the last month of 1969, with little publicity, the income tax law was changed to allow collectors of pictures or scores or manuscripts to take a deduction for gifts to museums, but not the artists who painted the pictures, or composed the scores, or wrote the manuscripts. Once again one of our most defenseless groups has been discriminated against, and they are obliged by law to be aware of it.

Somehow or other, in spite of all pressures to live a totally ephemeral existence, intent only on economic turnover, they also have to keep in touch with a timeless and selfless part of themselves which enables them to do their best work. If fewer of them are able to perform this extraordinary feat, no one should be surprised.

Up-to-dateness is now required of us all. When it becomes unendurable we drop out. Or, less radically and more often, we tune out everything contemporary that is not congenial. The perennial avantgarde, however, can neither drop out nor tune out. It is now required to keep abreast in fields other than its own (or it dries up) and to lead a full life (or it lacks the authority of experience.)

A news item as important as any other in our time will be the fate of the perennial avantgarde. We shall have to keep up to date on it.

TEN

POLITICS AND THE YOUNG
AMERICAN PRINCE

After we had taken our leave of Althea, who was to stay in the hospital as near to her husband as possible, Tommy, Judith, Vassily and I went downstairs to the lobby, which was now deserted except for a silent Puerto Rican in a grey uniform who mopped a floor. Toy rabbits and bears stared at us from the window of a gift shop that had been locked for the night.

Tommy had been in a state of agitation ever since his sister had brought news of the strike at Columbia. "I should have been there! I should have been there!" he muttered. He did not blame his father or anyone else for having kept him from performing what he plainly regarded as his duty as a student. His lean body was filled with the energy of guilt, which he wanted to expiate as soon as possible by going to his university.

"I'll take a taxi!" he told his sister, who instantly objected.

"You probably couldn't get into Hamilton Hall. The radio said it was barricaded. Why don't you wait until tomorrow? Get some rest. You're very nervous. *Under*graduates are doing it all. Maybe they don't even want you."

"They want me. I can talk to the blacks. There could be a split with them. Come on, I'll drop you off at home, and then hurry uptown."

A taxi appeared just then, and they jumped into it. Once they were inside, they remembered us and waved good night.

I told Vassily I would walk home. The cool night air felt good after the many scenes I had had to witness.

"Stay a minute," he pleaded. "There's an important question I want to ask you. It's lucky you stopped by tonight. You can see the whole business from a non-professional point of view." And then in a low voice, although there was no one else in the lobby at that late hour except a receptionist who read a

189

tabloid newspaper, he told me that he faced a serious dilemma. He had not been able to get into the distinguished research institute where he wanted to continue his studies in the field of genetics—"They say I'm too old! Me! Too old!"—but he had been offered a better-paid place in another organization that also did scientific research. The drawback to the job was that its kind of research was aimed at improving American weaponry. The money came from the Defense Department, and the weapons would be biological.

"I can't do it. I simply can't," he confessed.

"Then don't."

"But that means I'll have to be a G.P. I never specialized. I was always planning to go into research. Now I'll either have to stay on here, which is no more than a steppingstone, or else I'll have to be a general practitioner. One can't become famous at that."

"Your hero Chekhov did. And why do you worry about becoming famous?"

"I could never go back to Athens as an ordinary doctor. There are too many great men in our family. My grandfather—"

"Oh, come on! You'd be a very good G.P. and they're ten times as useful, as interesting, as human as the pure scientists I know."

"Are you asking me to be merely human?"

A door opened. The white-mustached old man with the heavy cane and the overlong overcoat was being ushered out of an office by a stout, middle-aged nurse who carried his cardboard valise. He looked in a deeper state of shock than when I first saw him. I walked over to see if there was anything I could do for him now. Vassily followed.

The old man had a hard time explaining his problem. He had lost his false teeth, and he spoke with a heavy accent. (Was it Hungarian?) Finally I learned from the nurse, who seemed to feel sorry for him, that he lacked the right papers and therefore there was no place for him in the hospital. I asked him to let me see his papers, and discovered among them an honorable discharge from the Army of the United States in 1919.

"This man is a veteran," I told the nurse.

"I know. He should go tomorrow to the V.A. They'll look after him."

"He's in no condition to go anywhere," Vassily said, picking up the helpless one's valise. "I'll find a bed for him in a ward. Don't worry, nurse. I'll take the responsibility." He said good night to me, and helped the old man toward an elevator.

The next time I saw Vassily was in Althea's house. The occasion was a small dinner party to which both my wife and I were invited, some weeks later, early in June. At the last minute my wife, whose curiosity I had aroused with my report of the previous dinner with the Blacks, received a telephone call from her aging father and felt obliged to drive to Long Island and see him. I went to the Black house alone. I was instructed to bring back an account of everything that happened and everything that was said.

Althea had told me on the telephone, when she asked me to dinner, that her husband's recovery had taken longer than the jovial doctor had predicted but at last after a blessedly uneventful visit to Bermuda, where he could hear the fall of each white jasmine petal in the garden, he felt better and planned to return to his office the following Monday.

He looked tan and rested when I saw him in the Louis XV drawing room, which was twenty degrees cooler than the Sahara of cement, fortunately short, that led me to his house. He had taken off his seersucker jacket, and invited me to do the same. When I looked surprised to see him as usual making a Scotch and soda for himself he told me that his doctor allowed him two drinks a day and this was the first. "Don't worry, that contract will go out to you next week, as soon as I get back to the office."

Althea's white skin looked pasty. Taking care of him, flying twice to Bermuda to be with him, keeping peace with her stepchildren, postponing a long-planned, important trip to Venice and the Biennale, winding up the season with a group show in her gallery: the last weeks had put several extra burdens on her strength. "If it hadn't been for Deborah," she said of her assistant, who was there to provide a table partner for Vassily, "I'd

have cracked up completely." This time it was Deborah who wore beige and Althea who wore yellow. Both looked as if the heat had ignored them. The daily discipline of dealing with customers appeared to keep them from sweating.

Tommy, the member of the family who interested me most, wore a white bandage on his head, over the left temple, where a detective had cracked him with a blackjack. Almost as soon as we had shaken hands he remarked bitterly, "I used to think paddy wagons were so funny in the old Chaplin comedies. Now I don't think they're funny at all. Too many of my friends were dragged off in them. We have to do everything in our power to prevent the creation of a police state."

"I certainly agree with you," I told him warmly. "There was no reason at all to slug you like that." It was the first time I had seen him since he had been injured. A few days before the injury, during the last week of April, between the beginning of the strike on the afternoon of the 23 and the police "bust" in the early morning of the 30, I had happened to run into him on upper Broadway, near Columbia. At that time he had told me what he thought of the strike, now that it had taken place, as well as what he thought of its leaders, the faculty and the administration.

He had never been a thoroughgoing activist. He admitted it. He had been caught up in the excitement of the strike, while it was being planned, but after it took place he became less emotional about it. And he had been absent from the campus at the very time when students, roused by a radical leader's eloquence, had rushed from the Sundial and taken over nearby Hamilton Hall. Though pursued by a telephone call and a visit from a student who admired him (Leon) he had stayed away from the university, not only in the afternoon but throughout the entire evening because he preferred talk to action, had a chance to sell a script to the movies and later had to look after his father.

I could see that as an exceptionally reflective student, intent upon becoming a psychologist (if the draft permitted him) he had also been distressed, as he told me frankly on Broadway, to find that the radical leaders of the strike wanted "to get power more than anything else. And headlines. When you get

to know them, they're very sick people. They won't see anything but what they want to see. Sometimes I wonder if they aren't doing all this so they won't have to take a look at themselves." But he was equally disappointed with the faculty, which he called "hysterical," and he thought the administration was much worse. "The administration is so bad that it justifies everything the kids are doing! You know what? The kids are *smarter!*"

After he had left us at the hospital on the morning of the 24, he told me, he went by taxi straight to Columbia but found it impossible to talk to his particular friend among the blacks who quietly but firmly ejected all whites from Hamilton Hall. Thereafter he spent almost all his time around Columbia, even though, as he said, "I began to be ambivalent about the strike. But after all I believed in it."

About three o'clock in the morning of April 30, he told me now in his home, he was standing with a few hundred students and teachers, sympathetic to the strike but not radically involved in it, in front of the east side entrance to the Low Library, which the radicals had seized and were holding. At last the police had arrived. A showdown was imminent. He and the others on the outside of the library were told by the police to move. He did not move. He had seen a teacher knocked down and blackjacked by some detectives in blue windbreakers that looked like Columbia jackets. The detectives had sprung up from bushes and beaten the teacher and kicked him, and then dragged him off.

"Those cops *enjoyed* it. They *liked* beating up that teacher. I know I should have run away, but I didn't. I just stayed there. I guess you could say I was hypnotized. I never thought anything could happen to *me*." And then the police shouted to him and the others to move, and no one moved, and the police charged. They carried flashlights and blackjacks. "It was then that I got cracked on the head. I fell down. I was dazed. But fortunately, no one arrested me. I guess they were saving their arrests for the guys who were still inside the Low Library."

Later he was treated at St. Luke's Hospital for his injury, which he said amounted to a slight concussion of the brain but no fracture of the skull.

Now, safely in his home weeks later, he was in the psychologically painful situation of having to defend an involvement which had brought on his injury, at a time when he was no longer deeply committed to it. When he spoke to us at the table he was sometimes quiet and sometimes deeply emotional.

He had had an extraordinary experience, and one that would mean more to him as time passed. He was the thoughtful kind of person who eventually made the most of each active encounter with the outside world.

The family treated him ever so slightly as a hero, and he was human enough to enjoy it. He played down his injury, however, with a stoicism that increased my respect for him. This was a youngster who did have the capacity to learn from experience.

Judith was the only member of the family who seemed to have suffered no change in the time since I last saw her. I believed that Siegfried Muhlhauser had succeded in making no impression on her. She still wore priestess black edged in white, though in a thinner fabric. She still allowed fashion to dictate that her knees be exposed in black stockings, and though beautiful she still managed to look as remote from the travail of sex as a nun who had consented to put on the garments of unconsecrated women. Her greeting to me was aloof and somehow suggested, without any mention of music, that she still disapproved of my bizarre interpretation of Varèse.

She was more responsive to Vassily. "You know Greece," she said to him. "Is it true that there are no cars and no motorcycles on Hydra? The noise on Mykonos was terrible. I can get a room on Hydra with some friends, and they tell me there is nothing noisy there except roosters and donkeys. They have a piano, but I'll have to keep it in tune. That's no problem." She had a many-sided competence.

"Your friends are right," he told her with none of the flirtatiousness he had lavished on her stepmother. He also was merely charming with Deborah. Perhaps neither of the younger women attracted him. "They can't have cars on Hydra. There aren't any roads." He took off the jacket of his white silk summer suit as soon as he was invited to. His shirt was a coral pink, and his glovelike trousers revealed a slim muscular waist. All

three women, including Judith, looked admiringly at him. All three men, including myself, looked away. He was too godlike to be endured.

"You've had your wish," he told me. "As of the first of October I shall be a G.P. In an office that I share with a gynecologist. I'm counting on the ladies to bring in their husbands for repair. As of the moment I am being destroyed by overwork. I made them sack Homer, and there's been no replacement."

"You fired him? Why?"

"A—he's too emotional and makes mistakes. One of his mistakes killed a patient. B—now that I've sacked him, anything he says to the FBI about me will be suspect."

"Vassily, you are—!"

"Please, the name is Basil."

"Vassily, you are a lineal descendant of the wily Greek who—who thought up the wooden horse!"

"Come, come, didn't you know we were really Turks or Arabs or Albanians or worse? We're not as blond as we used to be. We've disappointed the German scholars."

His revelations and his banter came as asides during a conversation that was otherwise, for at least an hour, wholly devoted to the assassination, a day or two earlier, of Robert Kennedy. The details and implications of that event, which shocked all of us, continued to hold our attention until we left royal elegance, some of us with our drinks in our hands, and sat down on the plainer furniture of the dining room. And even then, although we dropped further mention of the shooting by common consent, it retained its spell over us. Try as we would to discuss other subjects—art, love, music, books—we always came back to politics. We might have been taking our food in Washington.

"One thing is clear to me," Tommy said. Never once at the table did he mention his wound, but he did speak up for the political convictions that had brought it on. "The intelligentsia must be militant. We must never again allow the reactionaries, the cops, the trustees, the Establishment to run the show. There is a vacuum in leadership. Kennedy was shot trying to fill it. We must not let a horrible *accident*, the act of a psycho-

path, deter us from taking the lead again. We must push on and do the things he was prevented from doing."

Vassily disagreed with him. Although he spoke sympathetically, and treated Tommy with great respect, I wished he had let the manifesto pass. It was not a time to dispute with a young man who had been seriously injured during a fight that meant so much to him, a fight that he could easily have avoided. "Ten years ago I would have agreed with you, but now my experience in laboratories and hospitals, and my attempts to make some sense of it, convince me that the intelligentsia, who should of course rule as you say they should, are actually here on sufferance. They are a *biological* minority. Plato's Republic, the rule of philosopher-kings, could only have been imagined by a protected intellectual in a slave-state. Nothing like it can exist today in modern democracies. If intellectuals throw their weight about, as they have been doing lately in French and American universities, they will merely invite reaction of the most ignorant and repressive kind from a biological majority that far outnumbers them."

It was not the kind of argument that Tommy could permit himself to take seriously, at least at that time. "But that's against everything I believe in! Why do you think I got my skull smashed?"

"Wait a moment. Let's not get emotional, even in the smoke of battle. Let's reason this out. I study bodies. I try to draw scientific conclusions from my study of bodies. Fortunately for me, some geneticists and some constitutional psychologists have also been studying bodies. They have found some important facts about them. They—"

"Oh those guys!" said Tommy.

"Wait a moment. They have made some discoveries that are essential for an understanding of modern politics. Your political ideas are liberal, progressive and thoroughly admirable. You have been cruelly beaten up because you believe in them. But your ideas are not based on a scientific observation of human beings. What would you say if someone told you that human beings are naturally good, without aggressive instincts? You'd tell him to study Freud, who has proved the opposite. Well, I'm

telling you to look more closely at human bodies. If you do, you will find that the way most of them are made means that the intelligentsia must *never* be militant."

"How do you figure that?" Warts asked before his son could speak. "Now that's interesting."

"I'll confine myself to a few simple facts. The rest is too technical. Reliable scientists have found a close *statistical* relationship between body-types and mind-types. If you have a certain kind of body, the chances are you will have a certain kind of mind, acquire certain habits, catch certain diseases, suffer from certain mental illnesses. This is all rough and statistical. It has little to do with complex individuals. But it helps us to understand politics, which are also rough and statistical.

"After photographing *millions* of bodies in the nude and comparing them with the mental habits of the persons photographed, reliable scientists have reached the conclusion that the vast majority of men and women, about eighty percent, have heavy-gutted bodies and slow-moving minds that are certain, for ancient evolutionary reasons, to resist intellectual progress. In the face of this evidence we must question the progressive belief that everyone will evolve toward the urban intellectuality that urban intellectuals admire in themselves. This belief has been disproved by what we know about the physical and mental structure of most men, which has been shaped for aeons by a will to survive in brute aggressiveness and brute emotionality. Most men are biologically conditioned to be against progress and against enlightenment. If we are to educate them to be otherwise, we must begin by recognizing this fact."

"You haven't lost faith in education, have you?" Warts asked anxiously and suspiciously.

"Not at all. Men can become educated, but only if they recognize the inherent obstacles to education, the various determinisms that are working against them. Some of our most visceral bodies and our slowest minds have turned into men of genius, because they recognized their natural handicaps and transformed disadvantages into opportunities. Slum children with everything working against them have mastered the most

difficult arts and sciences, and made important contributions, because they understood their social bad luck. And conquered it."

"But you're talking about politics," Tommy said, "and you're claiming that we are doomed to reaction and to government by the worst. I don't buy that at all! If we had accepted that, we never would have won political freedom!"

"We are *not* doomed to reaction, or to government by the worst. My adopted country is *not* going to elect a Hitler. The worst would soon plunge us into chaos, and even the most backward people in the hospital wards appear to be aware of it. They see complexity every day on TV. Educated leaders can succeed in *quietly* governing the ignorant masses, and in *quietly* preventing them from making stupid decisions, but only if it is realized how precarious the situation of the educated person is. We must never talk big. We must never do what you students are doing now, talk of taking over."

Tommy looked genuinely puzzled. "What's wrong with that? If we have the brains, why can't we do it?"

"He's already answered you, sonny," Althea said crisply. "You're an eensie-weensie dealer, running a gallery in a hole in the wall. You're up against U.S. Steel and General Motors. If you're smart, you get them to buy one or two of your pictures and help you. If you talk big, you won't get anything. They'll close you up."

"Thank you, madame!" Vassily told her ardently. In the presence of her husband he had restrained his gallantries, but this one seemed safe. "You have put it much better than I could. Why am I cursed with my horrible scientific jargon? Every night I have to exorcise it. I read one of my favorite poets in Greek, by candlelight, and ring a little bell from a monastery, before I even try to write a line in English!"

The cool force of Vassily's reasoning, together with a revelation, if it was that, of such unscientific behavior, confused Tommy. "I still don't understand what you're saying," he complained. "You—"

"Well, you should," his father told him. "You have just had a very lucid explanation that even I could follow. Students

should cut their hair and shut up. I've felt it all along, but now I've been given a good scientific reason for it."

"Oh, I don't want them to cut their hair, Mr. Black!" Vassily touched his own head. "Where would that leave *me*? And I don't want them to shut up either. But let them say something interesting, original. And not of a kind that will bring down the backlash."

Tommy tried to reason with him. "I don't think you realize how far *in* this thing they are."

"Precisely. You put it very well." Vassily must have done some debating at Oxford. "And that is why they cannot perceive their effect on others. They're in and they cannot stand outside."

"I admit that most of them are only looking for jobs, and will sell out at the first chance they get. But there are some who won't. They really have superior minds, superior courage too, and they were *made* to fill the vacuum in leadership that does exist."

"Precisely. We have them in medicine too .They are the lonely ones, who will make important discoveries, or write good books or just help their patients with imagination. I say they belong to The Prince type, and I am writing a new Machiavelli for them. Only it will be more like Shakespeare's *Prince* than Machiavelli's."

"I didn't know Shakespeare wrote a *Prince*," Tommy said doubtfully.

"Of course he did. It was called *Hamlet, Prince of Denmark*. And he put more relevant ideas into it than any of Machiavelli's. His Prince doesn't have power, he has been denied it. He's more modern. You're a prince yourself, a young American prince, heir to all the ages. You're not willing to be a mere 'attendant lord' in the Prufrock manner. You're not content to 'swell a progress' of royalty through commoners. No, you want to be Prince Hamlet himself, and seize the power that has wrongfully been withheld from you. You want to take over. But the power is in the hands of the King and he has no disposition to give it to you. What are you going to do? Take it away by force? He has all the soldiers on his side. Whip up the mob

against him? You're a lean intellectual. What you say is 'caviare to the general.' He's a hearty tub of guts and a shrewd penny-pincher who serves up the food from your father's funeral at his own wedding to your mother. He can beat you at mob-whipping any day. What are you going to do?"

"Now this is exciting!" Warts commented. "I'm seeing the students and," he glanced at me, "the avantgarde in a new light. I like it. What move do you make?" he asked Tommy as if it were a game of chess.

"While the King is kneeling at prayers and does not see me, I put a sword through him. I'm not held back by any silly religious superstition. I want to win and I take every opportunity that is offered me." I admired Tommy's answer.

"But we're in modern times. Now he's no more religious than you are. He never prays, and he never exposes his back to you." It was plain that Vassily had carefully planned the dilemma with which he confronted the young American prince.

Tommy had also had some experience at debating. "Let's get away from the literary analogies and return to real life. We *are* in modern times, and I handle them modernly. I put together a coalition of all the disaffected subjects of the King. There are lots and lots of them! Workers, farmers, miners, minors, sailors, soldiers, his own bodyguard! And when I have put them together we find that there are many more of them than of the few troops who remain loyal to him. We beat him easily, we take away his power."

"Very good," Vassily said, admiring his style of play. "And when you have put together this grand coalition, how much of your own life remains? I understand you are interested in both psychiatry and movies. How much time will you have for them?"

"None at all," Judith answered for her brother and to her brother. "And that's why you have to leave political action to others. That detective almost fractured your skull! You can't stand a political speech on TV. It bores you after two minutes. And you're always talking about sublimation. As if you knew anything about it!" It was clear to us all that only her love for her brother made her seize this occasion to speak so sharply to him in front of strangers. It was necessary that he be

made aware of his mistakes. She looked embarrassed as soon as she had spoken. Later, when we got up from the table, she kissed him on the cheek.

"Good girl!" Althea said by way of encouragement, an encouragement that was not acknowledged by any perceptible sign. "When people talk politics to me I always think of Picasso. When the German tanks were outside his studio in Paris in 1944, and making so much noise that his windowpanes rattled, he forced himself to do his own version of a Poussin bacchanale. I guess that's what Judy means by sublimation. And when he protested against Franco he did it with paint."

"Oh, he's attended a lot of Communist rallies in Paris," Tommy remarked learnedly.

"And made a fool of himself every time he did," said Althea.

He seemed to feel cornered, and turned to me. "What do you think of all this?"

I felt that he was still inclined to put me on the spot because he had once regarded me as a teacher. "The evidence indicates that you are not especially gifted as an activist," I said reluctantly. "But you feel you should be one. This stupid war—over a matter that should have been handled economically—distresses you. All injustice distresses you. But you also want to be a scientist and an artist. One of the unexplored implications of both art and science is that one should accept injustice, provided it doesn't become *too* intolerable, and get on with one's work. If this were not true, there would be no scientific discoveries and no works of art, because there have always been injustices. The artists and the scientists *looked the other way.* They were selfishly preoccupied with their work. Your family seems to be telling you to look the other way and get on with your work."

"But what do *you* say?" he insisted.

I wished to be tactful, but I did not express myself as well as I should have. "I think you are temperamentally not suited to politics. You are too honest. You see too many sides to every question. But you should not receive any advice just now. It might only make you do the opposite."

"I don't follow you," he said with an annoyance that I now realize in retrospect was justified. "I can see there's a lot of

hostility behind what you're saying, but I simply don't get what you mean. I don't dig you. And the reviewers talk about your lucidity!"

He might have said more, but Althea chose that moment to rise, on a note of rather bitter confusion, and lead us all from the table to her studio, the greenhouse that was even cooler and more agreeable than her dining room. Art might pacify us.

Vassily gave a polite minimum of his attention to her studio and her extraordinary paintings and sculptures. I had expected no more. He never looked at such things in our house either. His range extended to science and literature, but no further.

Judith kissed Tommy, who had been wounded both visibly and verbally, on the cheek, and then slipped away from us and went upstairs. This time no piano music issued from her room. Perhaps she was writing a letter to Greece. Certainly she had no time for the visual arts.

"Every time I come to the studio," Althea said to me, "I think of Angie and the way he carried on that night. What have you heard from him?"

"Nothing. Except that he's giving lectures on the Coast."

"He's due back here next week," Deborah said to comfort her boss. "And as soon as he gets here, I'll see him."

"I had a call from Mr. Shaft yesterday," Althea said. "He wants Angie's sculpture more than ever, and that dealer of Angie's has gotten nowhere. I'll deliver that sculpture to Mr. Shaft, if it's the last thing I do!"

"Didn't the movie actress—what's her name? Eunice Something?—get the money away from Mr. Shaft for her film?" I asked.

"Her name is Eunice Knox," Tommy reminded me, "and she didn't get a cent from the great tycoon. She was naive enough to think he was interested in sex. She didn't know he's nobler than that and cares only for works of art—and his image. What would happen to his image if his name appeared in a gossip column next to hers? So he didn't put any money into the picture, and I haven't heard a word from her. Maybe she and your pal Angie are having fun out there on the Coast."

"Why, Tommy," Althea said, "I really think you are jealous!"

"Not at all. I am merely interested in the valuable property I entrusted to her. While I've been waiting I've put her into immortal verse that will be remembered and recited long after she has flickered off the late late show."

Without a word of encouragement from any of us, while rubbing his head, which apparently hurt just then, he recited, in an English accent that mimicked that of Vassily:

> There was a young lady named Knox
> Who was frightfully keen about cocks
> She could tell at a glance
> What you had in your—

"No, no, no!" his father roared with fiercer energy than I had expected of him. "Your limericks are something up with which I will not put."

"A free ticket to *She Couldn't Come* to anyone who supplies the missing lines," Tommy offered with a leer at Deborah.

"I haven't the slightest idea what they are," Deborah said demurely.

"I can guess, but I'm not talking," said Althea.

"Haven't we anything better to discuss than the poetic compositions of my son?" Warts demanded, again with a force that suggested the trip to Bermuda had restored his health.

"I had a letter from your assistant, Gulley," I told him. "He said I'd be hearing from you later."

"He got off a letter to you? He's been in the hospital longer than I was. Some hopped-up poet came into the office and slugged him. He didn't like a phrase in a letter Gulley wrote him. If anything terrible can happen, it happens to Gulley. It's good to have him around, he protects the rest of us."

The Irish maid came in with broguish word that someone wanted to speak to Mr. Black Senior on the telephone.

"I'm not at home," said Warts. "Who is it?"

When she named a name that sounded like Auchincloss he said, "Oh that's my lawyer," and got up and left the studio with a vigorous stride. He was humming a tune that sounded like "There Are Smiles that Make You Happy."

A few minutes later, while Tommy was asking again why I felt so sure he was not qualified for a political career, we heard

a loud noise in the room where Warts had gone. Althea ran toward it at once. So did the rest of us, with Vassily immediately after her.

In the library, among many books that he had edited, Warts lay on the floor, with a slight cut on his forehead where he had struck it against a table when he fell.

Vassily examined him. Then he turned to Tommy. "Call the hospital. I'll speak to them. We need an ambulance."

The wayward eye of Warts had closed. I no longer wondered what it saw.

INTERLUDE: THE COMPARATIVE INTELLIGENCE OF JEWS AND GENTILES

After a lecture in an auditorium which rose in tiers like a surgical theatre, and gave the lecturer the impression of being both patient and operator, a student in the front row complained that I was taking most of my examples of avantgarde art from Europe rather than America. He also said forcefully that he wished I would clarify my position on the different contributions made by Jews and Christians (a subject I had not discussed) since I looked like a Christian but very often seemed to him to talk like a Jew. How would I rate the comparative intelligence of Jews and Christians?

Dead silence in the auditorium. Gentle-faced students looked as if they feared I might be offended. Tough-faced students looked gleeful, as if they enjoyed watching me try to cope with that one. (I could of course have avoided it.)

I said that my father had been a Protestant, my mother a Catholic, and I had received nearly all my most useful education from Jews. As an American, growing up in Kentucky and later living in New York, I had felt a strong desire to understand a world for which I felt alarmingly unprepared. I received little

educational help from teachers who came from my own background. I received much more from Jews whom I met during and after college. My principal teacher, as I have said before, was Alfred Stieglitz.

(At this point my questioner smiled with open contempt. Since he sat close, I could hear the monosyllabic obscenity he muttered to the person next to him. This, together with his aggressive question, led me to believe he was a political activist who could have little understanding of an artist like Stieglitz, whose photographs required sensitivity and imagination if they were to be appreciated. On the basis of some experience with activist students, I felt sure that anything I might say would fail to satisfy him. He wanted action, I wanted thought. He would warm to strong and banal emotions, otherwise he could never hold a crowd, while I would mistrust them. Sometimes I could respect the political changes wrought by persons of his kind. No revolution, good or bad, had ever been made without such men. But even politically his air of scornful impatience and wilful ignorance would not be helpful now. He was not dealing with the docile Russian masses of 1917 or with the docile German masses of 1933; he had to persuade an entirely different kind of people at a much later date. He would finally be destructive even if he were working for the good cause, as I felt sure he was, of ending the Viet Nam War. He was not capable of the self-sacrifice that does get good work done occasionally by governments. He would not campaign patiently at election-time. He was the kind of person who used good causes to cover up bad characters. Or so I believed as I went on.)

One of the chief lessons I learned from my Jewish teachers, and it was sharply at variance with the "Christian" sentimentality that surrounded and sought to genteelize me, took the form of an unspoken attitude of warning. Don't count on an afterlife or on the benevolence of God. Don't count on anyone, don't count on anything; you must do it all yourself. That was the chief warning, if I may condense it so, that I received from my Jewish friends. And it was all done in silence.

As a child, after witnessing certain tragic events in my family, I had for a while possessed a similar toughness of mind. At the age of seven I already knew that any truth required strength, and no grace would come easily. But the later effect of an optimistic, over-trusting society, in the first flush of a new prosperity, had been to soften me. By the time adolescence arrived—physically

rather late, in my case—I expected far too much of a world that also seemed easy to conquer.

Then, fortunately, my Jewish teachers appeared, and the better ones among them reminded me of the need for unsparing self-criticism and a broader consciousness than I had imagined possible, if anything even slightly worthwhile was ever to be accomplished. This important lesson was part of *their* tradition, and had been learned by them only after centuries of fierce struggle and opposition. It was also part of the tradition of all men of culture. It was *not* part of my tradition. But I soon realized that it was of greater value, of far greater value than my own tradition, in helping me to see the world I lived in, the world I had once thought easy to conquer.

It would be unjust to find fault with my parents. In addition to health they gave me love, real love, which psychologically may be the greatest gift of all. Wisdom they could not so much as try to give me. It was not part of their tradition, which had turned almost deliberately improvident and impractical. (When I was offered a scholarship to Harvard they discouraged me from taking it.) There was none of the energetic Protestant ethic in them. (Or in me, for that matter; after all, I *could* have taken the Harvard scholarship, instead of one nearer home that permitted me to hold an afternoon job with a firm I knew.) They were nice, easygoing people of the middle class, with no purpose except to get through each day, since their marriage was unhappy, with as little conflict as possible. They were defeated in this modest aim, because my father lacked the ability to make money in a strange land. He might have done better if he had stayed in England. Also, his Cambridge accent made him a laughingstock in Kentucky, and my mother only seemed happy when she took an occasional trip to New York to visit rich relatives. (Catholics received even more hostility at that time in Kentucky than Jews.) Politically my parents were Republicans. (So I became a socialist at sixteen.) Socially they were marginal. Religiously their "Christianity"—Anglican in my father's case, Roman in my mother's—had become a mere emblem of hard-pressed respectability. As a rite of initiation, as an interpretation of the spiritual values of life, it meant little to either of them.

My Jewish teachers, on the other hand, though they seemed to get little preparation from Judaism itself (all of them specifically repudiated it) got much from the common experience of Jews. They had been *forced* to deal with new social trends toward

urbanization and alienation to which gentiles like my parents (they should not be called Christians, since their faith merely propped their desire for an agreeable escape) remained provincially aloof. My Jewish teachers, according to their individual talents—and I chose them for that—were therefore ready for the new discoveries and theories of science. They were ready for political revolution. They knew that the genteel tradition was over. They were ready to discuss everything that meant most to me—books, music, plays, films, paintings, psychologies, mathematics, philosophies, governments, religions.

Nearly all my gentile friends were in a state of shock, concealed for a while by their talents. My Jewish teachers adjusted themselves more readily to a series of painful crises (it was the time of Hitler) that did not take them entirely by surprise. They had not been lulled into the most stupefying state of all, the state of expectancy. They were ready for the worst, and for the many opportunities it offered. They perceived that a great cultural vacuum was being created by the destruction of the old muddle-headed softness, and they wanted to help fill that vacuum. Meanwhile they fought their enemies.

Later, when I lived abroad for a few years, I acquired European teachers who were also ready for the world as it had suddenly become, the postwar megalopolis that made them rich but uneasy. Their culture, their humanity, their relaxed originality reopened my eyes to realms of being that I had first encountered in art. But nothing they taught me bore so realistically on my actual situation as what I learned, and continue to learn, from my Jewish teachers in America. The reason may be that Europeans are not obliged to live in as drastic, as unpredictable a revolution as daily obliges us to think everything anew, revise our reflexes, or go under.

I must admit that, unlike C.P. Snow, I have found no evidence of a genetic superiority among Jews. Snow's opinion strikes me as being irresponsibly racist, and sure to revive anti-Semitism among the biologically visceral majority of the population, the ever-present backlash, whom Vassily Ventris describes in the preceding chapter. But I have found considerable evidence that Jews as a whole are readier to cope with the United States as it is today, readier than any other group among us. No wonder we get so much of our professorate and our other intellectual leadership from them! Leslie Fiedler put his finger on an important truth, I think, when he said of his fellow-Jews, "What they in

their exile and urbanization have long been, Western man in general is becoming." This means that if the WASP is to regain his sting, which is unlikely, he will have to go to school to Jews.

(My questioner was now smiling broadly, I noticed—though whether with approval or contempt I still did not know.)

As for the deep religious questions that we all sooner or later must face, neither Judaism nor Christianity, as they presently exist, can be of much help to anyone who wants to make the most of his existence. Nor for that matter can Hinduism, Buddhism, Islam or any other organized faith. In our search for fulfilment we can learn much from each of them, and will lose much if we fail to, but now we are all in the position of the avantgarde: we have to move into the unknown on our own. To the extent that we lean on any group myth, after puberty, we are incapacitated for significant action. If we attach importance to being Christian or Jewish or anything else, we merely confess our own inadequacy. Religion is what we make, as Whitehead said, of our solitariness.

Whitehead also says, now that I think of it, that "if you are never solitary, you are never religious." He has little use for churches, institutions, group enthusiasms, which "may be useful or harmful." He says, "Your character is developed according to your faith," and your faith is found when you are alone.

This is to the point today when there is so much desire in us to cease being outsiders and to move into in-groups. One of the surest effects of alienation from society as a whole is a strong impulse to compensate for the loss by joining a smaller social unit that may be still more attractive. If, for example, you disapprove of our government's policy in Viet Nam—and if you are interested in the humane arts you are sure to disapprove of it—you may join a protest group that will more than make up for your loss of conventional patriotism. Remember the solidarity of Woodstock. And there are smaller and more powerful in-groups for those of us who are ambitious, and we want very much to make them.

The catch is that we also want to find a faith. If we are students, good students, we know that we have been over-pragmatized, we are fed up with the "work-ethic," we don't want to sink into the rat race. We also know that religion is not primarily a social or political fact, as we were once told it was, except for those who are content to use it (or denounce it) as a mere institution.

We want to learn all that we can from religion, pure religion: how to transform dead moments into live ones, lust into love, counters into metaphors, power-drives into fraternity. But all this requires faith, and faith comes only when we are alone. "If you are never solitary, you are never religious." When you have found your faith in solitude you can return to society with the change of heart that is the highest fulfilment of all.

Many students are threatened today with this dilemma. They want very much to find a sustaining myth, a faith—and the new understanding that goes with it. They also want very much to belong to some in-group. Both are natural desires, and both are contradictory. The chances are they can't swing it. Most of their psychological problems start right there. Few can handle this double-bind.

The big political and social in-groups are still mainly controlled by gentiles. The small intellectual and artistic in-groups are now mainly controlled by Jews. This dilemma spares no one. Some gentiles mourn their loss of power. Some Jews mourn their acquisition of it. They would prefer to remain outsiders. They are afraid they will lose their old tough independence, now that they are part of the Establishment.

The dilemma can be transformed into an opportunity, but only by extraordinary individuals who get no help at all from their background. The new avantgarde will be composed of such heroes.

As for why I have taken most of my examples of avantgarde activity from Europe, the reason is simple. That is where it all began. It grew out of individual *need*. Quite possibly most future examples will come from America, however, where there is now still greater individual *need*.

Will there be enough intelligence to go along with it? Enough ability to find the culture that is also required? Enough courage? Enough staying-power? Enough grace? We can only hope for the best. Personally I am convinced that where there is real need for a new kind of hero, and favorable circumstances, the new kind of hero will appear. How real is our need? How favorable the circumstances?

I think of this every Wednesday, when I meet a class of adults, mostly mothers who, now that their children are in college, want to get an education for themselves. These are typical remarks they make about their children, the students: "Why does she

have to take a year off and just play around? Why doesn't he want to work? He only wants to paint! She's only nineteen, and she's already had two abortions! Why do they smoke pot! Don't they know that heroin is dangerous? You can get hooked on that stuff!" These mothers do not like what avantgarde ideas have done to their children.

The avantgarde will perhaps some day be regarded as a monstrous juggernaut, imported from a decadent Old World, which annually claimed the lives of thousands of young Americans that might otherwise have been clean and useful. The people who say this, however, may be reading books, looking at pictures, listening to music, and living in buildings that came from the avantgarde that survived. Many are called; few survive.

As for the comparative intelligence of Jews and gentiles (I noticed that my questioner was rising from his chair, and thought perhaps he would stop, listen and possibly ask another question) any answer I can make must be crude and meaningless. But this much can be said: on the whole our Jews begin life with a much more pertinent grasp of the problems and people they have to face; on the whole our gentiles have to work hard, perhaps a lifetime, to catch up with them, even when they begin with extraordinary talent. Their instincts must be shoved into a new context. The United States is in the process of forging an ideology, of reorganizing itself, of giving up hunches for formulas. While the new bureaucratic urbanization proceeds, all the old rules of the game are being changed. The former style of life is finished. A new style of life, which no one can foresee, is taking its place. All the old rituals have been challenged, but the formation of new ones may require as much blood-letting as they did.

Anyone can be destroyed in the process, and his departure will not be noticed.

The situation is now equally rough on Jews and gentiles. It is no doubt roughest of all on blacks, who have to fight harder than anyone else for a place in a society which, after they have got into it, they may find that they loathe.

The situation of the gifted individual, I believe, whatever his background, is this: how am I to be authentic, how am I to avoid being exploited, how can I go athwart this society and yet survive, how can I make the unreal hearken to the real?

Only in solitude can the answers be found. Only in society can they be tried.

True talent is known by its capacity to do what is needed here

and now. And that *always* goes against the grain. In India true talent would be for more pragmatism and more efficiency.

By this time my questioner was almost at the door of the auditorium. His back was turned to me. I could not see his face, whether or not he was smiling. But I did see his shoulders, and they seemed to be in a shrug.

EPILOGUE

About ten months later, in April of 1969 (almost exactly the anniversary of the night when I met the Blacks), Vassily came to my house for a drink and dinner. No one else was there. My daughter was away at school. My wife had gone to a *vernissage* at the Althea Lovelace Gallery and had not yet returned. As soon as I had put the drink in his hand, Vassily asked me: "Well? What's been going on?" His long black hair, which made him look like a leader of the French Revolution, fell on a beautifully cut grey suit that I had not seen before. His shirt was now a slightly more conservative yellow. His face may have picked up a line or two, but I did not see them. He seemed slightly less tense than in his hospital days. He was already, in barely six months, doing well as a general practitioner, with a crowded office the time I visited him. I felt that he had reconciled himself to his renunciation of research. As usual he made no comment on the new pictures that had been hung on our white walls since the last time he had been able to find a few hours for non-medical chatter.

"What do you mean?"

"You know very well what I mean. Those people I met with you. I think the name was Black. What's happened to them since the funeral?"

His question made me realize once again that, fascinating as he and the Blacks were, my revision of this book, which had already begun, might be helping to make it more human, because it emphasized people rather than ideas, but it also had to leave out much information and many names that the original draft had contained. I would be able to do no more than *suggest* the central problems of the current avantgarde in the arts and sciences. There would be not a word about computer music or

plastic sculpture. Or about DNA or the negative income tax
Living persons had permitted me to *indicate* rather than analyze,
to use the symbolic devices of narrative rather than the naked
statements of scholarship. And this method had meant an ex-
clusion of the detail and comprehensiveness that fact-finders
prefer, even in matters of taste and feeling. Their desire for an
encyclopedia of the indescribable had been denied.

Our artists might recognize the importance of passion in their
own work, but nowhere else. A poet might be all suppleness
about poetry, and all dogma about everything else. A painter
might be exquisitely understanding of his own art, and a crude
jargoneer on music or politics. A scientist might be tone-deaf,
color-blind and word-lame. Rarely would he understand, as
well as the author of the Philosophy of the 8-Ball did, the peril
of social preferment to personal fulfilment, because he was no
longer punished for his black arts.

In short, my subject required a multiple openness to experi-
ence, of the very sort that our most highly specialized artists
and scientists now declined, and so it had to take its chances
with readers who possessed such openness.

At the same time that I realized all this I realized that Vas-
sily was hungry for information about the Blacks. I also realized
that I must not tell him anything I knew about them at once.
For one thing I didn't know enough. I had not been seeing them
Althea had seemed cool on the telephone and I had not called
again.

Also, I suspected he knew more about them that I did. His
pretension of ignorance might be part of his Greek wiliness,
as a way of covering up any attentions he might have been
paying Althea. She had attracted him. That was clear. Usually
he followed up such attractions.

"Ah, the Blacks," I said. "Oh yes. I may be writing something
about them when I go to Greece for the summer. You haven't
seen them?"

"You really are going to Greece?"

"Yes. To Hydra."

"Hydra is the least interesting of the Greek islands."

"But I remember your recommending it to Judith Black. I
wonder if she went there?" I knew that she had.

He was equally cat-and-mouse with me. "I wonder if she did?"

"I only hope that Hydra is as quiet as you told her it was."

"Oh, it's quiet enough. A relative of mine has a house there. The love-calls of the donkeys are about all that shatters the silence. But no history. No ruins. Ancient Greece exists only in the minds of the tourists. When a heifer is brought ashore for slaughter, there are tourist jokes about Io. If someone kills flies with a swatter, his weapon is a thunderbolt and he is Zeus. Old-fashioned mock-heroics," he remarked with literary scorn. "No good for a book. Especially a book about the avantgarde. As a matter of fact, the mainland of Greece—Delphi, the Parthenon, Mycenae—would be even rougher on a book about the avantgarde. All those ruins make modern art seem pretty trivial."

"Not if they have been reduced beforehand, as I think they have been by good modern art, to mere stage props for a bigger drama than they ever witnessed."

"Bigger than the fall of the House of Atreus?"

"Yes. That only became important because we have preserved a few things that were written about it. What we are living through is still more important, and calls for still better playwrights."

"You see no value in the past, in archaeology?"

"On the contrary, our best modern artists take care to learn as much as they can from archaeology. There is no other way of understanding such artists as Stravinsky, Picasso, Joyce, Mann, Yeats and many others. The further we drive into the future, the more we need to refresh ourselves with the past. The battle of New York, which is already being refought in London, Paris, Rome and Athens, gets its best armament from the ruins of Troy, Pylos, Egypt, Israel, Sumer, India, China."

"I'm not interested in the battle of New York. What's been happening to the Blacks?"

"We'll hear when Buffie comes back. She's gone to Althea's gallery. But I did hear one thing." This was pure invention, conceived then and there to smoke him out. "I hear Althea is going to give up her gallery."

"Really!" He looked startled. "She didn't— Are you sure you're right?"

"Oh, it may be a false rumor." His tone, and the words he started to say but didn't, convinced me I *had* smoked him out.

"She *has* been thinking of closing the gallery," he said. He made this admission, I suppose, because he still hoped to get information about her from me. "She wants to paint. Just imagine I ran into her in my own office! She came to the gynecologist I share an office with." He neglected to say that he had already taken away a considerable portion of the practice of the gynecologist, who had overlooked the appeal of his charm and good looks and now wished him to go somewhere else. Nor did he mention his book, which had been slowed down by medical competition.

"But I got the impression from her," he continued, "that she was afraid to give up the gallery, now that her husband is dead." It was plain he had been seeing a great deal of her, and that he knew that I knew. But we tacitly agreed to respect his fiction.

"Tell me this," he asked when I said nothing, "is she really talented? I know nothing whatever about painting. But I feel she is."

"Of course she is."

"Would she be able to run her gallery and paint at the same time?"

"No."

"Mmm. I gathered she felt the same as you do. She said she wouldn't have enough energy for both jobs."

I said nothing. I sipped some fruit juice made to look like cocktail.

"Pity! There's really something quite heroic about her, you know." He wanted to declare his love for her, I thought, but didn't dare to.

"There certainly is," I said, to encourage him.

"The way she stood up under the scandal! She—"

"Scandal?" I knew a little about it, but not nearly as much as I would now have to know for my book. I pretended total ignorance.

"Oh, they hushed it up. It never got into the newspapers. But that time her husband fell, that time I rushed him to hospital—beastly hot weather—remember? He had been talking of

the telephone to his lawyer, and his lawyer had been telling him of a legal action that was being threatened by a Frenchwoman. It seems that Black had been financing the Frenchwoman in some cheap restaurant with centimeters in its name. Twenty centimeters, a tribute to an old sweetheart who had caught her imagination.

"Black must have been off his rocker! He should have sued *her*. She stole some money and jumped the country. But then, as an attempt at blackmail, to see if she could get any more dollars out of him, and forestall prosecution, *she* sued *him*. Or was threatening to. That was what he was listening to on the telephone, from his lawyer, just before we heard him fall. Oh of course it's possible that he was ready for another attack, he was in terrible shape, but I can't help thinking there may have been a slight psychosomatic factor. Of course it was all wrong of him to blame you."

"Me!" This came as a complete surprise.

"Yes. When he came around again, at the hospital, he sat up and said: 'If it hadn't been for that damn avantgarde book, I'd never have taken it so hard.' Unfortunately, Althea and Tommy and Judith were in the room when he said it. I would not have repeated it to them."

"What did he *mean?*" I was horrified.

"Oh, I think he only meant that the news on the telephone came as an extra shock because we had been talking about the avantgarde, and the avantgarde gave him hope. Then bang! Blackmail! He blacked out."

I was not willing to take the responsibility for a death. I got quite emotional. "You'd think I ran over him in a car! Or shot him! I had nothing to do with him!"

"Don't take it so hard. He would most likely have died anyway, and at just about the same time. But the thought of a perennial avantgarde, a kind of saving remnant, always fighting against tremendous odds, always contending with the phonies in its own midst, but finally pulling mankind through—that idea meant a lot to him. It gave him hope. He couldn't help blaming you, and making the others blame you, when the telephone call came from the lawyer."

"Blame me!"

"Don't give it another thought. He was played out anyway. I saw his tests. Too much stress! Too much stress! That's what I tell my patients. And a publisher feels it more than a *pure* scientist, far away from the market, protected in his lab, able to concentrate on one little experiment and forget everything else. Don't I know it! I'm a businessman too. When I look at the bills I have to pay, and the forms I have to fill out, I wonder why I'm not thinking up a new way to annihilate the enemy. My grandfather never worked like this!"

"Did Althea take Black seriously? Did Tommy? Did Judith?" I was beginning to understand the coolness of the family on the telephone and the injustice that had been done me.

"I'm afraid they did. They were quite bitter about you when they invited me to the house after the funeral."

"They didn't invite me. I was at the funeral, and I spoke to them, but they said almost nothing. They seemed frozen. At the time I thought it was just shock."

"Don't take it so personally. At the time they thought you might have had something to do with his death. I told them they were wrong. But he said a lot of other wild things, before he went into his coma. Now of course they have forgiven you."

"Forgiven me! This is all fantastic. And I was thinking of inviting them here!"

"Oh, they'd come now. They say nice things about you."

"Thanks very much. I'm glad I'm not doing the book for his firm! When he died I telephoned his assistant Gulley, and Gulley acted as if he had never heard of *The Perennial Avantgarde*. So I signed up with somebody else. It's all just as well. Gulley wandered into Czechoslovakia at the wrong moment, and they got him mixed up with a CIA man, and he's still in prison in Prague. Gulley was cold to me too! Now I understand! I murdered Black because I talked to him about a book!"

"That's a gross exaggeration, and you know it. Gulley will get out any day, and before he went there he gave me a very nice contract for *my* book. Althea is grateful to you. She thinks you helped bring round the sculptor Jones."

"I had nothing to do with it!"

"Well, in this comedy of errors she thinks you helped deliver the sculpture of Michelangelo Jones to Mr. What's-his-name."

"I had nothing to do with it. Shaft finally got his sculpture because Angie could only get $100,000 for another piece, and he decided, 'Why punish Shaft for offering me more?' So Angie's come out from behind the 8-ball and accepted two checks for $175,000. Since he's already endorsed them over to a man who is going to build a new house for him, and the house will cost half a million, you can't really say that he's come out from behind the 8-ball. I hear the electricity is still turned off in his old house. But Mr. Shaft, they say, is happy."

"Well, Althea is grateful to you for doing nothing. She didn't make anything on that deal, but perhaps she will later on."

"I couldn't care less. It seems I made her a widow."

"You're being unfair to her, you know."

"Now I understand the way she talked to me on the phone. It was a brush-off!"

"That's all over now. She's really an amazing woman. I know some extraordinary women in Paris and Athens, but I've never met anyone who could get so much done and still have the soul of an artist. Life is much harder here of course, but she manages it all so beautifully."

"I'm in no mood to do justice to my admiration for her now."

"Black left her almost everything, you know."

"So I heard."

"But she's been very generous to both of the children. They get more from her than they ever got from him. And someday she says she will give them the house, which could bring a very nice income."

"Do they appreciate it?"

"Tommy does. He's a very solid chap, you know. She made a remarkable confession to me about him. She said there was a time when she was dying to sleep with him. She came right out with it. She wanted to slip into his room some night and see what he was like. But the minute he husband died, she lost all interest in Tommy—that way. I didn't believe her at first, but now I can see she's telling the truth. They live in the same house together, but I'm absolutely sure there's nothing between them. He's not in the least jealous of her. She's become his mother at last. He kisses her on the forehead." The frequency with which Vassily was seeing the Blacks had been slipping out

so steadily that neither of us worried about his original fiction any more.

"And then he goes upstairs to do his work," Vassily continued. "When that actress decided his movie script was too risky, and might hurt her image, he was terribly disappointed for a while, and sulked pretty hard. Remember how he sulked to you about his political ideas? You pulled him up awfully short, and he hated you! If you hadn't been so sharp, he mightn't have believed you killed his father. Now he's put movies and politics behind him—at least for a while. Althea makes him keep after his doctorate. He says he needs a structured environment—one of those ghastly American phrases he uses so much—and she provides it. She's taken down the Pop art. He has nothing to complain about."

"Does she want to get married again?"

"No!" Vassily spoke with an emphasis that startled me, but I was unable to tell whether it came from relief or disappointment.

"Is Judith as grateful to Althea as Tommy?"

"I don't know. She has a lot more to be grateful about. It was Althea who saw her through that miscarriage. And—"

"Miscarriage?" I knew there had been a scandal about Judith on Hydra, but I didn't know that it had gone that far.

"Oh, some German conductor followed her to Hydra. She didn't like him, and from what I hear he got nowhere at all. She sent him packing to Athens and Cologne. But then she got mixed up with the Beautiful People. I'm only repeating what I've been told. She was trying to compose something of her own, but it was very far-out, and they couldn't care less for her kind of music. They danced every night to Rock, or the Greek kind of Rock, and she felt lonelier and lonelier. She began to wonder why her avantgarde music reached only a few people and Rock reached everyone. She was a teacher, used to having a lot of adoring students around her who treated her like a goddess. And her father had just died. She was in shock—and lonely.

"On Hydra she got none of the respect she was used to. She was beautiful, but everybody else was beautiful too. And nobody had ever heard of chastity. She began to wonder about

chastity too. The situation ate into her. For the first time in her life she drank alcohol. She began to dance, not the dance she was trained to do, but ordinary night club stuff, where everybody puts on a show of their own.

"And one night the poor girl fell. Some French exhibitionist, who wore bathing trunks that showed his parts, took her over. And the next night, just to make it worse for her, he slept with a boy instead of her. She couldn't take it. She had a breakdown. She wasn't ready for the sort of thing that goes on all the time among the Beautiful People. She was too old-fashioned, too serious."

"Poor Judith!" I said. At that moment my resentment of the Blacks disappeared. I could imagine what they had suffered when their priestess had her breakdown.

"Fortunately, the child was not born."

"Did you help with that?"

"Certainly not! Do you think I'm going to risk my license because she didn't have any pills?" he said indignantly. "Finally she missed only two weeks of teaching. Althea handled the whole thing perfectly. No one suspected anything. But I've never heard Judith express a single word of gratitude to Althea. She's never forgiven her for being her stepmother."

"Dear Judith!" I murmured, almost as if she were part of myself. "What a passionate woman she is!"

"Passionate? She's just the opposite."

"No, she's passionate, deeply religious. And of course, ridiculous too."

"What do you mean? I don't understand!"

Fortunately, I did not have to explain. At that moment I heard my wife's key in the door, and went there to let her in.

"Darling!" she cried with special gaiety, and kissed me. "Guess who I brought home? Some old friends of yours!"

Behind her I saw the red hair and extra-white skin, now with a healthy glow underneath it, of Althea. She stood arm in arm with Judith, who was speaking to her earnestly and, I thought, affectionately. Behind them stood Deborah Harris, carrying a bottle of champagne. Next to her stood Tommy, carrying two more bottles of champagne.

He looked stronger. His father's death seemed to have helped

him to pull himself together. He had delivered a powerful tribute at the funeral. I had run into him a couple of times since then. On each occasion he had spoken with enthusiasm of his latest readings among the psychologists—never a word about the Columbia strike or his film ambitions.

Still climbing stairs were Leonidas Shaft and Angie Jones, as elegant and inelegant as ever, and behind them others whom I did not recognize.

Angie was saying to Shaft impatiently: "No! You don't understand *anything*." Shaft was smiling nervously, like a child under justifiable correction.

From inside the house Vassily called to me: "What's going on?"

I did not know how to answer him. "Something that comes back every year. An insoluble question. A hardy perennial."

It was the best reply I could make, but it did not satisfy him. He came to the door for a scientific inspection.

INTERLUDE: THE RIGHT ATTITUDE TOWARD WOMEN

Ordinarily it is unpleasant, after one has told a story, to be asked to explain what it means. To the teller a story seems complete in itself. The chances are it will be polluted by interpretation. Why do the polluting oneself? There are others who can do it so much better.

But one evening, when a fresh-faced questioner raised his hand shyly near the end of a series of lectures on the avantgarde, I realized once again that we do not live any longer in a world of agreed-upons. The gentle breeze that for a while favored the art of our new century was long ago blown away by an electronic wind-machine that silences almost all communication.

He asked, "Please! Say it all over again. In a few words."

I could not honorably retreat into the ambiguities I would have preferred. The avantgarde was too important to him and to everyone. It should not be treated as a gnosis, no matter how often it had been gnostic.

My questioner was a handsome young heir who had attracted some attention in the hall when he announced—without guile, I believe—that he planned to start a foundation for the arts and would do so as soon as he had found a suitable wife. The seats around him were subsequently filled with new friends who, I suppose, consisted of candidates for grants and candidates for marriage.

Fortunately, I did not have to try to interpret my story, only part of which I had mentioned. I merely had to give him and his retinue, which quickly seconded him, a brief résumé. Such résumés have always stuck in my throat. They seem as misguided as the notetakers who write down every word of them. Yet there was no point in mentioning the folly of seeking with the mind alone that which can only be found in the marrowbone. The poetic plenitude was over. Alienation from self and nature, as well as from society and symbols, had become general. Everything must now be said and resaid. If one had the voice for it, it had to be shouted. Otherwise there would only be blankness.

The One Unchallenged Faith

The avantgarde is no longer our one unchallenged faith. It was (and is) too useful to merchants who had no sense of what it was all about. Its brief hour of acclaim, after more than a century of neglect and attack, was promptly exploited by profit-takers who had learned, in a time of despair, how valuable any faith can be.

Can an authentic avantgarde rise again? Talent is a ceaseless foundation. Gifted mutations are sure to appear. But their viability, in ever more demanding conditions is open to question. Can they expand, or must they expire? Their capacity for expansion is now plainly the key to their survival. And artists are showing no more of this capacity than businessmen or politicians; sometimes less. They have indeed been rewarded for staying narrow. From now on all genuine advance will be inclusive. Romantic egocentricity died with the old avantgarde.

The Literature of Fractions

In literature the fear of inclusiveness becomes psychopathically fiercer every day. To the avantgarde academy, stout champions of the art of fifty years ago, any attempt at wholeness seems thinness. They repeat the charge of Joyce against Yeats, that he had only confessed artistic weakness when he concerned himself with history, ideas, generalizations.

Among the custodians of style, any assimilation of new knowledge or search for new wisdom means a sure loss of effect. Style is a drug which only a few can acquire a taste for, and it loses its kick when it requires of elegant addicts that they become as protean as contemporary experience and pass readily back and forth between new concretions and new abstractions. They do not care to work so hard. They love language and use it well. They know there can only be a relaxed enjoyment of language when there is a relaxed agreement on major premises, such as Henry James had, and no rumbles of fundamental changes. However radical in their youth, or however mod in their latest garments, they do not love the world as it is, they love the world of the masters.

Meanwhile a younger generation emerges which cares less and less about the masters and more and more about its own desperate fulfilment in the world as it is. Books take on value for youth to the extent that they help it to organize its uncharted day-to-day experience. Often youth finds an experiential base in Yeats that is missing in Joyce. Appetite for aesthetic effect is consequently replaced, among all bright students except those who will teach English (and *their* literary faith is grimly tested by pedantic textual analysis) by appetite for meaning. How am I to live today? How am I to keep going? Those are the questions asked by talented students who would prefer not to evade the issue by ducking safely into the academy. They know that in such a situation only the most monomaniacal "fractions" can flourish (by roaring repetitions above the din) but they hope to become round numbers themselves. They prefer the haleness of wholeness.

The Mythmaking Sweepstakes

The most vivid mythmaking of the century has coincided with rapid urbanization and internationalism. Yeats, Stravinsky, Picasso, to name only three of the victim-heroes of abrupt deracination, guided a general flight from hearth to café to pad that still delights the recently rural. But urbanization, for those able to make the most of it, cannot be an end in itself. It must lead back to the natural thing—children, flowers, animals, rivers, meadows—that were overlooked in the rush to big cities. Yeats, born into true urbanity, member of a family of artists, found his way back from Chelsea and Dublin to his tower and Crazy Jane. Picasso, son of a museum man, worked one day on an abstraction, the next on a goat. Stravinsky, son of a musician, after his exile from Russia, found ways to replenish himself in several lands.

Now however all metropoles, led by New York, become daily more intolerable, not only in the air above but on the streets below and in the spirit within. Among the energetic young they beget unerring desperation. Youth seeks the natural things it has been denied. Communes are started on the land, the most undeveloped land possible, by those who were born in cities. It seems safe to suppose that if any durable new myths are created, they will come from artists who are urbanized to the point of being post-urban. If archetypes and gods are found, they will come from beneath asphalt and beneath mains. And post-urban discoveries may not have to be shouted, Chicago-style. Other quiet ones will have found them too. The new pantheon lies underfoot, in backyards. Blake's New Jerusalem may rise on the rubble of Radio City.

There is something dubious in the hope I have just raised. Archetypes *can* be found, gods too, and in such unlikely places as city dumps, housing projects, country club faces, TV commercials, if we know how to look for them. But who can be expected to have any energy left for such feats of imagination, after he has conquered his first revulsion from the ugliness and trickiness of the world he has to live in? Only the richly post-urban, able to accept and *enjoy* the muck they must understand and reshape; able to suffer the ghettos and not be crushed by them. Such lovers are rare. Such minds might give us new myths that would

reverse the direction of the technological society. Such minds might show us how to make the best from the worst.

But even if such minds appeared, it is unlikely that they could make us listen. And when we did listen, the chances are we would distort what they said.

Now there's a cause for youth to work on.

Painting and Sculpture

The plastic arts have not been unaffected by the predominant cerebrality of an industrial society. Freed from realistic chores by photography, rebathed in art history by archaeologists, European painters and sculptors moved adventurously toward abstraction, geometry, nuances. Their discoveries were vigorously extended by hard-pressed American artists who came into their own as a school at a time when hysterical postwar prosperity was radically changing the lives of all citizens, whether they worked with brushes or plows or computers. For a few artists the new abundance meant sales. For their champions and collectors it also meant no time for contemplation. Art received much public attention and little private absorption. It became a conversation piece at parties and a standby in picture magazines. But there were no hours of solitude to look at it and to let it sink in.

Despair soon replaced hope among manual artists who lacked the solace of verbal modulation. Success had meant less to them than they expected. Suicides occurred and were played down at the same time as dealers, curators, collectors, critics bustled effervescently from one international showing to another.

It was a situation that everybody knew about and everybody decided to overlook. It was deplored, but who could feel a rational guilt about a freak of fate that put an unnatural strain on the makers of a product and no more than the usual strain on those who dealt in it? The usual strain was hard enough.

The most noticeable response of young artists to this dangerous situation, which may also threaten them some day, if they are sensitive enough to feel it, has been to clamor for a killing, with some rule-breaking novelty, before they reach twenty-five. Otherwise they may never be noticed. They want to use the last glimmer of avantgarde mystique to gain a few collectors before everyone sees through the threads on the elbow of the tradition of the new.

A few artists, however, old and young, realize soberly that it may be doomsday before visual images receive the contemplation they need. Before a money-dazed society, caught up now in problems of equal distribution, releases its members for their aesthetic needs. And so these artists marshal their energies for new works for new viewers who *can* somehow find the time for contemplation. My guess is that the new works which obtain contemplation from serious viewers will come from artists who have been forced by their danger to break free from the narrowness of aestheticism and to find images in nature that resacralize our daily experience. It all depends on how much the artists can learn from their own contemplation. It all depends on how deeply *post-urban* they are. However unjust their burden, there are no suicides among artists who feel wonder.

Music and the Sacred

Music has received far less attention from us than painting (it takes too much time) and so it has not been subject to the same temptations. But it has been subject to others that are usually traced to its steady disaffiliation from liturgy and folksong. In this sense it has become, like painting, progressively more "abstract," that is, more dependent upon the wealth of the inner life of the composer. And since music is a social art, composers are often as much impoverished (inwardly) by their social skills as they are rewarded with performances and commissions. The apartness of Ives and Varèse cannot have been wholly accidental. It meant less attention and more originality. More mystery.

Resacralization will be needed if music is to regain its capacity to speak to us in our loneliest and most critical moments. As an entertainment it does brilliantly as it is. But extraordinary talent cannot be content to help others pass the time. New composers will be finding new ways to chant our profoundest hierophanies (revelations of the real, the enduring) and to remind us of what we lack.

Theatre and the Profane

A few facts are clear. Artists who face the problems of their craft and their epoch are no match for a sophisticated bourgeoisie

which treats them as exploitable ornaments, producers of excitement, gifted idiots, extenders of the state, creators of temporarily sustaining myths, praiseworthy victims. Artists are no match for publishers, college presidents, heads of departments, directors of museums, owners of art galleries, editors of magazines, concert managers, contractors, producers. Art is free in the West, as it is not in the East, but the men and women who make it, if they are truly talented, must obey their deepest consciences, while those who profit on them need only obey the law. It is a handicap that few can carry. The rare exceptions only demonstrate the painful reality.

This reality, so far as I can see, is not the result of anyone's villainy. It just happened. Urbanization went too far. In a new situation any serious commitment became a serious disadvantage.

And so we live in a new kind of social order that has not yet been obliged to provide for the repairmen of its soul. Our rituals have become trivial. Sometime in the future, when outrageous mistakes have come to general attention, when the increasing disrepair of our soul is at last appreciated as a pragmatic mistake, when myths no longer sustain, when workers cannot be persuaded to go back to their factories, when soldiers refuse to go into battle, when even the banks feel the pinch, some improvements may be made. But until then we shall have to listen to the most touching anecdotes from publishers and dealers and presidents, while Havana cigars are smuggled in from London and the best brandies are passed.

The new reality is nowhere more evident than in the theatre, which should be the greatest of the arts, since it can include them all, but actually is in the worst condition. It is more directly at the mercy of a public that is over-vitamined but sick, rich but apathetic, fun-loving but fearful of play.

Can an avantgarde theatre change all that? Hardly. But a theatre *could* be resacralized into relevance—if it developed the right attitude toward women.

What is the right attitude toward women? I'll try to make it clear.

Architecture and Archetypes

Excessive reliance on intellectual programs has been a prime characteristic of the best new urban architecture, which is also

the single instance of the avantgarde's public triumph. Beauty of design has been accompanied by ominous suggestions of the penitentiary. (Psychologists might say that the architects either had much of the unconscious dictator in them or that they, somewhat like Dostoevsky's Grand Inquisitor, gave office-inmates the disguised prison cells that best suited their kind of forced labor.) An intelligent person would admire the lines of a multiple dwelling by Le Corbusier at the same time that he refused to be enticed into it. It is significant that a few intelligent youngsters are opting out of cities visually dominated by skyscrapers and settling instead in huts near naturally beautiful places like the Taos pueblo. Is this spontaneous minority protest as unreasonable as more conventional parents seem to believe?

A bit of history may help us to understand. In classical terms, an excessive respect for Logos, the principle of rational thought that has vigorously dominated Western civilization since the rise of science in the seventeenth century, has meant an excessive disrespect for Eros, the once countervailing principle of love. The next time we laugh at the flower children we might remember that for over three centuries thought has been allowed to rule without enough of the checks and balances of feeling. And there is every indication that, despite impromptu minority protests, this over-urban, over-intellectual power-drive will go on until there is a general disaster. Pollution of air, contamination of rivers, misuse of language in media, uprooting of agricultural folk, debasement of them in cities, teenage drug-taking: these familiar headline stories are mere symptoms of an earlier and more central disease, the determination to rule others through the efficacy of thought unimpeded by feeling.

When men of action were given science by men of thought, they knew how to make the most of it. They have taken such command that they now dominate all but a few of our scientists and artists. Yet a perceptive youngster is thought backward when he seeks to escape their encirclement.

Nothing is more pointless than to rail against our new technology; it has offered us more opportunities than our ancestors ever dreamed of. We rail because we are afraid we cannot find the clarity and the courage to make the most of these opportunities. We are not really worried about our *external* abilites. We know that we are practical and can impose group disciplines upon ourselves—in such matters as racial justice, birth control, land conservation—when they are absolutely required. But we

do worry about our *internal* abilities. We are afraid to let feeling return to its old equality with thought. (If feeling were released now, it might lead to a bloodbath.) We can face Logos but not Eros. We can face *yang* but not *yin*. What would happen if we let the old intangibles, as the lawyers call them, return to parity? The world would no longer be neat and schematic. Anything might happen *now*. Such is our fearful commitment to scientific order that we must ignore the emotional part of our being, which some scientists say determines most of our actions. At a time when hospitals report more psychiatric disorder than ever before there is a significant drop in the patients who seek psychotherapy. We have troubles? Let's sleep on them.

Too much will has led to a failure of will. We are witnessing the collapse of an era. And we secretly enjoy such collapses so long as we do not have to recognize that we also are collapsing. And when we perceive our own danger we are paralyzed.

In such a plight total inaction may see us through. Or so we like to believe.

Who can avoid collapse? Some very simple people, some artists, some women. They have kept closest to the life of feeling. In the case of the simple people, they have been able to ignore the menacing encroachments of intellect. In the case of more complex people, they have been able to retain their suppleness in the face of over-intellectual or over-emotional monomanias. They have been "posturban."

As for theatre, it is interesting that its decline from greatness began at the same time as the rise of the systematic investigation of nature in "the great century," as Whitehead calls it in his book on science, the seventeenth. That was when Logos moved out of the house, shabby but cosy, that he had shared so long with Eros. That was when he established the modern pattern of divorce.

The birth of tragedy may well have taken place, as Nietzsche assures us, when Apollo and Dionysus were united in a unique act of all-male generation. The rebirth of tragedy will only take place when Logos and Eros are reunited (after that bloodbath that we all justifiably fear) and when a woman plays the latter rôle. The right attitude toward women, even among women themselves, is what is needed if the arts (and their recent necessity, the avantgarde) are ever to come back again.

But what *is* the right attitude toward women?

The Philosophy of the 8-Ball

The right attitude toward women is adoration, even when they do not deserve it. It is quite possible that if they received adoration, the most unworthy ones would in time make themselves deserve it. They would be returning to the part they were made to play (before male abstractions dethroned them), the part they always wanted to play. They would know that the adoration was not meant for them personally but for a sacred power incarnate in them. They would be turned into priestesses. That is, some of them would. And those few would set the style of our civilization.

Does this seem too remote and highfalutin? For some it will always seem so, but there are others.

It is a verifiable fact that when we treat women, all women— and the feminine part of men—with reverence, we ourselves feel and behave better. Our relations with all human beings are improved. We grow more intelligent in our defense against our natural enemies. (If very feeble, we learn how to frighten them.) We grow more skilful in whatever art we practise, beginning with the art of living. We appreciate the beauty of children, animals, plants, skies. We accept the weather. We enrich ourselves with the arts, all the arts. We also enrich ourselves with the sciences. And we see our political duties with greater clarity because we know those whom we must help to protect.

Even in such good moments, evil does not cease to exist, but it is seen more clearly for what it is. We recognize first our own proneness to it—how easily we can fall out of reverence, out of love, into their opposites. We know for example that instinctively we are inclined to treat others as sexual objects, not fellow-creatures who deserve our deepest respect. We also know that instinctively we are inclined to treat others as economic objects, not fellow-creatures who deserve an I-Thou dignity. We recognize our own will toward exploitation. We do not begin by finding it exclusively in businessmen, women, politicians, deans, trustees.

Our theatre is unfortunately willing to treat others as sexual objects and as economic objects. When it points the finger of shame, it always points it at someone else. Who that someone is depends on whom its paying audience hates. And all this means

simply that our theatre serves a Logos that has been unchecked so long that now it has become almost insane.

It is a commonplace of our theatre to say that our actors cannot do Shakespeare or Chekhov because they lack the technical training that is still obtainable in Europe. The real reason is that they have seldom been trained in the reverence toward others that is essential. They deal in feelings, but they ordinarily have been estranged from them—by the manipulatory skills, the misuse of Eros, that helped them get ahead.

For Eros did not die after she (sorry, but here Eros has to be a she, not a he) was rejected by Logos. She worked for him in various disguises, in such places as Hollywood and Broadway, at whatever prostitution was required.

I am trying to suggest the complex situation that our students are rebelling against. Unfortunately, they usually lack verbal imagination (or training) and take their texts and pretexts from newspapers. Because they have been overschooled in public relations, they are unable to speak their real thoughts. They pretend, for example, to be more interested in blacks than they really are. And when they speak of blacks they usually speak of abstract persons rather than real ones whom they have had a chance to know with some intimacy. (The movement from small towns makes that difficult.) And the blacks understand all this, and the distance between them, as occurred dramatically during the Columbia strike and later at Wesleyan, is increased. A more probing attitude toward love and guilt is needed. People who are out of touch with themselves, who ignore the demands of authenticity in their rush to take the correct, group-approved liberal stance, are not capable of love. They would be healthier if they adopted a Rilkean skepticism about the word and the emotion . . . But in spite of all this, the protest of youth is real, a genuine movement toward the re-establishment of Eros, and some day it will become soundly self-critical and find the right way to speak.

Reverence for women would *not* mean an end of tragedy. It would mean an appreciation of tragedy—in plays, in others, in oneself. Most of us cannot even face play-acted tragedy, as in *King Lear*, which is said to suffer from difficulties of production but really suffers from our unwillingness to face its darkness and be purged by it. (Now do you begin to understand why there is a drop in psychoanalysis? People cannot even face themselves when they have others to listen to them!) Fortunately a few can

still face tragedy, either on the stage or in their own lives. The others will be forced to face it by the disasters that our irreverence toward nature is obviously preparing.

And that irreverence has received assistance from many philosophers, beginning with Aristotle and going into some of the most respected names of our own day. A catastrophe appears to be needed to convince the most thoughtful of men that the right attitude toward women is now essential to life.

Science and Art

Vassily Ventris (one of the few persons in the story whom I mentioned to the students) has a genuine reverence for women. He also qualifies as a genuine mutation. When his story appears in book form I suggest you study him closely.

Politics and the Young American Prince

The young American prince, sudden beneficiary of many new privileges, is having some natural difficulties fitting into his role as heir apparent. But his reading has made him more aware of the possibilities of existence than the king, his weary father, or the queen, his exhausted mother.

If he becomes an activist, the chances are he will have to sacrifice his life, either inkily or bloodily, to his cause. In terms of historical approbation his case will resemble that of the *early* Russian revolutionists, those who threw bombs and were forgotten. Psychologically he will be consumed by the paranoid distortions that he says are needed now for effective revolutionary action. Physically he may be consumed by his ignorance of chemistry. Politically, he may help along some needed reforms at the same time that he is, as Vassily says, bringing down the backlash. And the arousal of backlash may in time lead to a true revolution. (The education of the backlash.) His action therefore may possess a certain historical value, no matter how much we dislike his self-evasions or his exhibitionist style—or his attempt upon our lives.

If he refrains from action and tries patiently to find a new way of life, a new adjustment of thought and feeling, Logos and Eros, he may rebuild the avantgarde. *The dying avantgarde is as blindly*

exploitative toward talent and audience as greedy industrialists
are toward land, water and air. There is an exact parallel between
our predominant attitudes toward nature and art. A healthy
avantgarde will respect the ecology of both.

A Conclusion

The confession that I have heard more often than any other from
students, artists, scientists and indeed everyone else has been
that their lives are slipping away from them unlived. (Usually they
say it with an extenuating laugh, and almost as if they were talking
about someone else. And sometimes they look as if they were
already in their coffins, with serenity painted on them by a
mortician.) When I press them for an explanation they usually
admit to an inability to organize their minute-to-minute experi-
ence. They lack a detailed sustaining myth that transforms their
experience into spiritual wealth. "I act like I'm having a hell of a
good time, but actually of course I'm worried." They admit they
have greater opportunities than their ancestors ever had (they
pity their parents) but say they can't do anything about the
opportunities. "Too much is going on" is their usual justification
"I see something clearly and mean to do something about it, and
then it gets away from me."

Is there a treatment for this worst disease of all? Yes, and it
begins with the discovery that those who suffer from it *desire*
it. They would much rather let their lives be sneaked away from
them, most often by worthy causes, than insist on the joyful
transformation of every moment that has been described here by
masters in copious detail.

Appendix

SPEAKING OF BOOKS:
THE CHANGING OF THE AVANT-GARDE*

The other day a student said to me, "You know this death-of-God stuff doesn't mean a thing to me. But the death of the avant-garde—that really hurts." And I knew at once what he meant.

When I was in college I too believed in the avant-garde. I read Baudelaire, Flaubert, Joyce, Lawrence, Proust, and I reached the youthful conclusion that the stuffiness they attacked would some day be overcome. My confidence in the future was increased by such delights as the sculpture of Brancusi, the architecture of Wright, the painting of Picasso, the music of Stravinsky. To me it was plain that the avant-garde, as represented by them and others, would mean sooner or later an end to the business-as-usual dullness that oppressed me in the classroom, at home and nearly everywhere else.

That was a long time ago. Now I teach college students, and hear comments, such as the one I have mentioned, that mean they want to feel the same optimism I felt in an earlier day; but I have to disappoint them. In spite of their natural desire for a happy ending I have to say that the avant-garde has been taken over by the very forces it once attacked. Except for a small portion of it which daily retreats further into one private language or another (and secedes further from the cares of ordinary human beings) the avant-garde has become a label, a brand-name that helps salesmen to sell Op dresses, Boulez records and McLuhan paperbacks. In an overproductive economy where merchandising is at last more important than manufacture, the avant-garde label is needed now to embellish the consoling myth that humanity, despite its many new misgivings, is still going forward.

Idealistic youth does not like to hear that the avant-garde is no longer a promise that it can be sure will be kept. Books about Van Gogh, Schönberg, Kafka, Le Corbusier and other forerunners have led my students to expect a steady increase of cultural

* *The New York Times Book Review*, April 16, 1967

progress. They do not enjoy being told that Hazlitt wrote, as long ago as 1814, in "Why the Arts Are Not Progressive," that what "depends on genius or feeling soon becomes stationary, or retrograde," and only "what is mechanical . . . is progressive." Or that his grim thought has been grimly confirmed a century and a half later by the way the myth of the avant-garde is now shrewdly aimed at "culture consumers" and has become as subject to "turnover" as cars or cosmetics. A blurb for a Robbe-Grillet novel subtly asks readers to overlook its dullness because it is *littérature objective,* the newest excitement of the avant-garde in Paris. And if this kind of pitch fails for that book, it is soon used again by another publisher on another novel by another man. There is chic—and money—in the avant-garde.

When the avant-garde was born in 19th-century France its members believed in it as a way of combatting the sentimental *kitsch* that had followed the rise of industrialism. The plain people, once the anonymous creators of robust ballads, exquisite embroidery, brilliant folksongs, now preferred bad art to good— "Pamela" to "Tom Jones," Waldteufel to Wagner, rose-tinted sunsets to those of Turner. The avant-garde was a reassertion of authenticity and craftsmanship that became a way of life. Writers and other artists (scientists too, so long as they had a hard time) found a sustaining faith that nourished them during their years of rejection. A really new book, like "The Red and the Black," had necessarily to speak a new language that not many readers could expect to understand right off. In time, however, the rest of the world would catch up with the new language and begin to appreciate what it said. In Stendhal's case this occurred about half a century after he died or at least his books were first reprinted then.

Social revolutionaries soon seized upon the avant-garde mystique and adapted it to their own purposes. They convinced themselves that the great mass of mankind was only waiting for spiritual pioneers to lead them into a new sensitivity that even the most commonplace citizens, or so Friedrich Engels believed, would acquire. Ideas would "trickle down." Naturally the avant-garde moved ahead of the regular army, but after a while, of course, the army would catch up, and all would share in a great victory. The military metaphor was no more than the right way to read history. Humanity would go forward.

Meanwhile faith in the avant-garde sustained skeptical writers,

like Flaubert and Maupassant, who did not in the least share the revolutionaries' hopes for *all mankind*. These writers quarreled inevitably about the composition of the avant-garde—who belonged to it and who did not (see the "Journals" of the Goncourt brothers)—but its value to the world seemed to them self-evident. As far as I know, none of them imagined that it would some day be appropriated by its deadliest foes. They could not foresee that its appeals, born of the loneliness of its adherents, would be converted into a political technique by demagogues and into a weapon of war by dictators. In their understandable naiveté they failed, for example, to anticipate the genocidal constructions that could be built upon the word "forward."

What is more, when war ended and peace came at last—at least to the more prosperous parts of the world—the most imaginative avant-gardiste remained unable to predict what the new postwar prosperity would do to his beloved creed. He did not see how useful it would prove to merchants of fashion, as an aid to accelerating the obsolescence not only of books and pictures but of clothes and upholstery. (See any copy of Vogue or House Beautiful.) He failed to anticipate that it would become the criterion of snobbism in our day, among those who had never opened its books, or glanced at its pictures, or turned on its music—or shared for a moment the courage that produced them, although they can talk and dress as if they did.

Why did the *avant-gardiste* lack the earthy insight that might have led him to foresee these present-day exploitations of his most cherished faith? First, he was so used to poverty that he could not understand prosperity. (When each new picture brought Picasso a small fortune, he still preferred to pay small bills with canvases rather than cash.) Also, the adherent's faith meant so much to him that he could not look ahead and see what soon became obvious to more practical minds: that sizeable profits could be realized on the one faith that stood unchallenged, in an age of expediency, when all other faiths, religious and secular, had been put on the defensive. He did not know that people would need a sustaining myth and that he had created one of the best.

He was still blindly in love with the avant-garde. To him it meant living in a magic world that retained its wonder and surprise, a world he could celebrate, a world not yet confused by science, business and technology. Living there meant being like

a child, able to see what the emperor really had on, and able also to announce it without fear. Anyone who gave up a child's freedom, he believed, surrendered to the forces of spiritual death.

Such an attitude, rejecting any traffic with the forces that were actually reshaping the world around him soon became *too* childlike. By the time Dada appeared in World War I, the avant-garde was already declining into a babel of private languages that said "To hell with you" to everyone who did not speak each one of them. (Science, of course, had always had its private languages, but science might produce something useful, like antibiotics, television or the bomb.) Historically, the avant-garde declined first in France, where it began; only later did the United States experience both its rise and its fall. Now we Americans, our education hastened by our more complete technicalization, are quite as advanced in internecine esthetic strife as any other land, and for some decades have been influencing the rest of the world with our jazz, our skyscrapers, our tough-guy fiction, our action painters, our Pop Art.

Nevertheless our colleges still graduate large classes of compulsive advance-guardsmen who cling babylike to an earlier mystique and refuse to recognize its present condition. The mere sale of books is confused with reading them. (About five pages of good ones get read, a publisher tells me.) Teachers persist in plugging old causes which no longer have any meaning—for instance, the Sexual Revolution, which they will not see is now as dead as the Russian one, and serves chiefly to sell psychoanalysis, miniskirts and pills. They denounce puritanism at a time when syphilis is kept alive by post-penicillin teenagers who never encountered a single Victorian taboo. Or they announce "the end of ideology" when pluralistic pragmatism, once the basis for avant-garde criticism of all programmatic solutions, has hardened into such a formidable and deaf ideology that it prevents us from listening to the people of Vietnam. And in the arts, against the counsels of great practicing artists like Yeats and Stravinsky, most of us cling to the bland assurance of the scientist Jacob Bronowski, who insists that in 50 years "we shall have a Renaissance that will put the Italian one to shame."

Students do not like to contemplate the change of the avantgarde into a lucrative museum piece. They are entering an ever more competitive society that wants them to make good, and soon. To succeed, they will have to sell their best wits in a tough market-place, and sales of that sort are not made without genuine

enthusiasm. They want to believe fervently that the avant-garde is still going forward.

When they are honest, however, or imaginative enough to recognize the truth of their predicament, they see that the myth of the avant-garde is one more of many lures being used to entice them into what they call "the rat race." They need time to recover from the shock. That is a major reason why they now rather famously prefer to "play it cool." (And why 90 per cent of them go into graduate schools.) Enormous new anxiety, about far more than the draft, has to be held at bay while eager young minds look to their own resources in a time of genuine bereavement.

It will be a healthy thing when they take stock of their own resources, rather than count any longer on a faith that, as one student said has "gone and died." They know now that the dead faith must be replaced by an undiscovered new one that will take students, artists and scientists into a new loneliness, grimmer than any of them ever knew before. Only out of loneliness, faced without the dubious consolations of the old avant-garde, can a new one come again.